TIDEWATER SPIRIT

TIDEWATER SPIRIT

CULTURAL LANDMARKS, MONUMENTS
& HISTORY *of* EASTERN VIRGINIA

Photographed and Written by
BRYAN HATCHETT

THE
History
PRESS

Published by The History Press
Charleston, SC
www.historypress.com

Copyright © 2021 by Bryan Hatchett
All rights reserved

Cover images photographed by Bryan Hatchett.

First published 2021

Manufactured in the United States

ISBN 9781467149235

Library of Congress Control Number: 2021934085

Notice: The information in this book is true and complete to the best of our knowledge. It is offered without guarantee on the part of the author or The History Press. The author and The History Press disclaim all liability in connection with the use of this book.

For my parents.

About thirty years ago, my father asked me,
"Bryan, what are you going to do with all
those pictures?"

Contents

Th: Jefferson begs the marquis de la Fayette's acceptance of a copy of these Notes. the circumstances under which they were written, & the talents of the writer, will account for their errors and defects. the original was sent to Mons". de Mar--bois in December 1781. the desire of a friend to possess some of the details they contain occasioned him to revise them in the subsequent winter. the vices however of their original composition were such as to forbid material amendment. he now has a few copies printed with a design of offering them to some of his friends, and to some estimable cha--racters beyond that line. a copy is presented to the Marquis de la Fayette whose services to the American Union in general, & to that member of it particularly which is the subject of these Notes, & in that precise point of time too to which they relate, entitle him to this offering. to these considerations the writer hopes he may be permitted to add his own perso--nal friendship & esteem for the marquis. Un--willing to expose these sheets to the public eye the writer begs the favor of the Marquis to put them into the hands of no person on whose care and fidelity he cannot rely to guard them against publication.

Foreword

BY ROBERT WILSON

For the many years I have known Bryan Hatchett, I have thought of him as an attorney who took pictures. He also collected them, so when I visited him from time to time in New York, he would show me his fine assemblage of photographs—nighttime train images by O. Winston Link and Chesapeake Bay subjects by Marion Warren. Hatchett had a good eye for the work of others, both those whose images he acquired and those whose images he accepted for publication in the calendars of Chesapeake Bay watermen that he produced for nearly two decades. His own photographs would also appear in the calendars, where they more than held their own. Over the better part of the past decade, visits to him or from him have involved glimpses of the evolving project that is now before you as *Tidewater Spirit*. Seeing so many of his images together in the finished work changes my formulation about him. I realize that he has become a photographer who once did some lawyering.

The book draws upon both of Hatchett's vocations, giving serious weight to words as well as to photographs. But more to the point, he uses the words of several of the earliest observers of Virginia—John Smith, William Byrd II and Thomas Jefferson—to establish, when read in conjunction with Hatchett's own contemporary images, the permanence over the centuries of Tidewater's most alluring qualities. History is often defined as a warning

Jefferson inscribed the flyleaf in the copy of *Notes on the State of Virginia* that he gave to the Marquis de Lafayette. It is one of the two hundred copies that he had privately printed in Paris. This extraordinary piece of history is in the Albert and Shirley Small Special Collections Library at the University of Virginia.

(that tired Santayana quote about not knowing the past condemning us to repeat it) or as a confirmation of the present's superiority, but as Hatchett shows so strikingly in *Tidewater Spirit*, history as an exploration of our continuity with the past also offers consolation—consolation of a sort we need more than ever.

It should be said that, although the thrust of this book is celebratory, Hatchett brings a modern sensibility to his subject. Thus, Jefferson's problematical views on race are noted, even as Hatchett wonders how the naturalist and amateur meteorologist who was our third president would regard the changes we have wrought onto our climate.

A large portion of the book focuses on the tidal waters near where Hatchett grew up and on which his years of calendar-making concentrated. As he demonstrates in his photographs, we can continue to visit the places supported by these waters once we have visited them in these pages. *Tidewater Spirit* is a work, then, that reflects Bryan Hatchett's continuity with his own past, affirming him as just the sort of guide this subject calls for.

Robert Wilson is the editor of *The American Scholar*, the quarterly magazine of the Phi Beta Kappa Society. He is the author of *Mathew Brady: Portraits of a Nation* and *Barnum: An American Life*. The author's friendship with Bob began at Hampton High School, followed by their years as classmates at Washington & Lee University.

Photographer's Notes

There was a time when they taught Virginia history in every fourth-grade class in the Commonwealth. I hope they still do. My generation of fourth graders made replicas of the Jamestown fort out of popsicle sticks.

Back in the summer of 1980, a career move was about to take me from Virginia to New York. I set out with a borrowed camera to take a few pictures of where I came from—my hometown of Hampton. New York turned out to be a good place to learn photography, meet working photographers, and see their prints in galleries and museums. Taking

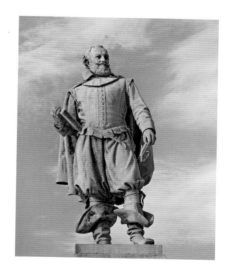

pictures became part of the rhythm of my visits back to family and friends on the Virginia Peninsula.

Eventually, my brother Philip in Newport News, our good friend John Cabot Ishon in Hampton and I published an annual wall calendar featuring photographs—some by me, many by other bay-area photographers—celebrating the Chesapeake Bay watermen. We published the "Chesapeake Bay Watermen Calendar" for nineteen years. The

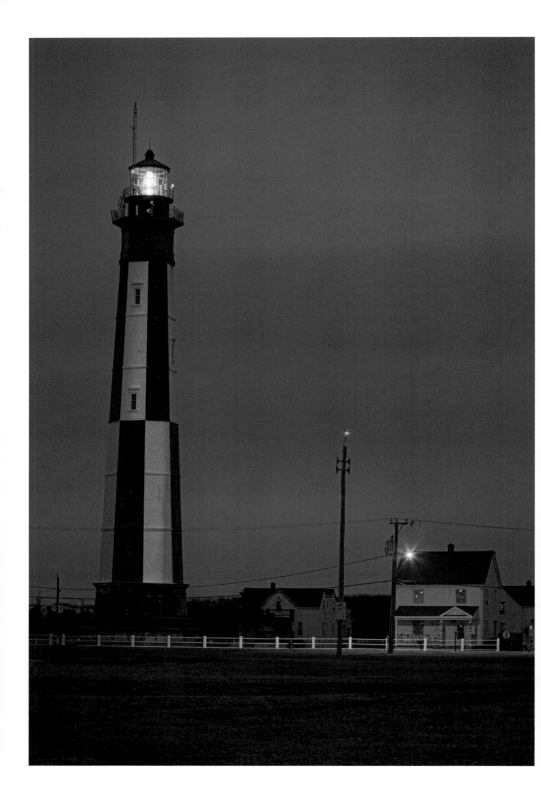

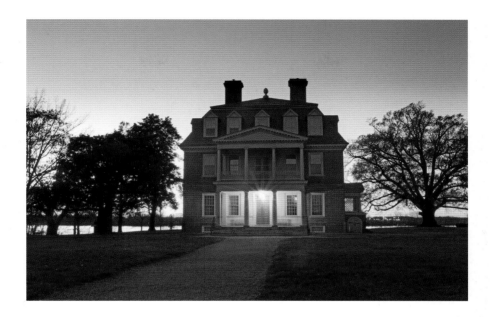

collection of photographs in this book started with those calendar pictures.

Why the watermen? The only answer I have is that the link the watermen have to Chesapeake culture and history is just so easy to see. Their workboats have the same lines as their fathers' workboats, the same white paint and some built in the same boatyards. When I was lucky enough to be invited aboard and share a waterman's day, we would reach crab pots or oyster beds in the warm light and dark shadow of dawn. Soon, the familiar elements of a Chesapeake morning, as if they were dance partners of long standing, would once again fall into graceful alignment.

As I look back on it, the calendar project was a lucky kick in the pants—just what I needed to prompt me to seek out places in eastern Virginia, learn their stories, and sometimes, I would bring back a picture worth keeping.

PREVIOUS The statue of Captain John Smith by sculptor William Couper on Jamestown Island. Compare this likeness of Smith to one created during his lifetime on page 22. More on William Couper, a Norfolk native, on page 204.

OPPOSITE Cape Henry Lighthouse, completed in 1881.

ABOVE The Great House at Shirley Plantation on the James River.

Introduction

*There is but one entrance by sea into
this country, and that is at the mouth of
a very goodly bay the wideness whereof
is near eighteen or twenty miles.... This
bay lies north and south, in which the
water flows nearly two hundred miles,
and has a channel for a hundred and
forty miles of depth between seven and
fifteen fathom, holding in breadth for the
most part ten or fourteen miles.*
—Captain John Smith

"A VERY GOODLY bay"—Captain
Smith describes the Chesapeake
with a poetic turn of phrase. Other
early Virginians could be just as
nimble with words. William Byrd II
whets our appetite with "oysters as
savory and well-tasted as those from
Colchester or Walfleet." A young
Thomas Jefferson's sparse entry

on the first page of his Garden Book—"wild honeysuckle in our woods open"—celebrates the arrival of spring. "Wild honeysuckle" was Jefferson's name for a species of azalea.

The photographs in this book are of places that have *survived*—many that Smith, Byrd, and Jefferson would recognize if we could miraculously bring them back.

The Virginia they would find today still has its "very goodly bay." Oysters still grow in the tributaries to that "goodly bay." Azaleas bloom each April and May in Tidewater gardens both large and small. Our celebrated predecessors could walk inside buildings from the eighteenth and nineteenth centuries, a few from the seventeenth, still standing on sites where the first settlers explored the New World, where Virginia played its role in inventing a new country, and where a subsequent generation fought a Civil War that nearly destroyed everything.

John Smith, William Byrd II, and Thomas Jefferson each left us rich written accounts of the Virginia they lived in. Just as Captain Smith's "very goodly bay" begins this introduction, many of the pages to follow will begin with a brief quotation lifted from letters, diaries, manuscripts, and books written by Smith, Byrd, and Jefferson.

These short passages will be our starting points, linking us back to the lives of prior generations. The Virginia of Smith, Byrd, and Jefferson, in part, is our Virginia as well. Geography and place names remain largely the same. Their descriptions of what they saw, where they traveled, what's in bloom and what's ready for harvest will sound very familiar.

Tidewater is the Virginia region east of the fall line for the rivers that flow into the Chesapeake Bay—a definition that dates back to colonial times. In our time, and causing much confusion, *Tidewater* is often used to refer solely to the region surrounding Hampton Roads in Southeast Virginia. The broader definition suits our purpose here—photographs and text conveying a sense of time and place, what has changed and what has not. On these pages, just as our ancestors did, we will call the region Tidewater—stretching from the North Carolina border north to the Potomac shoreline.

PREVIOUS In the quote on the previous page, Captain Smith estimates the "wideness" of the Chesapeake at its mouth to be "near eighteen or twenty miles." These figures are very much in keeping with the seventeen miles that the Chesapeake Bay Bridge and Tunnel Commission measures as the shore-to-shore distance of the bridge-tunnel that crosses the bay between Virginia Beach and the tip of Eastern Shore.

OPPOSITE Christ Church in Lancaster County, completed in 1735.

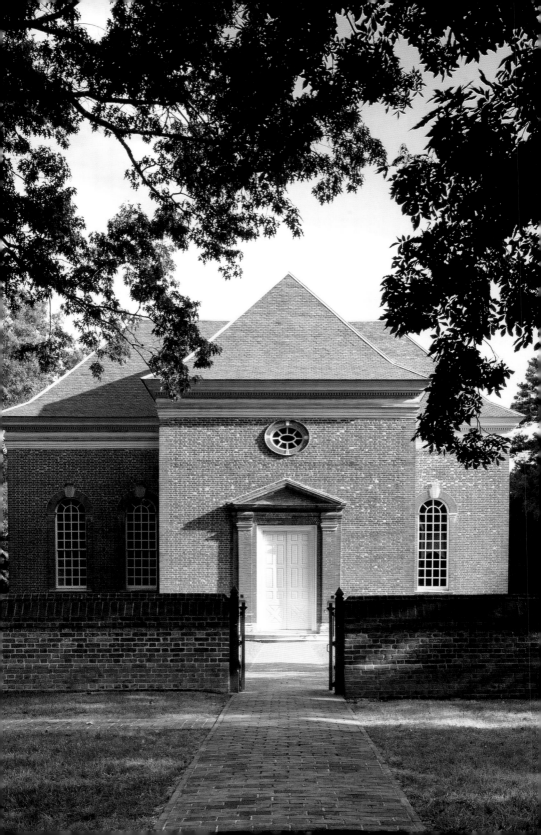

INTRODUCTION

The early pages of *Tidewater Spirit* contain images of Virginia's natural history beginning with the arrival of spring, cycling through the seasons into the dead of winter just before spring returns. Next, photographs of surviving buildings move our story along—colonial-era buildings, as well as others from the nineteenth and early twentieth centuries. These later buildings may not be as familiar or as celebrated as those from Smith's, Byrd's, and Jefferson's lifetimes, but each has a fascinating history all its own.

Images in the final chapters give us the chance to reflect on:

- The preservation era that rescued many historical buildings from neglect or even destruction—starting in the nineteenth century with Mount Vernon.
- The links that join modern-day maritime and seafood industries and Tidewater farms to colonial times.
- The extraordinary miracle that Tidewater still has open spaces set apart from modern commercial development—sites that still match descriptions of the New World, as recorded by Smith, Byrd, and Jefferson.

As you might imagine, this project has prompted me to ponder how many open spaces in eastern Virginia have been lost, how many wonderful buildings have been destroyed by fire or other calamity—or simply torn down before their value was appreciated. But not so in these photographs. Most of these scenes continue intact. You can seek them out and see for yourself.

That's something to celebrate.

Primary Sources

THREE EARLY VIRGINIA BOOKS

CAPTAIN JOHN SMITH

The Generall Historie of Virginia, New-England, and the Summer Isles

AS MENTIONED in the introduction, for many of the photographs on these pages, the accompanying text begins with a quotation from Captain John Smith, William Byrd II, or Thomas Jefferson. A small number of the original volumes of books written by Smith and Jefferson have survived and are highly prized. William Byrd's most celebrated writing was published well after his death, but his original manuscripts have been preserved.

Captain John Smith returned to England from Virginia in 1609. His celebrated map, based on his explorations, first appeared in 1612. His only other time in the New World was in 1614, when he traveled farther north up the Atlantic coast. In fact, it was Captain Smith who named that region "New England." Smith's account of his own time in the New World is a major part of his *The Generall Historie of Virginia, New-England, and the Summer Isles*, published in 1624.

He divided *Generall Historie* into sections he called "books." Smith acknowledged that much of the "Third Book" is "extracted" from accounts

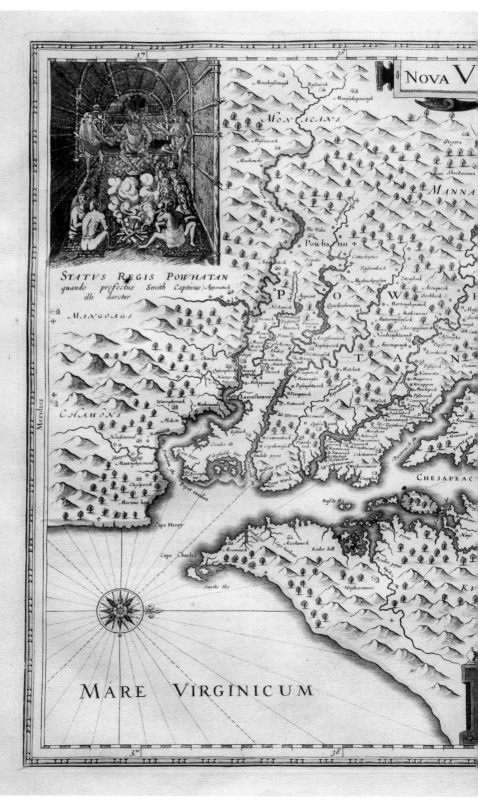

NIÆ TABVLA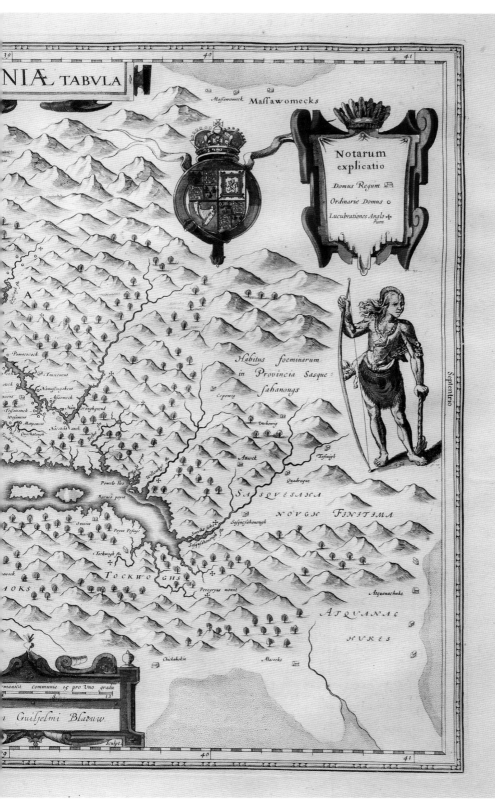

Maſſawomeck **MaſſawomeckS**

Notarum explicatio

Domus Regum
Ordinariæ Domus
Lucubrationes Anglo rum

A

Pameocock

S. Tauxenent

Namaſingakent
Aſſaomeck
Nacotchtanck
Quachatomak
Nametaquick Mattaponck
Woſameus
Teſſamaock
Quachatomak
Nacotchtanck

Habitus foeminarum
in Provincia Sasque-
ſahanougs

Cepowig

Vtchowig

Attaock Teſinigh

Quadroque

Powels Iles

Barnets poynt

Dennics

Poynt Peſeney

Tockwogh flu

SASQVESAHA

NOVGH FINITIMA

SASQVESAHANOVGH

Sasquesahanough flu
Sasquesahanough flu

TOCKWOGHS

MOKS

Perigrins mount

Atquanachuke

ATQVANAC

HVKES

Chickahokin Alacocks

Septentrio

mauica communia 15 pro Vno gradu

Guiljelmi Blaeuw.

Sculpſ.

written by other Jamestown explorers who accompanied Smith. Those accounts first appeared in *The Proceedings of the English Colonie in Virginia*, which Smith published in 1612, along with his *A Map of Virginia*. For the sake of clarity, the Smith quotations appearing in *Generall Historie* that originated in *Proceedings* will be so identified.

PREVIOUS Captain John Smith published his Virginia map in 1612. In addition, contemporary atlas publishers made many reproductions of the Smith map. The version shown here was published by Willem Blaeu of Amsterdam in 1650. Captain Smith drew his map from the perspective of a ship traveling west across the Atlantic. Once you get used to the map's placement of north on the right, not at the top, the Smith map's resemblance to our modern maps is remarkable.

ABOVE This copy of *The Generall Historie* is in the Albert and Shirley Small Special Collections Library at the University of Virginia. Captain Smith included his own image in *The Generall Historie*, as well as one of Pocahontas. Both engravings are attributed to Simon van de Passe, a Dutch and British printmaker.

WILLIAM BYRD II

The History of the Dividing Line betwixt Virginia and North Carolina

WILLIAM BYRD II, the son of a prominent landowner and fur trader in Henrico County, was born into privilege in the New World. The year was 1674, well before the tensions that sparked the Revolution. Educated in England, including the study of law, Byrd lived roughly half his life there, making three separate extended stays as an adult. At various times in London, he was agent for the Governor's Council or the House of Burgesses. For most of his life in Virginia, he was a member of the Governor's Council. He died in 1744.

It is Byrd's private writing that interests us here. He is perhaps best known today for his diaries and the two narratives he wrote regarding the survey of the border between North Carolina and Virginia in 1728. None of these works were published in his lifetime. Modern thinking is that Byrd circulated *The History of the Dividing Line betwixt Virginia and North Carolina, Run in the Year of Our Lord 1728* in manuscript form among friends as would befit a gentleman writer of his time. It was first published in printed form in 1841 and is now regarded as a classic of early American literature. Byrd's second narrative, *The Secret History*

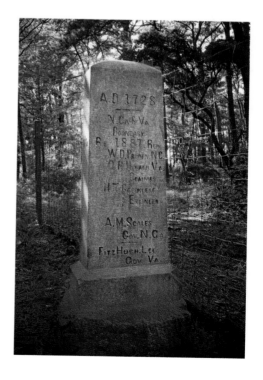

William Byrd's survey of the Virginia–North Carolina border left no permanent monuments. A century and a half later, the line was surveyed again. This time, the surveyors left behind twenty-eight granite monuments, including this one—Monument "No 1." It is roughly a half mile west of the Atlantic coastline. The wire fence next to the monument is here because this isolated area still has wild horses.

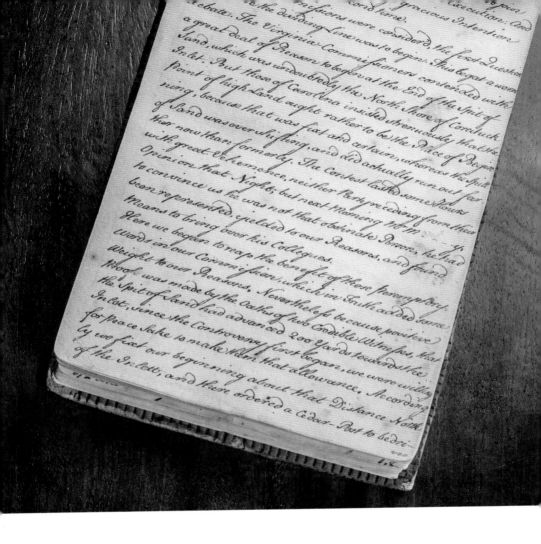

Byrd's manuscript for *The History of the Dividing Line Betwixt Virginia and North Carolina* is turned to the page that begins his description of driving a cedar post into the sand to mark the start of the survey. The manuscript is in the collection of the American Philosophical Society.

of the Line, tells the same story, but this time, in the form of a humorous and, in some places, bawdy private journal. Byrd substituted false names for the actual participants, apparently to add even more satire to *Secret History*.

Virginia's Lieutenant Governor William Gooch appointed Byrd to the Virginia delegation conducting the survey. They met the North Carolina delegation on March 5, 1728, at Currituck Inlet, an entrance from the Atlantic to Currituck Sound and Back Bay that has long since filled in with sand.

THOMAS JEFFERSON

Notes on the State of Virginia

THOMAS JEFFERSON wrote *Notes on the State of Virginia* in response to a list of "queries" he received from François Barbé-Marbois, a French diplomat in Philadelphia, in 1780. Similar inquiries went to the other states as well. Jefferson was Virginia's governor at the time. His lengthy responses became Jefferson's only published book. A photograph of the copy of *Notes* that Jefferson inscribed to the Marquis de Lafayette appears on page 8.

Jefferson's *Notes* is a treasure trove of facts about the Virginia of his time—geography, climate, resources, and natural history. Other parts of *Notes* contain Jefferson's thoughts on politics, education, religion, liberty, and law. These are the passages frequently cited by Jeffersonian scholars. It has to be added that his writing in *Notes* on slavery and his assessment of the differences between Black and white people can be disturbing to a modern reader—very much at odds with the same author's "all men are created equal." On the other hand, Jefferson acknowledges in *Notes* that slavery posed a grave moral issue for his "country"—the word he regularly uses in *Notes* to refer to Virginia. "Indeed I tremble for my country when I reflect that God is just: that his justice cannot sleep for ever."

Jefferson privately published two hundred copies of *Notes* in 1785 in Paris, where he was serving as America's minister plenipotentiary. A French translation was published in 1786, and a London edition in English in 1787.

2

The Powhatan Indians

The first land they made they called Cape Henry; where thirty of them, recreating themselves on shore, were assaulted by five savages who hurt two of the English very dangerously.

—Captain John Smith

The complicated relationship that the 1607 colonists would have with the Powhatan Indians—the Native Americans along the Virginia shoreline—begins with Captain Smith's one-sentence description of bloodshed on the very first day that the English explorers went ashore (page 150).

The Indian leader was Chief Powhatan, who ruled a political alliance of Algonquian-speaking tribes covering nearly all of modern-day eastern Virginia. Powhatan's name derived from his birthplace, the Native settlement Powhatan located on the north bank of the James River, just below the falls at modern-day Richmond.

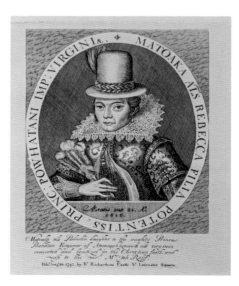

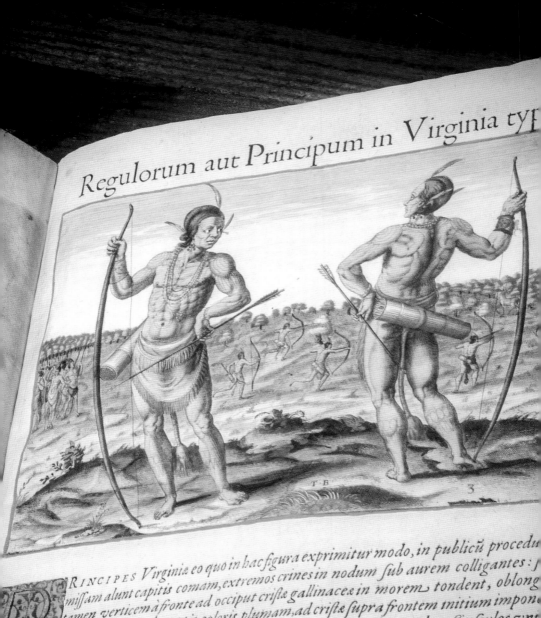

RINCIPES *Virginiæ* eo quo in hac figura exprimitur modo, in publicū procedu
missam alunt capitis comam, extremos crines in nodum sub aurem colligantes: s
tamen verticem à fronte ad occiput cristæ gallinaceæ in morem tondent, oblong
lucris cuiuspiam elegantis coloris plumam, ad cristæ supra frontem initium impon
ad singula latera pone aures breuiorem. Auribus appendent vel crassiusculos vni
quidpiam, veluti magnæ alicuius auis pedem, prout illis in mentem venit. Præterea fronte
entum, ipsum etiam corpus, brachia & crura vel puncturis ornant, aut pingunt, alia tamen
le incolæ, ratione. Torquem ex vnionib. aut globulis ex ære, quod ipsi magni faciunt, in collo
isdem armillas in brachiis. Sub pectore proxime aluum notæ apparent, vbi sanguinis missio.
nt, cum morbo corripiuntur: anteriori corporis parti feræ cuiusdam pellem eleganter concin
ant, vt illius cauda post nates propēdeat, pharetram gestantes e tenui iunco contextam, v.
ntensum, altera sagittam tenētes, ad defensionem parati. Eo ornatu incedunt vel in bellu.
 aliquod festum & celebre conuiuium profecturi. Ceruorum venatione plurimum d
m magna copia in ea Prouincia: nam fœcunda est, amœna & syluosa. Fluminibus
rii generis piscibus plenis. In bellum profecturi, colore quopiam corpus quam maxime h

The Powhatans had no written language. Their structures were biodegradable. None survive. At just a handful of archaeological sites, modern scholars have identified the remnants of postholes where Powhatan houses once stood. Watercolors drawn by John White are our visual record of the Indian people the English explorers encountered on the New World's Atlantic coast. White and Thomas Hariot, a mathematician with a knowledge of astronomy and navigation, were both members of Sir Walter Raleigh's expedition to Roanoke Island (in what is now the Outer Banks of North Carolina) in 1585.

After returning to England, Hariot wrote *A briefe and true report of the new found land of Virginia*, published in 1588. It was the first book about North America written by an Englishman who had actually sailed to the New World. Two years later, Hariot's narrative was republished by Theodor de Bry in Frankfurt. The de Bry edition included copperplate engravings based on White's watercolors.

A briefe and true report stirred interest in exploring the New World even though it coincided with news reaching Europe that when White and his party returned to Roanoke Island in 1590, they discovered the site deserted. The 115 English settlers who had traveled there in 1587 were never found—an expedition that is frequently called the "Lost Colony." Among the missing were White's daughter and granddaughter. The next attempt by the English to place a colony in America would be seventeen years later at Jamestown.

PREVIOUS, INSET This portrait of Pocahontas is the only known image of her made during her lifetime. Captain Smith included the engraving in *The Generall Historie*.

PREVIOUS Theodor de Bry published *A briefe and true report of the new found land of Virginia* in four languages. This is the Latin version in the collection of the Mariners' Museum in Newport News. The English translation of the large type at the top of the page is "An example of the Rulers or Chiefs in Virginia."

3

Spring and Summer

DAFFODILS

LET'S START with something very basic that Virginians share with their predecessors who left the Old World for the New: the rhythm of one season passing to the next.

Gloucester County daffodils are the first hint of spring in Tidewater. Usually the first blooms appear in March, but sometimes in late February, which is way too early because future cold snaps are still likely. Locals say that early settlers brought daffodil bulbs with them from Europe. No one knows that for sure. In the picture on page 31, daffodils are blooming in front of Gloucester Courthouse, a building that is traditionally listed as dating back to 1766. It took more than two centuries for Gloucester to outgrow its courthouse. They stopped holding court here in 1982.

If the 1766 date is correct, the earliest years of the courthouse would have overlapped with the last years of John Clayton's time as the clerk of court. Clayton is a celebrated Virginian not for his lengthy service as clerk, beginning in the 1720s, but as a collector of New World plant specimens. He compiled an extensive list of herbs, fruits and trees native to Virginia (page 42). In a real sense, twentieth- and twenty-first-century Gloucester daffodil growers have been walking in Clayton's footsteps, cataloguing old daffodil variations and developing new ones.

A Gloucester woman named Eleanor Linthicum Smith is credited with being the first in the county to see the daffodils' commercial potential. Around 1890, she began shipping them by steamboat to her son who worked at Baltimore's Union Station. He resold the flowers to depot newsboys. Mrs. Smith packed her daffodils standing up in laundry baskets, covered with cheesecloth.

Beginning in the early twentieth century, Gloucester and neighboring Mathews County became a commercial center for daffodils, owing to a microscopic worm that infested the daffodil bulbs in Holland. In 1926, the Dutch firm of M. van Waveren and Sons reached out to find an alternative site in America for cultivating daffodils. They leased three hundred acres at Charles Heath's farm, Auburn, in Gloucester County. Later, Heath's son George took over management of the expanded business. Other local farmers became daffodil growers as well.

In the peak years, local farmers cultivated up to one thousand acres of daffodils. These days, George Heath's son Brent and his wife, Becky, are Gloucester's only commercial growers and importers of daffodil bulbs. Even so, daffodils remain central to the area's culture.

The courthouse building at Gloucester Courthouse is traditionally dated at 1766. The white columns and portico are not original. Constructed in a Colonial Revival style, they were added circa 1900.

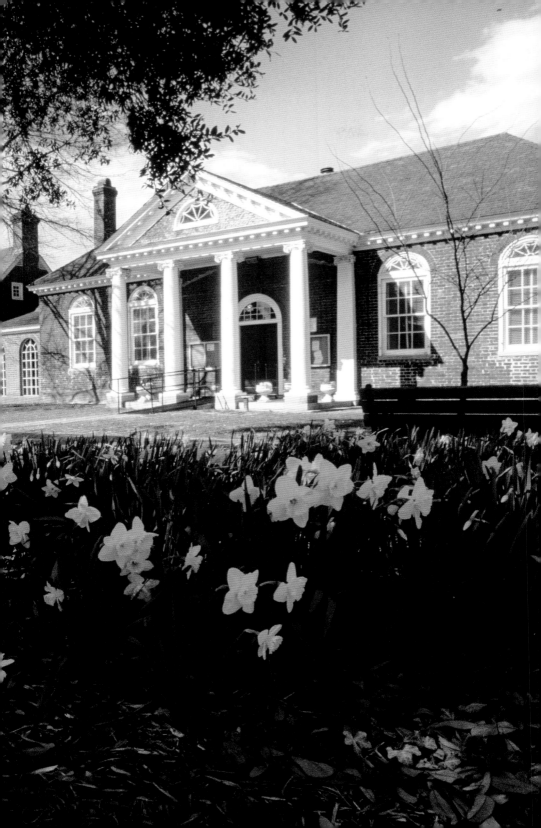

DOGWOOD TREES

Several of our men had intermitting fevers but were soon restored to their health again by proper remedies. Our chief medicine was dogwood bark, which we used, instead of that of Peru, with good success.

—William Byrd II

WILLIAM BYRD II, while surveying the Virginia–North Carolina border in the early eighteenth century, relied on a tea made from "dogwood bark" as a remedy for "intermitting fevers." "Peru" in the above quotation refers to quinine, which can be made from the bark of cinchona trees, which are native to Peru. Dogwood bark served a similar purpose during the Civil War. Southern doctors turned to dogwood bark as an alternative to quinine, which had been made scarce by Union blockades of Confederate seaports.

Dogwood trees grew at Thomas Jefferson's Monticello and George Washington's Mount Vernon. In 1918, to "stimulate an interest in the history and traditions of the Commonwealth," the Virginia General Assembly named the dogwood the state flower.

The governor back then was Westmoreland Davis. Governor Davis's ownership of the *Southern Planter*, a monthly agricultural magazine published in Richmond, had propelled him into state politics. In 1920, Governor Davis designated March 30, 1920, as Arbor Day and used the occasion to celebrate the state flower, then just two years old. In his proclamation, the governor requested "the people of Virginia…to plant American dogwood about their homes, around school buildings, the public parks and cemeteries, in all other public places and along the public highways." The modern practice in Virginia is to observe Arbor Day on the last Friday in April, when dogwoods are usually in bloom.

ABOVE A closeup of a dogwood bloom.

OPPOSITE Dogwood in full bloom at St. John's Episcopal Church in Hampton. The initial church parish here was Kecoughtan Parish and dates back to 1610. The current building, the church's fourth, was rebuilt from the charred exterior walls left standing after the Hampton fire of August 7, 1861, during the Civil War.

AZALEAS

Wild honeysuckle in our woods open.

—Thomas Jefferson

JEFFERSON RECORDED the above words on the very first page of his Garden Book, a journal he kept for most of his life. The above entry is from May 4, 1766. The "wild honeysuckle" he spotted was in the woodland near Shadwell, his boyhood home. Today, the name for this species is pinxter flower azalea (*Rhododendron periclymenoides*).

Years later, in *Notes on the State of Virginia*, Jefferson compiled a long list of Virginia's ornamental native shrubs. Included in the list is "Upright honeysuckle, Azalea nudiflora," which refers to the same azalea species that he had called "wild honeysuckle" in the Garden Book nineteen years earlier.

But it was not Jefferson who inspired Norfolk to cultivate a municipal garden and to fill it full of azaleas—it was Charleston, South Carolina's success at attracting visitors to see its azaleas, traveling there even during the Great Depression.

In 1938, Norfolk received a grant from the Works Progress Administration (WPA) to begin the project, then called Azalea Gardens. Two hundred Black women and twenty Black men did the hard work. With shovels, hoes, pickaxes and wheelbarrows, they cleared out overgrown vegetation from the 150-acre site. In 1958, the Old Dominion Horticultural Society took over the maintenance of the site and changed its name to Norfolk Botanical Garden. Azaleas, blooming in April and May, draw the garden's biggest crowds.

Pinxter flower azalea (*Rhododendron periclymenoides*) in Norfolk Botanical Garden.

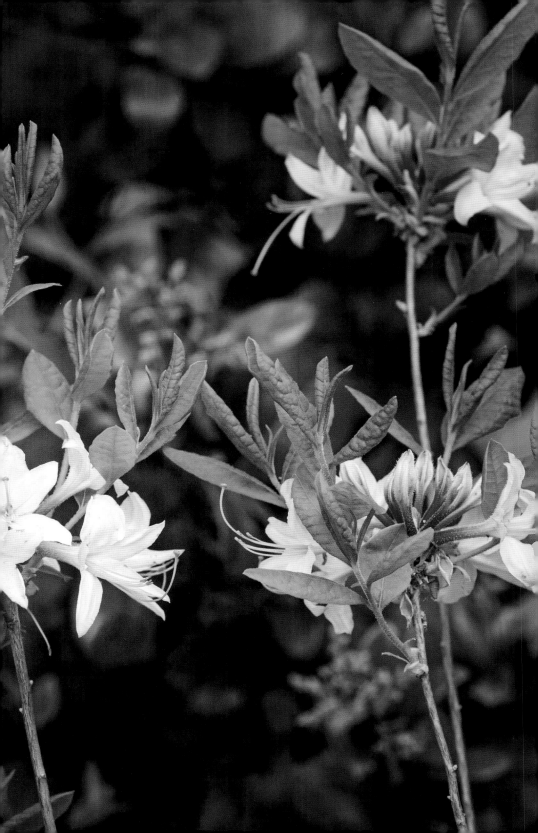

A hot summer morning on
Back River, near Messick Point
in Poquoson. The humidity
diffused the sunlight into a
yellow glow.

...it's the humidity

The summer is hot as in Spain....The heat of summer is in June, July, and August, but commonly, the cool breezes assuage the vehemence of the heat.
—*Captain John Smith*

SCHOLARS SAY that Captain Smith chose his words carefully when crafting his description of Virginia's summer climate. He sought to generate interest in the New World by making a reference to the Old that would be familiar to his readers.

A century and a half later, in *Notes on the State of Virginia*, Thomas Jefferson was much more precise. He wrote that, on a day in August 1766 in Williamsburg, "the mercury in Farenheit's thermometer was at 98° [omitting an "h" from "Fahrenheit"]." In the summer of 1779, "the thermometer was at 90° at Monticello, and 96 at Williamsburgh [adding an "h" to the "Williamsburg" spelling we have come to use today]." Jefferson determined that "the difference between Williamsburgh and the nearest mountain...to be on an average 6⅛ degrees of Farenheit's thermometer." Even with global warming altering our modern climate, our hottest days follow a pattern that John Smith and Thomas Jefferson would recognize.

Autumn and Winter

Gloucester County

From September until the midst of November are the chief feasts and sacrifice.
—Captain John Smith

INTRODUCING his readers to some of the Powhatan Indian words and customs he had learned, Captain Smith wrote in *A Map of Virginia*, "They divide the year into five seasons." Two of the Powhatan seasons overlap with our autumn months. The season for "the earing of their corn" is "*Nepinough*," followed by "*Taquitock*, the harvest and fall of leaves."

It was late September—*Nepinough* or maybe *Taquitock*, based on Captain Smith's vocabulary lesson—when I came upon the derelict skiff in the photograph on page 39. The time was late afternoon on a very overcast and dreary Sunday. The location is a marsh that feeds into Severn River and Mobjack Bay in Gloucester County. I stopped the car to look at this wonderful boat, all the while, eyeing a thin sliver of blue sky off to the west, just below the heavy clouds. There was a chance that the setting sun would peek through, just before sinking below the horizon. I decided to wait. Fifteen minutes later, a bright warm light skidded over the marsh. It lasted for about two minutes.

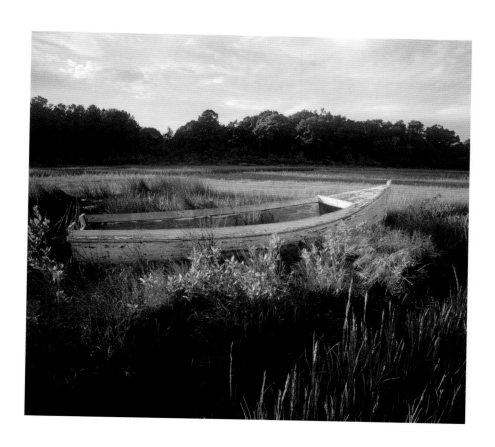

ABOVE An autumn day in Gloucester County.

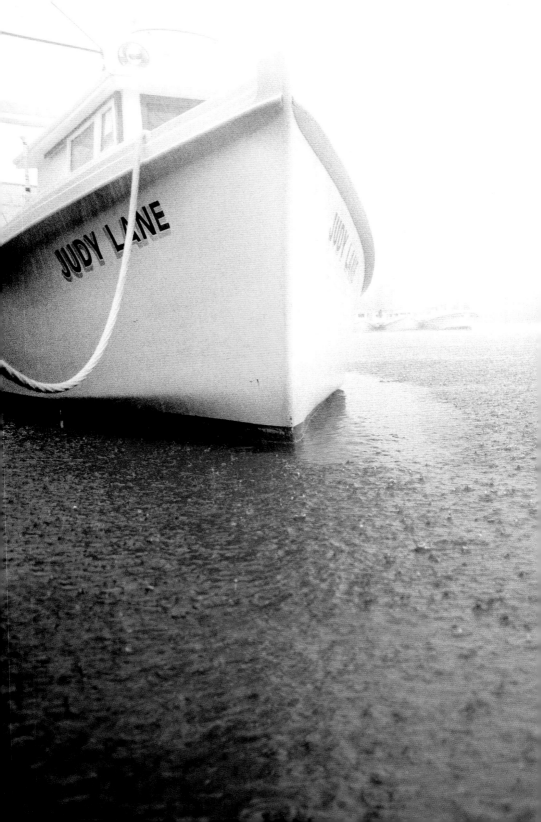

Hurricanes and Hard Rains

We sometimes saw the land by the flashes of fire from heaven, by which light only we kept from the splitting shore, until it pleased God in that black darkness to preserve us by that light to find Point Comfort.

—*Captain John Smith*

CAPTAIN SMITH'S lyrical "flashes of fire from heaven" is in the description he published of a storm that he and his party encountered in September 1608 at the mouth of the Poquoson River. It occurred near the end of his second exploratory voyage up the Chesapeake Bay. They would reach Jamestown a few days later.

The most consequential weather event for the early Jamestown settlers was a storm, probably a hurricane, in July 1609. While en route to Jamestown, the *Sea Venture*, flagship of the colony's third supply mission, encountered this storm somewhere in the Atlantic. With Sir George Somers, the admiral of the Virginia Company, and Captain Christopher Newport both aboard, the *Sea Venture* weathered the storm for three days. On the fourth morning, Admiral Somers himself "discovered, and cried LAND!" according to the account of passenger William Strachey. The land was the island of Bermuda. The crew navigated toward a reef off the shoreline where the *Sea Venture* went aground. All 150 souls onboard survived.

There, they built two replacement ships that reached Jamestown on May 23, 1610, ten months later than planned. It was then that the *Sea Venture*'s crew and passengers discovered that about 75 percent of Jamestown's colonists had died of starvation and related diseases during the colony's "starving time." Another supply ship arrived from England two weeks later, and with those provisions, the Jamestown settlement survived. The shipwreck of the *Sea Venture* is often cited as the likely inspiration for Shakespeare's *The Tempest*.

OPPOSITE Hampton waterfront during Hurricane Floyd in 1999.

SOUTHERN MAGNOLIA

*I must refer to the Flora Virginica of our great botanist Dr.
Clayton, published by Gronovius at Leyden, in 1762. This
accurate observer was a native and resident of this state,
passed a long life in exploring and describing its plants, and is
supposed to have enlarged the botanical catalogue as much as
almost any man who has lived.*

—Thomas Jefferson

THE NEW WORLD was an exotic place for travelers
from the Old, in part because of the new plant life they
encountered. If you have had the good fortune to find a
southern magnolia (*Magnolia grandiflora*) seedpod in early
fall with its red seeds still in place (i.e., before the birds
have eaten them), then you know that it's breathtaking.

The European settlers had never seen one before. In
the eighteenth century, Mark Catesby became the most
celebrated naturalist to visit America. He arrived in
Williamsburg in 1712 and collected seeds and botanical
specimens. Ten years later, he made a second trip to
the New World, this time, to the Carolinas. In 1731,
he published the first volume of *The Natural History of
Carolina, Florida and the Bahama Islands*, filled with engraved
prints of watercolor drawings. Though Virginia is not in
the title of Catesby's book, Thomas Jefferson, in *Notes on
the State of Virginia*, cites Catesby as illustrating nearly one
hundred of "our birds."

John Clayton, a contemporary of Catesby's, also
documented American plant life. When not collecting
species, he served as clerk of court in Gloucester County
for roughly half of the eighteenth century (page 42).

Red seeds cling to a magnolia seedpod on a tree in the front yard of
Berkeley Plantation in Charles City County.

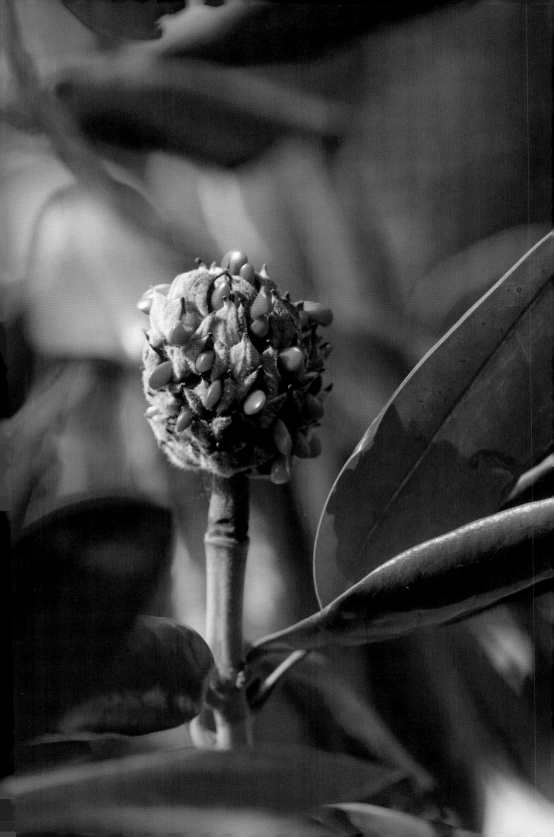

For many years, Clayton sent dried plant specimens to Catesby and to Jan Frederik Gronovius, a botanist in the Netherlands.

In 1739, Gronovius published the first volume of *Flora Virginica*, and he published a second volume in 1743. Both were based on Clayton's specimens and catalog of the native plants of Virginia. A subsequent 1762 edition, formatted into a single volume, is the one that Jefferson mentions in the previous quote (taken from *Notes*).

The Gronovius collection has been preserved in the Natural History Museum in London—a collection that includes *Magnolia grandiflora* leaves,

now brown and very brittle, that were sent by John Clayton to Europe in the eighteenth century.

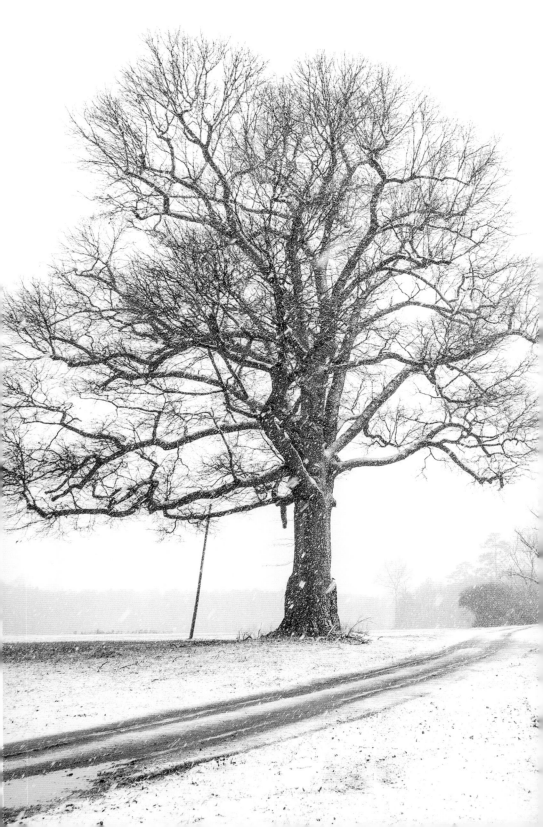

Snow

The elderly inform me the earth used to be covered with snow about three months in every year.
—*Thomas Jefferson*

IT IS ALL but impossible to resist speculating about what thoughts Thomas Jefferson would have on all manner of subjects arising in our time. We will yield to this temptation merely to say that Jefferson—who recorded weather observations throughout his adult life—would have been fascinated and opinionated about twenty-first-century global warming.

About his own time, he wrote in *Notes on the State of Virginia*, "Both heats and colds are become much more moderate within the memory even of the middle-aged. Snows are less frequent and less deep." Two pages earlier, Jefferson partially contradicts this conclusion—or, at least, puts it into context. He recalls that a mere five years prior to publishing *Notes*, he had lived through a very sharp cold spell. Measured on what he calls a "Farenheit's thermometer," Jefferson records that in Williamsburg, the mercury dropped to just 6 degrees Fahrenheit on a day in January 1780. (Throughout *Notes*, Jefferson never varies from spelling Fahrenheit as "Farenheit." That spelling appears ten times.) A few sentences later, he writes, that, in the winter of 1780, "York river, at York town, was frozen over, so that people walked across it…Chesapeake bay was solid, from its head to the mouth of Patowmac."

Falling snow on Rolfe Highway in Surry County.

CHRISTMAS

The next night, being lodged at Kecoughtan six or seven days, the extreme wind, rain, frost and snow caused us to keep Christmas among the savages, where we were never more merry, nor fed on more plenty of good oysters, fish, flesh, wildfowl, and good bread, nor never had better fires in England, then in the dry smoky houses of Kecoughtan.

—Captain John Smith

CAPTAIN SMITH and his men celebrated Christmas of 1608 in the Indian town of the Kecoughtans. The quotation above is the Captain's description of the hospitality they received. On Smith's Virginia map, Kecoughtan is the site of modern-day Hampton. Actually, Captain Smith recorded that he and his party left Jamestown on December 29, arriving at Kecoughtan the next day. In Smith's time, Christmas was a twelve-day celebration. Consistent with that custom, Smith described the bounty he and his men received at Kecoughtan as a Christmas feast.

In the photograph on page 49, a Christmas Day snow has fallen on Abingdon Episcopal Church in Gloucester County. It is Virginia's largest colonial church. Construction of the present building began in 1750. Much of the interior is original. The church can claim that Thomas Jefferson worshiped there when visiting his William & Mary classmate John Page.

John Page was born into a prominent family and raised not far from Abingdon Church at Rosewell plantation. Jefferson's biographer Dumas Malone says that Jefferson brought his "fiddle" with him on visits to Rosewell. Like Jefferson, Page became a political leader. At various times, he was a member of the Virginia House of Delegates, governor of Virginia and a member of the House of Representatives in the new nation's very first Congress.

OPPOSITE Abingdon Episcopal Church, Gloucester County.

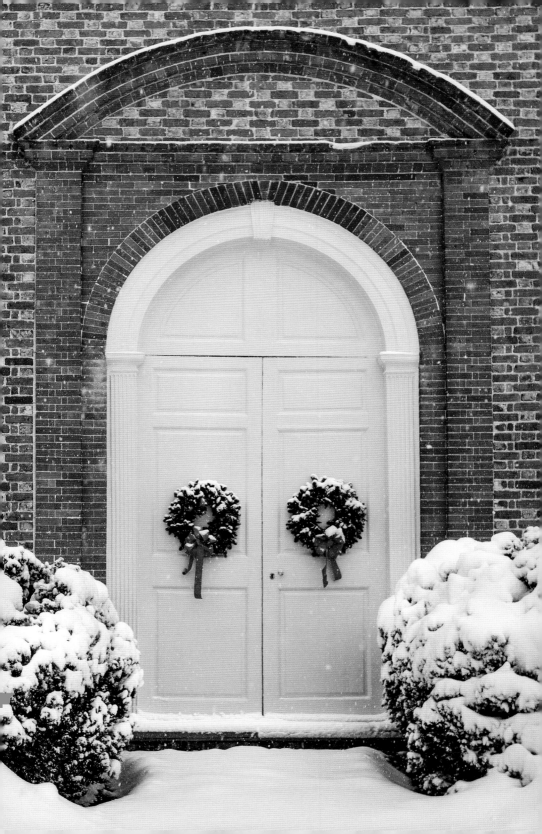

Homes of the Virginia Signers of the Declaration of Independence

THE *VIRGINIA GAZETTE*

IN JULY 1776, two Williamsburg newspapers published the news from Philadelphia: the Second Continental Congress had adopted the Declaration of Independence.

The *Virginia Gazette*, printed by John Dixon and William Hunter Jr., published the Declaration on the second page of its July 20 edition. Six days later, a second newspaper, also called the *Virginia Gazette*, printed by Scottish immigrant Alexander Purdie, put the Declaration on its first page.

The Virginia delegation that voted for independence numbered seven politically prominent men. All but Thomas Jefferson lived in eastern Virginia. The Revolutionary-period homes of three of the Tidewater delegates—George Wythe, Thomas Nelson Jr. and Benjamin Harrison—survive and are open to the public. For the two Lee brothers who signed the Declaration—Francis Lightfoot Lee and Richard Henry Lee—the surviving home is Stratford Hall, the grand house on the Potomac where they grew up. To our generation, the least familiar Virginia signer is Carter Braxton, who lost his home to fire during the war. But Elsing Green, an earlier residence in King William County, still stands.

Jefferson's Monticello, as it stood in 1776, reflected his initial design and is not the Monticello familiar to modern visitors. In 1794, Jefferson began the

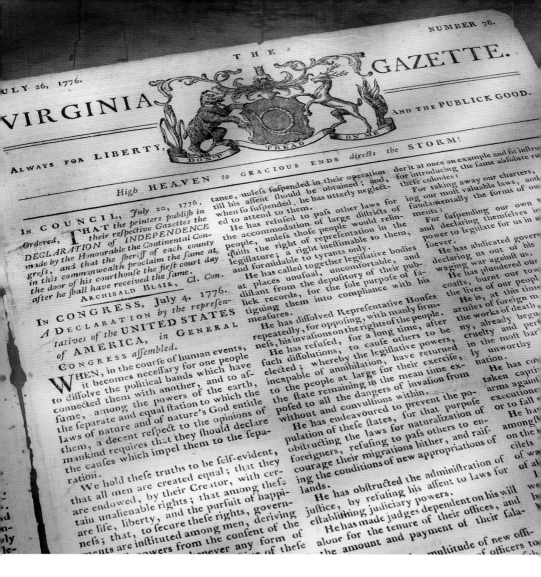

demolition of the first Monticello to make way for a second, the celebrated version that survives today.

Photographs of the surviving homes of each member of the Virginia delegation appear in this chapter.

Photographed in dappled light is a surviving copy of the July 26, 1776 *Virginia Gazette* with the Declaration of Independence on page 1. This rare copy is in the Albert and Shirley Small Special Collections Library at the University of Virginia.

Wythe House, Williamsburg

Home of George Wythe

George Wythe

GEORGE WYTHE'S signature is at the top of the column of Virginia signers of the Declaration of Independence. Richard Henry Lee's is just below.

The five Virginians who signed in early August 1776 left these prominent spaces for Wythe and Lee to write their names when they returned to Philadelphia from Virginia. Wythe was a lawyer, law professor and classical scholar. His most famous students were Thomas Jefferson and John Marshall.

George Wythe and his wife, Elizabeth, lived in an elegant brick house on Williamsburg's Palace Green, with the Governor's Palace to the north and Bruton Parish Church to the south. The couple had her father, Richard Taliaferro, to thank for their good fortune. Taliaferro owned a plantation west of Williamsburg and was a builder as well. He is believed to have designed and built this house in the 1750s. Taliaferro retained ownership, granting Wythe and Elizabeth rights to the property during their lifetimes. They lived at this Williamsburg address for more than thirty years. Wythe continued living in the house for four more after Elizabeth's death in 1787.

In the fall of 1776, Wythe and Elizabeth remained in Philadelphia so Wythe could continue his term in the Continental Congress. They lent their house to Jefferson and his wife, Martha. Jefferson was in Williamsburg to serve in the House of Delegates, the lower house of Virginia's new legislature. Five years later, General George Washington established a headquarters in Wythe's home to plot his army's advance against the British at Yorktown.

In the early twentieth century, the house was the parish house for Bruton Parish Church and home to its rector the Reverend Dr. W.A.R. Goodwin. In these rooms, Dr. Goodwin mapped out his plan to restore Williamsburg, re-creating it as it looked in colonial times (page 125). The house is now owned by Colonial Williamsburg.

ABOVE George Wythe's signature as it appears on the Declaration. Reproductions of the signatures made by the other Virginia signers appear on the pages which follow describing their specific houses.

OPPOSITE Wythe House in Williamsburg.

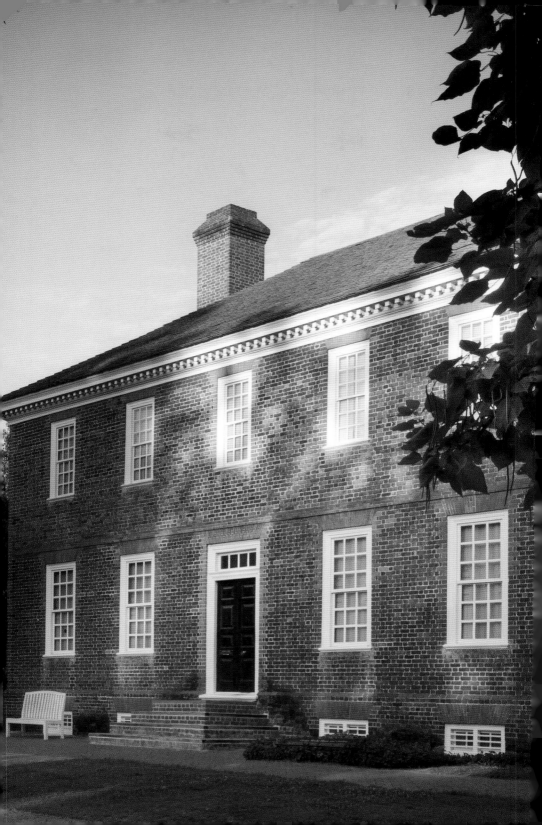

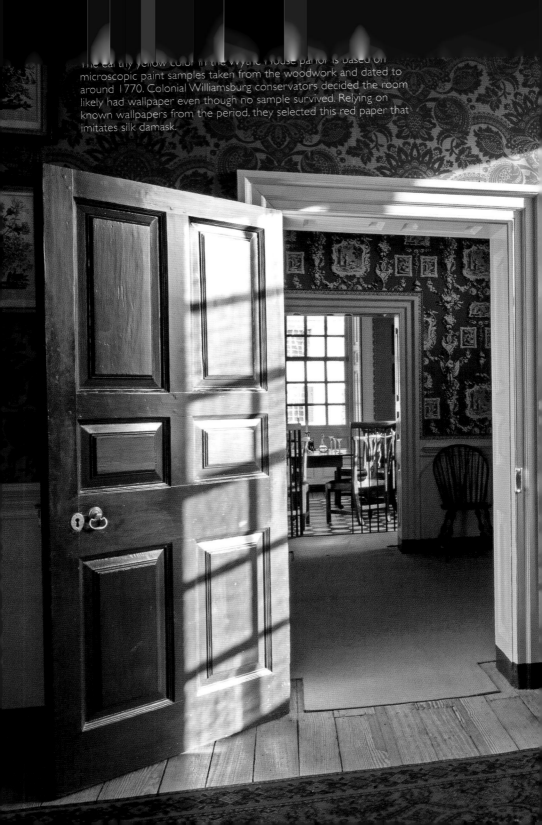

The earthy yellow color in the Wythe House parlor is based on microscopic paint samples taken from the woodwork and dated to around 1770. Colonial Williamsburg conservators decided the room likely had wallpaper even though no sample survived. Relying on known wallpapers from the period, they selected this red paper that imitates silk damask.

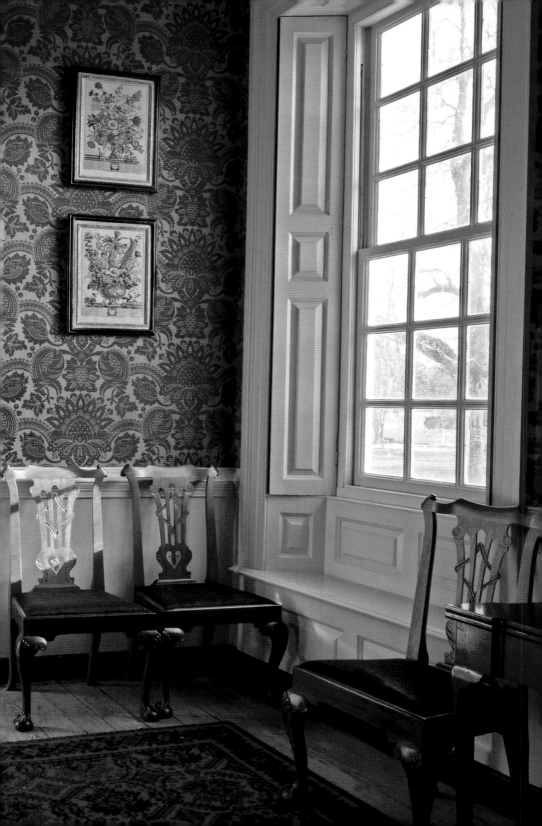

STRATFORD HALL, WESTMORELAND COUNTY

Boyhood Home of Richard Henry Lee
and Francis Lightfoot Lee

Richard Henry Lee
Francis Lightfoot Lee

THE TWO LEES were the only brothers to sign the Declaration of Independence. By 1776, they were accustomed to casting votes together. Beginning in 1758, they served in Virginia's House of Burgesses along with a third brother, Thomas Ludwell Lee—each representing a different county—Richard Henry (Westmoreland), Francis Lightfoot (Loudon), and Thomas Ludwell (Stafford).

John Adams, in the diary he kept in Philadelphia, described Richard Henry Lee as a "tall, spare…masterly man." When the Continental Congress met on June 7, Richard Henry rose to his feet and proposed that Congress declare independence, that the thirteen colonies be "absolved of all allegiance to the British Crown." Lee's motion, seconded by Adams, initiated the formal debate that would ultimately result in the Declaration a month later.

The Lee brothers grew up at Stratford Hall in Westmoreland County. Their prosperous father, Thomas Lee (circa 1690–1750), built this imposing Georgian home on a high bluff that reaches the Potomac River less than a mile away.

Richard Henry's Chantilly-on-the-Potomac, a home he built near Stratford Hall did not survive to the present day. Francis Lightfoot's home Menokin was in neighboring Richmond County. The Menokin Foundation has begun an innovative effort to preserve the ruins of this home, filling in missing pieces with glass so that the surviving original architectural detail will remain visible.

Robert E. Lee was born at Stratford Hall on January 19, 1807. His family connection with the Lee signers is through Richard Lee II (1647–1714), a grandfather of the two signers and great-great-grandfather of Robert E. Lee. Since 1929, Stratford Hall has been owned by the Robert E. Lee Memorial Association.

OPPOSITE A portrait of Henry Lee III, better known as Light Horse Harry, hangs in the dining room at Stratford Hall. An exterior image of the mansion is on page 122.

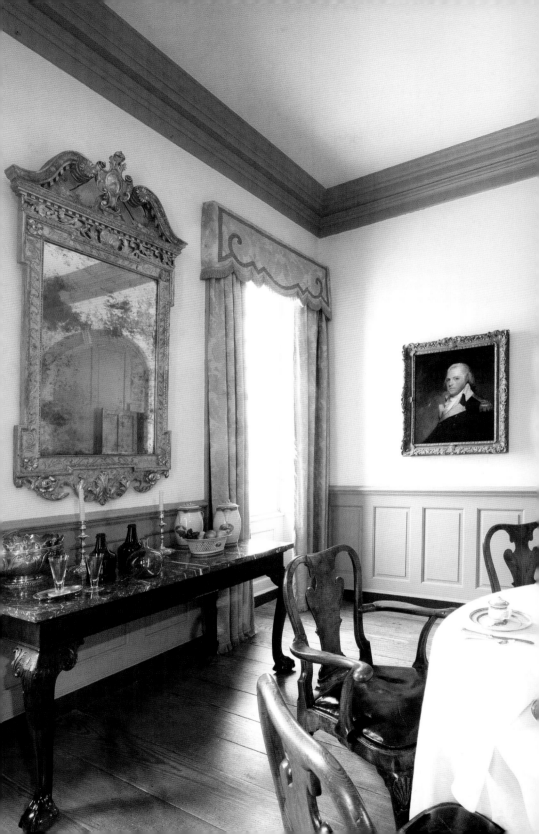

From Monticello to Williamsburg

The Travels of Thomas Jefferson

Th Jefferson

"ON THE FRINGE of western settlement" is how Dumas Malone, Thomas Jefferson's biographer, describes Shadwell plantation, Jefferson's birthplace. From Shadwell, his family could see the Blue Ridge Mountains on the western horizon. Years later, Monticello, Jefferson's grand creation, would have a view of the same mountains. Both sites were far removed from eighteenth-century Virginia's commercial and political center in Tidewater. As a result, Jefferson spent much of his early life traveling to and from Williamsburg, more than one hundred miles southeast of Albemarle County. Not an easy journey, the most direct route was by horseback and required crossing the James River twice, both times by ferry.

Jefferson meticulously recorded in his Account Book virtually all of his purchases, including travel expenses. The earliest Account Book entries that scholars have located begin in 1767, the early days of Jefferson's law practice. The following is a summary of the entries Jefferson made for his trip east in December 1771. He was on his way to marry Martha Wayles Skelton at the Forest, her father's plantation in Charles City County, north of Williamsburg:

- CHRISTMAS EVE. Jefferson, accompanied by his enslaved servant Jupiter, departed Monticello, then in its early years of construction, with Jefferson occupying two small rooms. They spent the night at Fork Church Ordinary, six miles southwest of present-day Palmyra, for two shillings.
- CHRISTMAS DAY. "Gave servt. [servant] at Martin Key's 7½ [pence]." The location is probably near present-day Columbia. At Goochland Courthouse, they crossed by ferry to the southside of the James River for two shillings.
- Apparently, Jefferson lingered for one or two nights at Eppington, the home of his future brother-in-law Francis Eppes at Bermuda Hundred in Chesterfield County.

- DECEMBER 28. Crossed the James River by ferry at Bermuda Hundred to reach Charles City County for four shillings.
- DECEMBER 29. "Gave Mrs. Sk——— 10 [shillings]." "Mrs. Sk———" is Jefferson's abbreviation for his fiancée, Mrs. Skelton. A second entry on this date is a ferry crossing at Westover for one shilling, four and a half pence. The reason for this entry, a day after the earlier crossing, is not clear.
- DECEMBER 30. Jefferson paid county clerk Mordecai Debnam forty shillings for a marriage license.

The wedding took place on New Year's Day 1772. In mid-January, the married couple traveled by phaeton—a horse-drawn carriage—to neighboring Shirley Plantation and Tuckahoe Plantation in Goochland County. The phaeton needed repairs at both places. The Account Book entry for the Tuckahoe repair was Jefferson's last for the trip.

The rest of the story of the post-wedding return to Monticello comes from the couple's great-granddaughter Sarah Nicholas Randolph, who preserved the version of events passed down from Jefferson's daughter Martha. The family story is that the trip began with a light snow on the ground. As the newlyweds traveled west, the snow deepened, becoming too deep for the phaeton to make it up Monticello mountain. Jefferson and his bride finished the last eight miles on horseback.

A portion of the page from Jefferson's Account Book for December 1771 where he recorded the expenses for his trip to Charles City County to marry Martha Wayles Skelton. The book is in the Massachusetts Historical Society's Coolidge Collection of Thomas Jefferson Papers. This image was furnished by the society.

TIDEWATER SPIRIT

They arrived late at night; the fire was out, and the servants had retired to their quarters. But soon, finding a bottle of wine "on a shelf behind some books," the happy couple "startled the silence of the night with song and merry laughter."

The South Pavilion, shown in the foreground, is where newlyweds Martha and Thomas Jefferson spent their first night at Monticello in January 1772 after traveling through a deep snow. Years later, the South Pavilion acquired the nickname "honeymoon cottage."

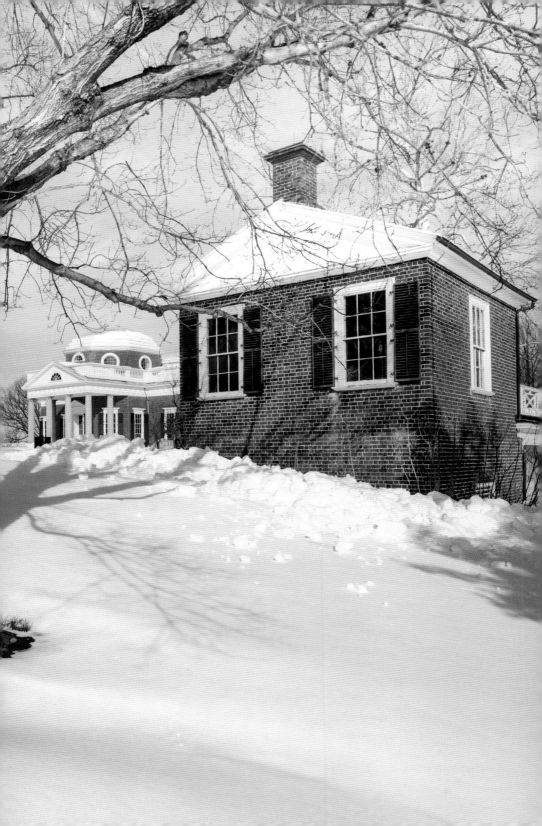

Berkeley Plantation, Charles City County

Home of Benjamin Harrison

Benj Harrison

BENJAMIN HARRISON stood at six feet, four inches tall, was overweight, and was apparently not shy about making light of his large stature. Benjamin Rush, a Declaration signer from Pennsylvania, later quoted Harrison as joking about the risk of the British hanging each of the signers for treason, "I shall die in a few minutes and be with the angels," but the much thinner Elbridge Gerry of Massachusetts would "dance in the air an hour or two."

Harrison and Richard Henry Lee were political antagonists. In Philadelphia, it became clear to John Adams that "Jealousies and divisions appeared among the delegates of no State more remarkably than among those of Virginia." Those tensions were not confined to Philadelphia. Back in Williamsburg at the 1776 Virginia Constitutional Convention, Patrick Henry engineered to have the Virginia delegation reduced from seven to five members, thereby omitting Harrison and Carter Braxton—but not before those two signed the Declaration. Harrison maneuvered his way back into the Virginia delegation, replacing Jefferson, who returned to Virginia in September 1776.

Harrison was actually Benjamin Harrison V. His father, Benjamin Harrison IV, built the manor house at Berkeley Plantation in 1726. It stands on the shoreline above Harrison Landing on the James River, thirty miles north of Williamsburg. Harrison V inherited Berkeley at the age of nineteen, forcing him to withdraw from William & Mary to take on his new responsibilities.

In January 1781, a British force, led by none other than Benedict Arnold, sailed up the James River as far north as Richmond. When returning downriver, Arnold's men plundered Berkeley—an act seen by many historians as a rebuke of Harrison's signing of the Declaration.

After the war, Harrison held political office for the remainder of his life, including speaker of the Virginia House of Delegates and governor. Two of his descendants inherited Harrison V's political skills. His son William Henry Harrison was elected president of the United States in 1840, as was his great-grandson, also named Benjamin, in 1888.

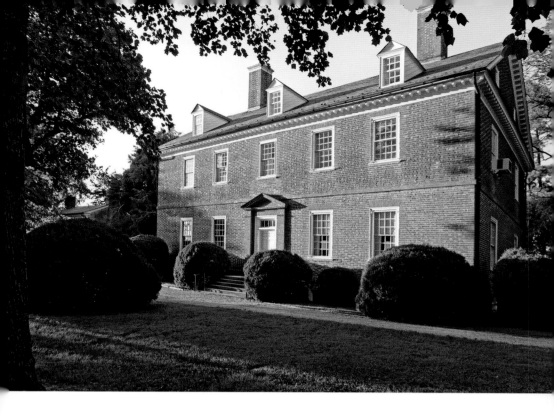

In the mid-nineteenth century, Berkeley fell on hard times. The Harrison family lost ownership of it in the 1840s. In July and August 1862, following the Seven Days' Battles, General George McClellan's Union troops—140,000 soldiers—camped at Berkeley Plantation. The house served as a hospital. President Lincoln visited Berkeley on two occasions during that encampment.

In 1907, John Jamieson bought the property. Forty-five years earlier, Jamieson had been a teenage drummer boy in McClellan's army at Berkeley. His son Malcolm and his wife, Grace, restored the house. Their son Malcolm Eggleston Jamieson; his wife, Judy; their two children, Mac and Cary; and three grandchildren are the current Jamieson generations who preserve Berkeley. The historic house is open to the public.

ABOVE
Berkeley Plantation manor house on the James River.

FOLLOWING
The dining room at Berkeley Plantation.

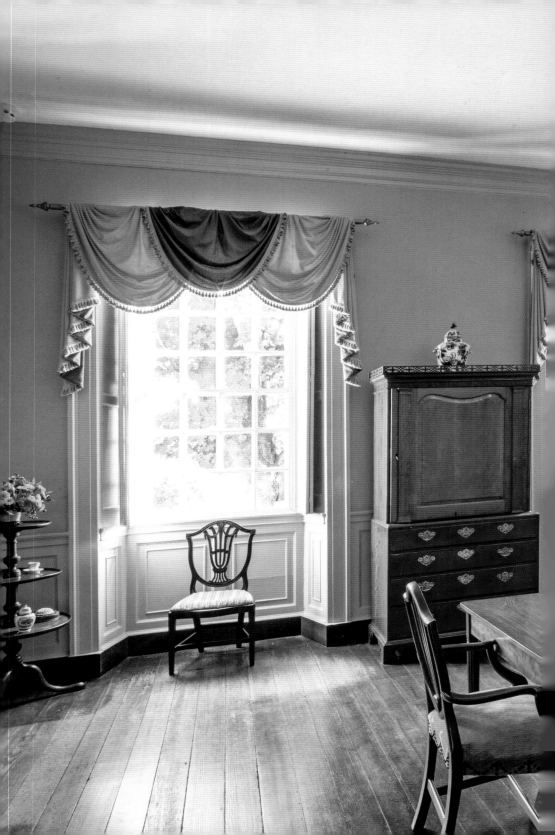

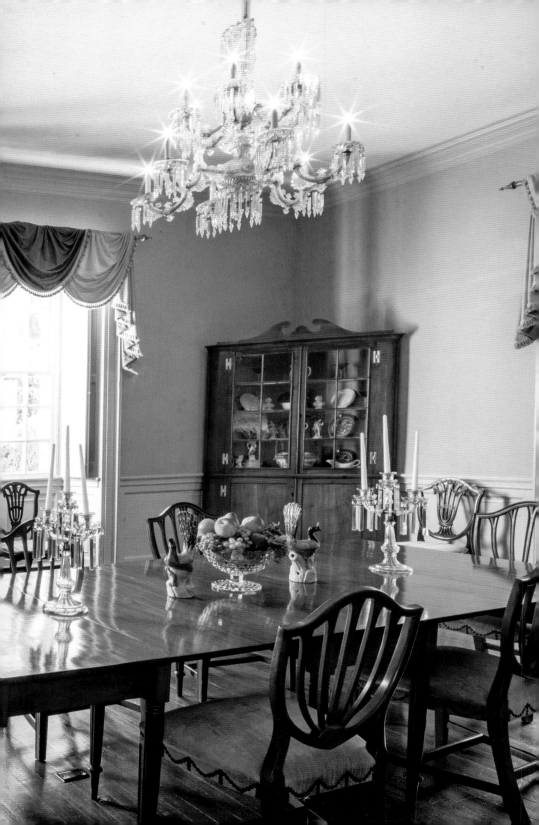

NELSON HOUSE, YORKTOWN

Home of Thomas Nelson Jr.

THOMAS NELSON JR. and his wife, Lucy, traveled from Yorktown to Philadelphia in the fall of 1775. John Adams recorded in his diary, "Nelson is a fat man" but also acknowledged that he was "a speaker, alert and lively, for his weight."

Nelson was an early advocate for independence. In March 1776, he briefly returned to Virginia to serve as a delegate at the Virginia Convention in Williamsburg. That convention passed a unanimous resolution instructing the colony's delegation in Philadelphia to propose independence from Great Britain. In mid-May, with those instructions in hand, Nelson traveled back to Philadelphia.

Virginia's darkest days of the Revolution came in June 1781, when the General Assembly, the new state's legislature, retreated to Staunton, seeking a temporary meeting spot beyond the reach of British troops to the east. There, they elected Nelson governor, adding that responsibility to his existing duties as brigadier general in command of Virginia's militia.

Just four months later, in October, the tide of war turned. Nelson's three thousand militiamen joined other American and French troops in the Battle of Yorktown. The Marquis de Lafayette later said that Nelson recommended his own house as a target for the French artillery. He quoted Nelson as saying, "Never spare a particle of my property so long as it affords a comfort or a shelter to the enemies of my country." The cannonade did indeed hit Nelson's home. It also

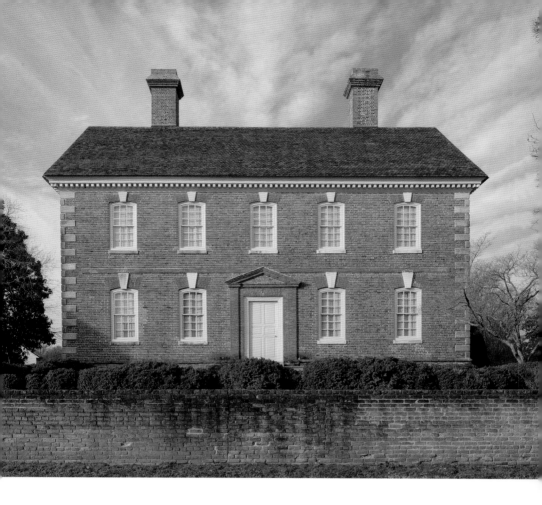

hit the nearby home of Nelson's uncle, leaving it in ruins. British General Lord Cornwallis had commandeered that home for his headquarters. Yorktown proved to be the war's decisive engagement.

Nelson and his family moved into the house we now call Nelson House in 1766. It had been built around 1730 by his grandfather Thomas "Scotch Tom" Nelson. Scotch Tom settled in Yorktown in 1705, became a successful tobacco planter, and established a mercantile business. The National Park Service acquired the house in 1968.

OPPOSITE This cannonball is one of two in the east wall of Nelson House. They were cemented in place in the twentieth century to fill the scars that date back to the Battle of Yorktown.

ABOVE Nelson House faces the York River.

ELSING GREEN, KING WILLIAM COUNTY

Home of Carter Braxton

Carter Braxton

CARTER BRAXTON was caught in the crosswinds of his time. He joined the Virginia delegation in February 1776. There is no record of Braxton favoring independence until late in the spring. But once that decision was made, he cast his vote and signed his name to the Declaration.

While in Philadelphia, the conservative Braxton wrote a pamphlet warning against the risks and potential excesses that could accompany democracy—"the tumult and riot incident to simple democracy" was Braxton's colorful phrase. For Virginia's new state government, Braxton advocated having the governor elected for life (i.e., "during his good behavior") and an upper house whose members would also have life tenures.

In short order, it became clear that Braxton's proposal for life terms was very much out of step with the prevailing mood in the summer of 1776. Richard Henry Lee called the pamphlet a "contemptible little tract." There were rumors that Braxton's wife and father-in-law were loyal to the King. All of this influenced the Virginia Constitutional Convention, then sitting in Williamsburg, to remove Braxton from the Virginia delegation when his term ended in August. The Revolution itself proved Braxton's loyalty to the new nation. By war's end, his shipping-related losses left him virtually insolvent, except for his landholdings.

Braxton represented King William County in the House of Delegates, beginning with that body's first session under Virginia's 1776 state constitution. After the Revolution, the state legislature twice elected him to the Council of State, which served as the governor's executive advisory board. He held that office until his death in 1797.

Elsing Green is on the Pamunkey River in King William County, north of West Point. It is believed that the manor house was built sometime between 1715 and 1720 and acquired by Braxton in 1753. By the beginning of the Revolution, Braxton had moved to Chericoke, also on the Pamunkey. Chericoke burned in December 1776, just months after Braxton's return from Philadelphia.

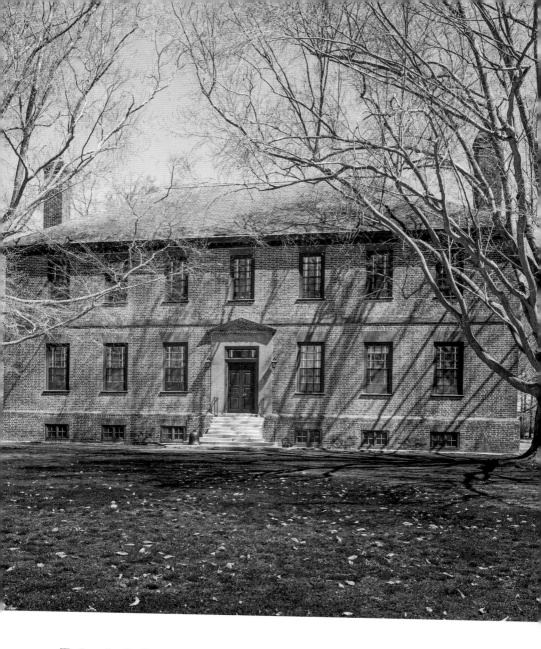

Today, the Lafferty Foundation owns Elsing Green and operates it as a working plantation, open to the public by appointment.

The view of Elsing Green that faces the Pamunkey River.

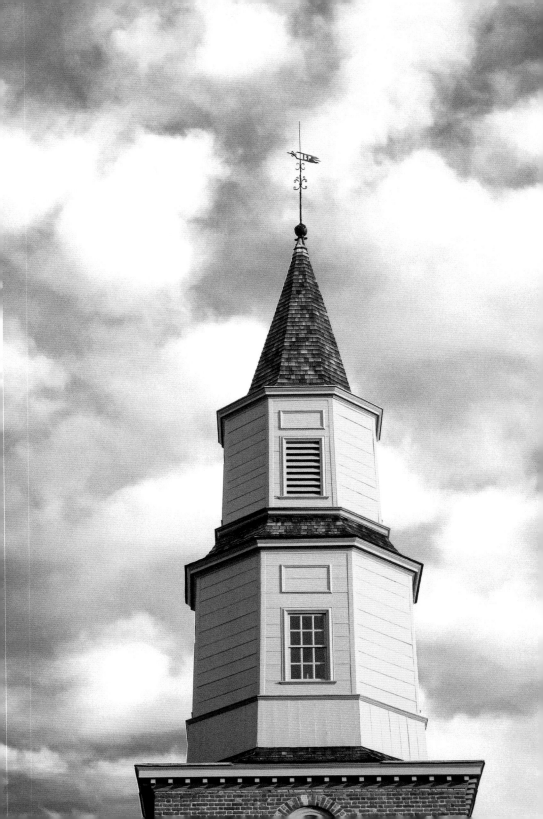

6

Churches

BRUTON PARISH CHURCH, WILLIAMSBURG

The present state of our laws on the subject of religion is this. The convention of May 1776, in their declaration of rights, declared it to be a truth, and a natural right, that the exercise of religion should be free.

—*Thomas Jefferson*

PORTIONS OF FOUR Virginia churches from the seventeenth century survive and stand on their original sites; many more remain from the eighteenth. Bruton Parish Church in Williamsburg is a good place to begin this story, as many of the leaders of the Revolution worshiped here, including Thomas Jefferson, James Madison, and George Mason.

The Church of England was the established church in colonial Virginia. Law required colonists to attend services and pay a tax to support the Church of England's ministers. In the spring of 1776, when independence was being debated, nine of the original thirteen colonies levied taxes to support established churches.

OPPOSITE The steeple above Bruton Parish. In 2012, the church confirmed that the weathervane, shown in this photograph perched atop the steeple, dates back to 1769, when the steeple was first constructed. Following this discovery, Colonial Williamsburg replaced the original with a copy. The original iron weathervane is now preserved indoors.

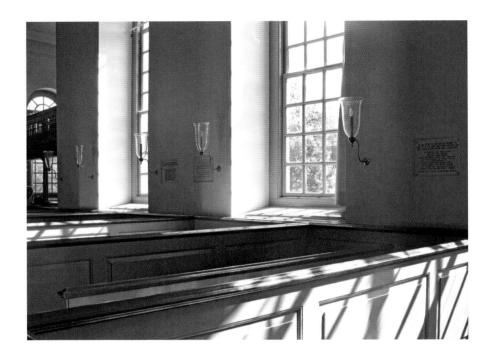

In May 1776, Virginia's revolutionary convention, meeting in Williamsburg, adopted the Virginia Declaration of Rights, drafted in large part by George Mason. Section 1 begins: "That all men are by nature equally free." A month later, Thomas Jefferson would capture the same thought with "all men are created equal." However, it's section 16 of the Virginia Declaration that interests us here: "all men are equally entitled to the free exercise of religion according to the dictates of conscience." But, section 16 stopped short of explicitly severing Virginia's connection with the Church of England. In 1777, Jefferson, sitting as a member of Virginia's House of Delegates, proposed doing just that. He drafted "A Bill for Establishing Religious Freedom," declaring that "no

Window light from Duke of Gloucester Street in the sanctuary of Bruton Parish Church. The original construction of the church was completed in 1715.

man shall be compelled to frequent or support any religious worship, place, or ministry whatsoever." Jefferson's bill failed to pass.

Eight years later, House of Delegates member James Madison reintroduced the bill, and this time, on January 19, 1786, it was signed into law with only minor changes to Jefferson's original language.

The nineteenth century visited hard times on Bruton Parish, as it did for all of the Virginia churches that had once been part of the Church of England. Richmond had long since replaced Williamsburg as the state capital. The building fell into disrepair. Many of its original features, including the high-backed pews, were removed.

In 1903, the Reverend Dr. W.A.R. Goodwin became the rector of this historic church. Dr. Goodwin led the congregation to restore the sanctuary to more closely resemble its original appearance. They completed the project in 1907, in time for the three hundredth anniversary of the nearby Jamestown settlement. Goodwin's role in twentieth-century Williamsburg was monumental (page 125).

Eastern Virginia is filled with historic churches. This chapter features nine of them, each with an interesting story.

ST. LUKE'S CHURCH, ISLE OF WIGHT COUNTY, AND ST. PETER'S CHURCH, NEW KENT COUNTY

TALL TREES and a peaceful graveyard surround St. Luke's Church near Smithfield in Isle of Wight County. An oral tradition in Isle of Wight places St. Luke's origin in 1632. But scholars, relying in part on the church's architectural features, theorize that it was built nearer the end of the seventeenth century. The current stained-glass windows date back to the 1890s. The original glass was probably clear. Only bits and pieces of St. Luke's seventeenth-century woodwork have survived—a single baluster in the altar rail and a lintel over a door leading from the tower to the church.

St. Peter's Church, nested in the woods of New Kent County, has its own long-standing mystery. The mystery is not about its age—its construction was completed by 1703—it's about Martha and George Washington. There are conflicting accounts regarding whether their wedding took place inside St. Peter's or at Martha's nearby home, White House Plantation. Martha's first husband, Daniel Parke Custis, was a vestryman at St. Peter's. Seven years into their marriage, Colonel Custis died, leaving Martha a young widow with two small children. Two years later, in 1759, she married Washington.

Today, St. Peter's is an active Episcopal church; St. Luke's is not. Christ Episcopal Church, a few miles away in Smithfield, holds worship services at St. Luke's every fifth Sunday of the month (when that occurs).

ABOVE St. Peter's Church in New Kent County.

OPPOSITE St. Luke's Church in Isle of Wight County near Smithfield.

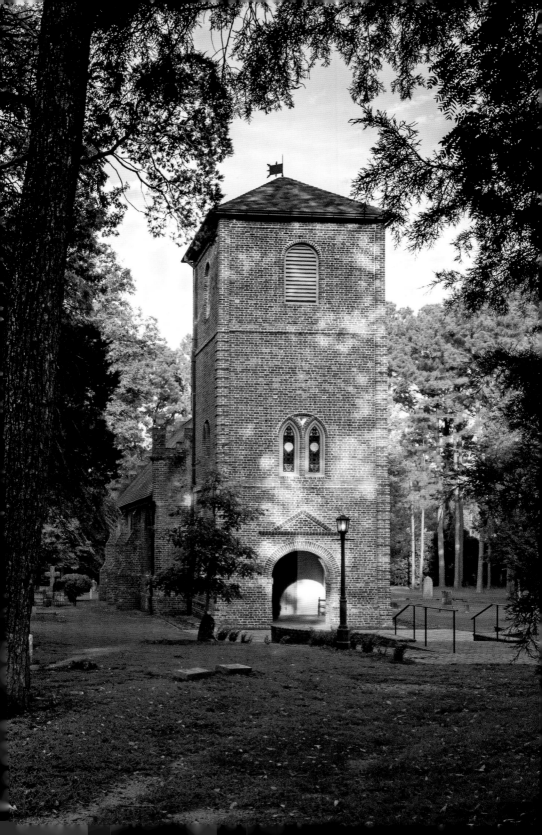

CHRIST CHURCH, LANCASTER COUNTY

WHAT SETS Christ Church in Lancaster County apart from its peers is its well-crafted, sophisticated features—features that have survived for almost three hundred years. In 1730, Robert "King" Carter, the wealthiest tobacco planter in the Virginia colony, funded the building of a new Christ Church to be made of brick, replacing the wooden church that his father had built a half-century earlier. Based on surviving correspondence, it is likely Carter contributed to the structure's design and provided enslaved and indentured craftsmen from Corotoman, his plantation four miles away on the Rappahannock River.

Christ Church is one of the two surviving colonial-era churches in Virginia with its original three-tier pulpit, and it is the only such church with its original high-back box pews. The building was constructed in the shape of a Latin cross. From the pulpit's top tier, the rector would deliver his sermon. The sounding board, just above, has a sunburst pattern of inlaid wood. The church's rural location on Virginia's Northern Neck proved to be a safe distance from the military encounters of the Revolution, the War of 1812 and the Civil War. In part, that explains why so many of its sophisticated features remain intact.

Robert Carter did not live to see his church completed. He died in 1732. Carter's son, John, in a letter written in 1734 to his father's agent in London, said he hoped to finish the church "sometime after Christmas." "There is none in this country to be compared to it," he wrote, "but the expense occasioned thereby has been very considerable."

Christ Church's three-tiered pulpit, high-backed pews, and compass-head windows. An exterior view of Christ Church appears on page 17.

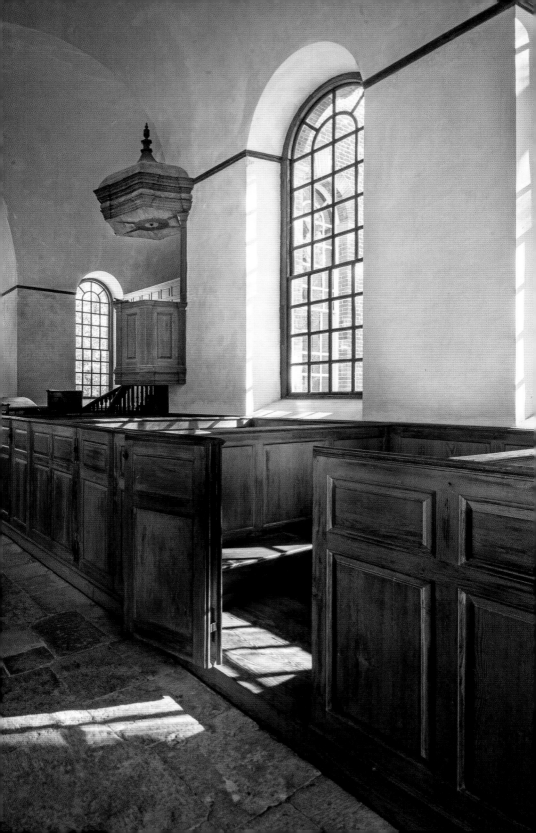

CHRIST CHURCH

Robert "King" Carter's Tomb

ROBERT "KING" CARTER died in 1732. More about Carter and his role in creating Lancaster County's Christ Church appears on page 76. Carter and his two wives were buried a few feet outside of the church's east exterior wall. The tomb of Carter's first wife, Judith Armistead Carter, was made of limestone; Carter's tomb and the tomb of his second wife, Betty Landon Carter, were both made of marble. On top of each of these elaborate monuments is an inscribed epitaph. Carter's inscription is in Latin.

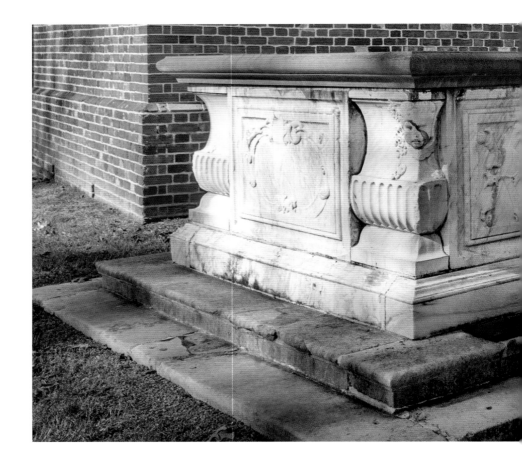

Damage to the tombs, caused by weather and possibly by vandals, occurred throughout the nineteenth century into the early twentieth century. An early account of this damage comes from Episcopal bishop William Meade. Following a visit to Christ Church in 1837, the bishop wrote that the tombs of the two Carter wives were "falling to pieces." The church initially restored the tombs in 1927—a restoration that preserved fragments of the originals. More conservation occurred in the 1960s and in 1980. Years later, the church moved the fragile tops indoors. There, the remaining original fragments are displayed, joined with replacements to

Three Carter tombs are alongside Christ Church's east wall. Robert Carter's tomb is on the far left. Beside it is the tomb of his second wife, Elizabeth "Betty"; next is the tomb of his first wife, Judith.

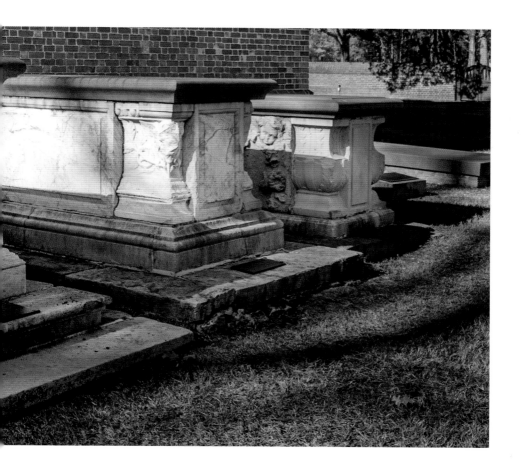

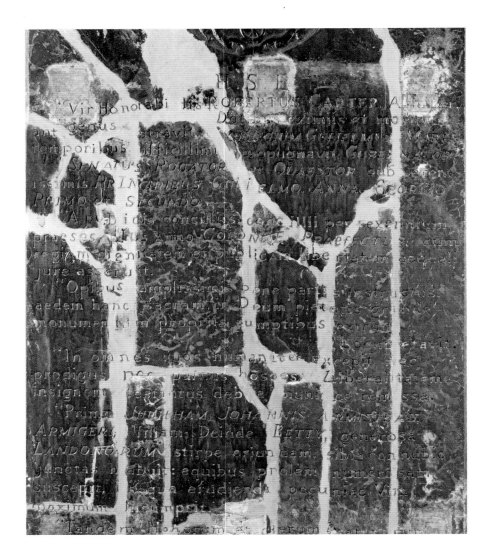

fill in the portions that have been lost. The tops that now rest on the three tombs are copies that were fabricated as part of the 1980 restoration.

The top of Robert "King" Carter's elaborate tomb with its Latin inscription is preserved in the Bayne Center on the campus of Christ Church, just a short walk from the tomb itself.

HERE LIES BURIED

Robert Carter, Esq., an honourable man, who by noble endowments and pure morals gave lustre to his gentle birth.

Rector of William and Mary, he sustained that institution in its most trying times. He was Speaker of the House of Burgesses, and Treasurer under the most serene Princes William, Anne, George I, and II.

Elected by the House its Speaker six years, and Governor of the Colony for more than a year, he upheld equally the regal dignity and the public freedom.

Possessed of ample wealth, blamelessly acquired, he built and endowed, at his own expense, this sacred edifice, a signal monument of his piety toward God. He furnished it richly.

Entertaining his friends kindly, he was neither a prodigal nor a parsimonious host.

His first wife was Judith, daughter of John Armistead, Esq.; his second, Betty, a descendant of the noble family of Landons. By these wives, he had many children, on whose education he expended large sums of money.

At length, full of honours and of years, when he had well performed all the duties of an exemplary life, he departed from this world on the 4th day of August, in the 69th year of his age.

The unhappy lament their lost comforter, the widows their lost protector and the orphans their lost father.

This translation of the Latin text of Carter's epitaph appears in Bishop William Meade's *Old Churches, Ministers, and Families of Virginia*, published in 1857.

CHRIST CHURCH, ALEXANDRIA

GEORGE WASHINGTON was one of the first parishioners to buy his own pew at Christ Church in Alexandria. The sanctuary was completed in February 1773. Eight years later, to raise additional money, he began paying the church an annual rent for the same pew.

James Wren, a local vestryman, drafted a set of plans that was used to construct Christ Church, as well as neighboring Falls Church, nine miles to the northwest. Given the design similarities that these two churches share with Pohick Church near Mount Vernon, Wren's plans were likely used to build Pohick Church as well. The prolific Wren also designed the Fairfax County Courthouse.

Hand-lettered tablets on each side of the pulpit contain the Apostle's Creed, Ten Commandments and the Lord's Prayer. James Wren painted them himself. The tablets have never been retouched. Over time, the original white background has turned to a soft brown. Beginning in 1816, the church converted its original box pews to enclosed slip pews. Washington's box has been reconstructed in its original location. No record survives of the design of the original pulpit. The current wineglass pulpit dates from the 1890s. It was put in place because the design was considered consistent with late eighteenth century styles when the church was first built.

Robert E. Lee began attending Christ Church sometime after his family left Stratford Hall in 1811 (page 122) and took up residence in Alexandria. During the Civil War, the Union army occupied Alexandria, seizing Christ Church for use as a military chapel, with services conducted by army chaplains. In 1866, the army returned the church to its parishioners.

OPPOSITE The Christ Church wineglass pulpit, as viewed from George Washington's box pew.

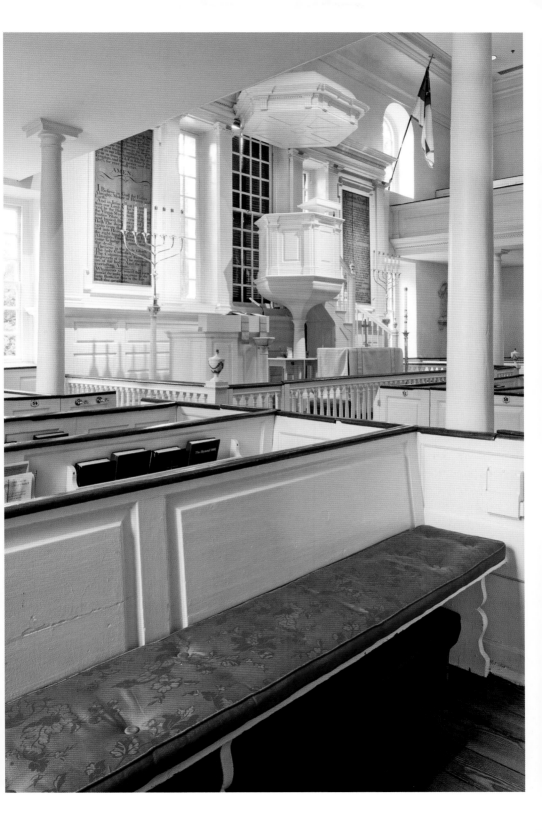

St. Paul's Church "Borough Church," Norfolk

ON JANUARY 1, 1776, in the early days of the Revolutionary War, Virginia's colonial governor, Lord Dunmore, ordered the shelling of Norfolk by the Royal Navy ships in the Elizabeth River under his command. Most of the city was destroyed by fire during the attack and in the days that followed, but the exterior brick walls of Norfolk's Borough Church—thirty-inch-thick walls that had been built in 1739—remained. It took a decade to rebuild what had been lost inside. The church is Norfolk's only building still standing from the colonial era.

A royal charter by George II created the borough of Norfolk in 1736. The church's traditional name, Borough Church, is linked to that designation, though its more proper name was Elizabeth River Parish Church. Borough Church was Norfolk's only church until 1773. Now shaded by tall trees, the churchyard was Norfolk's only public cemetery until the 1820s.

During the occupation of Norfolk in the Civil War, the Union army used St. Paul's as a place of worship. After the war, the federal government reimbursed the church $3,600 for the losses incurred as a result of this use.

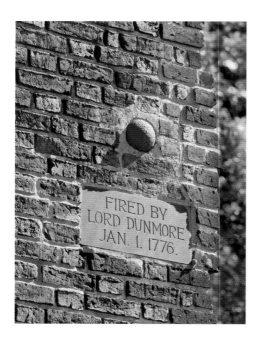

By far, the church's most famous feature is a cannonball that is believed to have been fired at the building on New Year's Day 1776 by the Royal Navy. The cannonball, according to a newspaper story from 1848, was discovered by one of the church's vestrymen. He found it in the ground inches away from the church's southeast corner. The church later cemented the cannonball in an unrepaired indentation in the church's bricks above where the cannonball had been found. The cannonball's story is rarely told without adding that, in the twentieth century—long

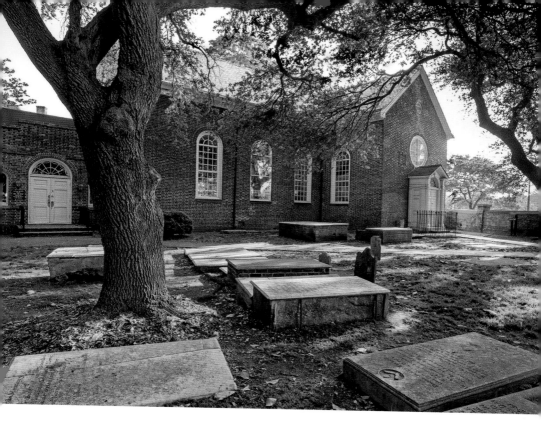

after the United States and Great Britain had become strong allies—England's Lord Louis Mountbatten visited Norfolk and toured St. Paul's churchyard. About the cannonball, Lord Mountbatten is said to have remarked, "Damn near missed it, didn't he?"

OPPOSITE In 1901, the Great Bridge Chapter of the Daughters of the American Revolution provided the inscription that appears just below the St. Paul's Church cannonball.

ABOVE A view of the south wall of St. Paul's and a portion of the church graveyard. Twenty-four veterans of the Revolution and twenty-two from the War of 1812 are buried here.

MATHEWS BAPTIST CHURCH, MATHEWS COUNTY

THE BEAUTIFUL STEEPLE on the Mathews Baptist Church building dates back to 1905. But the church itself is much older than its current structure. It was organized around 1776, when Virginia's leaders enacted laws that benefited Baptists and other "dissenters" to the colony's established church, the Church of England.

In December 1776, Thomas Jefferson and James Madison were members in the very first session of the Virginia House of Delegates. They led the effort to pass a bill that expanded on "free exercise of religion" language in the Virginia Declaration of Rights (page 72). The new law, with a very long title—"An act for exempting the different societies of Dissenters from contributing to the support and maintenance of the church as by law established, and its ministers, and for other purposes therein mentioned"—exempted dissenters from the tax that funded Virginia's Anglican churches. Jefferson and Madison's goal was to gain support from religious dissenters for the Revolution.

A bird has flown inside the belfry of Mathews Baptist Church and is perched on top of the bell.

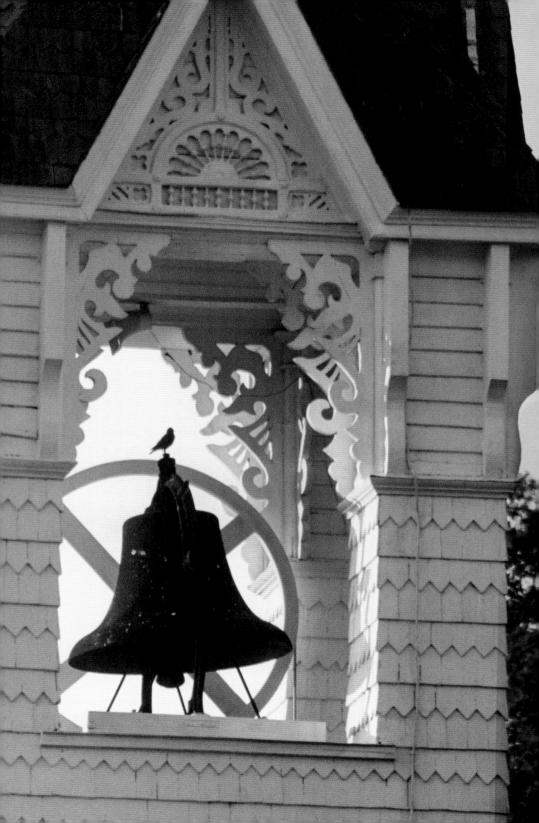

OLD PRESBYTERIAN MEETING HOUSE, ALEXANDRIA

THE CHURCH OF ENGLAND dominated religious life in colonial Virginia—so much so that it was Philadelphia, not Virginia, where Lucy Grymes Nelson, Thomas Nelson Jr.'s wife, attended her first Presbyterian worship service. She traveled there from Yorktown in August 1775, accompanying her husband when he joined the Virginia delegation to the Continental Congress. The Church of England was all she had ever known.

On their way north, the Nelsons crossed the Potomac River at the seaport town of Alexandria. There, Scottish immigrants were busy building their own Presbyterian meeting house. They had brought their Presbyterian faith with them to the New World. As dissenters to

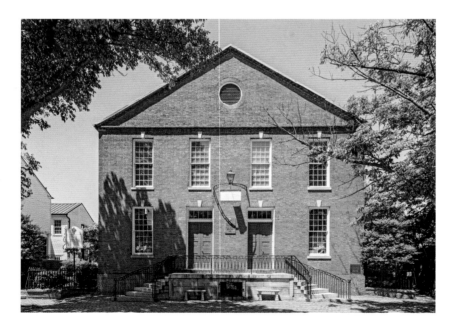

ABOVE The Old Presbyterian Meeting House, completed in 1837, is two stories tall and largely resembles the original 1775 structure that was on this site.

OPPOSITE The organ behind the pulpit dates back to 1849 and is still playable. A second organ, installed in 1997 at the opposite end of the sanctuary, is used for most services.

Virginia's established church, they used the name "meeting house" rather than "church" for their place of worship.

The 1775 Alexandria Presbyterian Meeting House was largely destroyed by fire in 1835. Based on surviving accounts, many features of the original meeting house were incorporated into the structure that replaced it and stands on the site today. It was completed in 1837.

Like Alexandria's Christ Church (page 82), the 1775 meeting house had a strong connection to George Washington. It was the site of the memorial services that followed Washington's death in 1799. John Muir, the minister at the meeting house, participated in Washington's funeral service at Mount Vernon.

There is no surviving record of the style of the pews in the 1775 church. Assuming they were consistent with prevailing styles of the eighteenth century, they were either enclosed slip or enclosed box pews. The 1837 building has enclosed slip pews. The meeting house held services during the Civil War, but membership declined in the late nineteenth century. It ceased operating as an independent church between the late 1890s and 1949. Today, this historic site is home to a vibrant congregation.

SWAIN MEMORIAL CHURCH, TANGIER ISLAND

THE NARROW PENINSULA that separates Chesapeake Bay and the Atlantic has long been called Eastern Shore. There, in both Maryland and Virginia, every town has a Methodist church, usually the town's largest. It is the shore's dominant religious faith and has been for generations. The spread of the Methodist faith here coincided with America's Second Great Awakening in the early nineteenth century and Francis Asbury's visits to the region.

Born in England, Asbury responded to a call from the faith's founder, John Wesley, to be a missionary to the American colonies. His first visit to Eastern Shore was in 1783. Over the years, he returned fourteen times, preaching in camp meetings and churches.

A fisherman named Joshua Thomas brought Methodism to Tangier Island in the early 1800s. After attending two Eastern Shore camp meetings—one in Pungoteague, Virginia, in 1805, the other in Annemessex, Maryland, a year later—Thomas; his wife, Rachel; and fellow Tangier Islander Thomas

Tangier Island's first church building went up in 1835. Ten years later, circuit-riding preachers from the mainland started supplying the church's pulpit. The present building dates back to 1899.

Crockett held their own prayer meeting in Crockett's home. The meeting started a Methodist revival on the island. In 1808, Tangier held its own camp meeting. It became an annual tradition.

Joshua Thomas became a celebrated figure, remembered both for his role in the camp meetings and for his encounter with Royal Admiral George Cockburn in the War of 1812. During the British encampment on Tangier, the admiral referred to Thomas as "Parson of the Islands," ordering him to preach to the British fighting force before they disembarked to fire on Baltimore. The sermon contained a bold prophecy, one that the admiral undoubtedly did not expect. Thomas recalled years later, "I told them it was given me from the Almighty, that they could not take Baltimore, and would not succeed in their expedition." Indeed, the British did lose the battle. Their "bombs bursting in air" over Baltimore's Fort McHenry inspired Francis Scott Key to write a poem he called "Defence [sic] of Fort M'Henry." We know it today as the lyrics to "The Star-Spangled Banner."

Truth be told, Thomas's own recollection of his sermon is all the documentation there is. Should we take it at face value? They do on Tangier Island.

Remembering the War

Fort Monroe, Hampton

TACTILE, POIGNANT reminders of the Civil War—now more than a century and a half old—are scattered throughout Tidewater. In this chapter, we will visit just a few.

The massive live oak tree that dominates the photograph on pages 94 and 95 is on the edge of the parade grounds inside Fort Monroe's moat and stone walls. Yes, a moat. It's the largest moat-encircled stone fortification in North America. Fort Monroe is on the north shore of Hampton Roads, where it flows into the Chesapeake Bay. It was one of the many coastal fortifications that Congress funded following the War of 1812. Fort Sumter was another. See page 158 for more about Fort Monroe and the lighthouse that shares this same point of land.

The tree is called the Algernourne Oak, named after an earlier fort built on this site in the seventeenth century. Virginia Tech conducted tests in 1977 that put the Algernourne Oak's earliest days in 1540. So, the Algernourne stood as a mature tree in August 1619, when twenty or more Africans landed on the shoreline where Fort Monroe would later be built. They were the first recorded Africans to arrive in England's mainland American colonies. Held aboard the English privateer *White Lion*, they had been captured by the

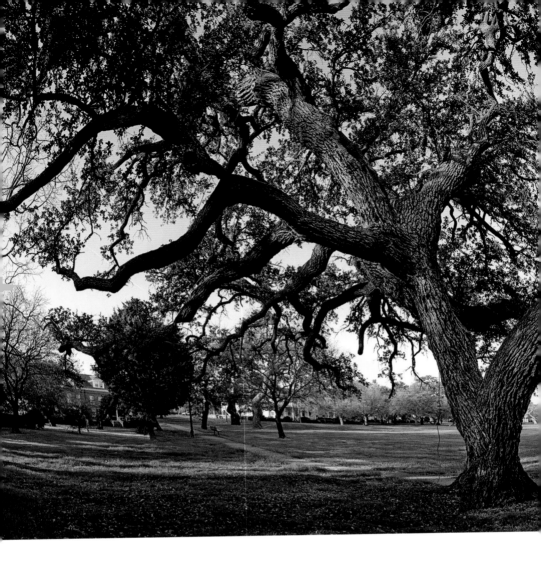

English from the Spanish slave ship, *San Juan Bautista*, bound for Vera Cruz, on the coast of Mexico.

During the Civil War, Fort Monroe never left Union hands. In May 1862, President Lincoln traveled by steamer to Fort Monroe, where he spent five days reviewing plans for the Peninsula campaign to push northwest to Richmond. While at the fort, Union forces succeeded in gaining control of Norfolk. At the war's end, Confederate president Jefferson Davis was imprisoned for two years at Fort Monroe. Eventually, he was charged with treason, but there were many delays, and the case never reached the trial stage. On Christmas Day 1868, President Andrew Johnson ended the matter

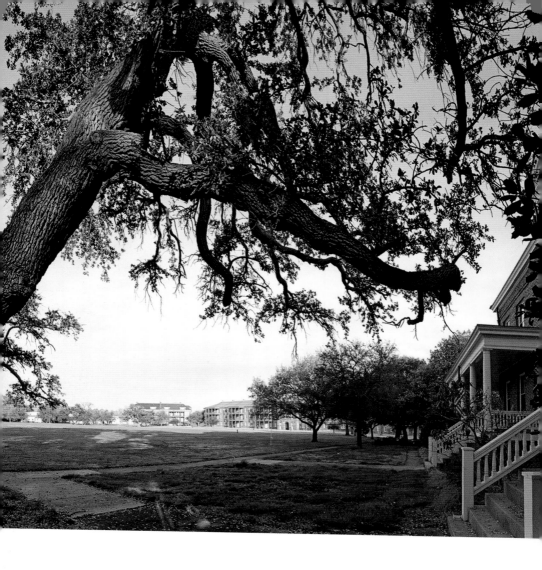

by granting a pardon and amnesty to all who had fought against the United States in the Civil War.

The Algernourne Oak's long life continues to this day.

The Algernourne Oak stands on the edge of Fort Monroe's parade ground, which was first leveled and marked off in October 1824, two weeks before Marquis de Lafayette's visit to the new fort.

FRANKLIN AND ARMFIELD OFFICE, OLD TOWN ALEXANDRIA

THE 1300 BLOCK of Duke Street in Old Town Alexandria is lined with row houses from the nineteenth century, each with a painted brick front. Old Town Alexandria comprises a little over a square mile, with block after block of beautifully preserved eighteenth- and nineteenth-century architecture.

The building at 1315 Duke Street has a history very much out of step with the charm and upscale trappings of its current iteration. From 1828 to 1936, the building was the headquarters for Franklin and Armfield, the dominant slave-trading firm of the 1830s. It also served as John Armfield's residence. His partner Isaac Franklin ran the firm's markets in Natchez and New Orleans. Franklin and Armfield annually purchased one thousand or more enslaved people from sources in the upper South, who were then resold in Natchez and New Orleans. There, they brought higher prices owing to the greater demand for enslaved people to work on the cotton plantations in Mississippi and other deep South states. Most of the enslaved people made their trips aboard ships owned by Franklin and Armfield that sailed from Alexandria's Potomac River dock.

The current structure at 1315 Duke Street is all that remains of the trading site that once covered a half-block. Based on a nineteenth-century photograph, there have only been modest changes made to the building's street-front exterior. During the slave-trading period, high walls of whitewashed brick extended from each end of the house on the street front. Enslaved men were sheltered on the west side, women on the east. Alexandria fell into Union hands early in the Civil War. The occupying army quickly recognized that the Franklin and Armfield slave quarters were a ready-made prison and used it as such for the remainder of the war.

In 1996, the Northern Virginia Urban League bought the building to use as its headquarters. "A spin of poetic justice" is how the Urban League characterizes the property's new role. The league renamed the building Freedom House, and it operated a museum in the basement. In 2020, the City of Alexandria purchased the property from the Urban League with plans to preserve the site and its history.

OPPOSITE 1315 Duke Street was once the headquarters of the slave dealers Franklin and Armfield.

WILLIAM B. SELDEN HOUSE, NORFOLK

THIS IMPOSING HOME was originally the residence of Dr. William B. Selden. It was built in 1807 at the corner of Freemason Street and Botetourt Street. Years later, Dr. Selden's son, also named William and also a doctor, lived here. The younger Dr. Selden was a surgeon in the Confederate army.

From 1862 until the end of the Civil War, the Union army used the house as its headquarters for the federal occupation of Norfolk. That may explain how the house survived.

After the war, in April 1870, Robert E. Lee traveled to Norfolk to visit the younger Dr. Selden in this home. Lee's Norfolk visit was near the end of his two-month trip through the South. From Norfolk, accompanied by his daughter Agnes, Lee traveled by steamboat up the James River, stopping to visit cousins at Shirley Plantation (page 172). By steamboat and train, the pair traveled to see more family at White House plantation in New Kent County. From there, with his son Robert, Lee made brief stops in King William and Gloucester Counties. Finally, after four days in Richmond, Lee, with Agnes, returned to Lexington, where he was president of Washington College. Lee died later that year.

The Selden house's medical heritage continues. It's current owner, Dr. Albert L. Roper, can be seen sitting on its front steps in the accompanying photograph.

The William B. Selden house was used by the Union army as its headquarters in occupied Norfolk during the Civil War.

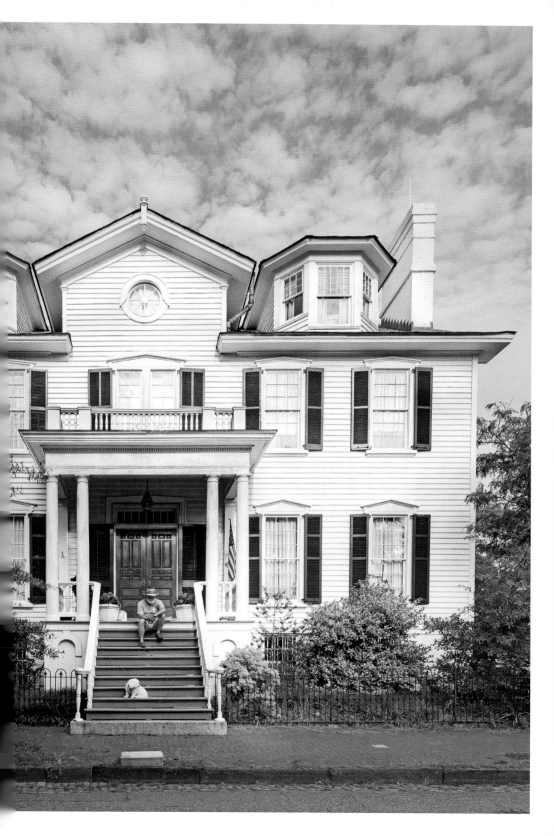

". . . GONE FOR SOLDIERS EVERY ONE," GLOUCESTER AND HOPEWELL

MUCH OF THE FIGHTING and much of the dying in the Civil War was done by men whose names have been lost to history. The graveyard surrounding Ware Episcopal Church in Gloucester County has two small tombstones, each marked "Confederate Soldier Un Known, Died at Burgh Westra, 1862." Burgh Westra was the home of Dr. Philip A. Taliaferro, who turned his house into a hospital for wounded soldiers. Dr. Taliaferro and his half-brother, Confederate general William B. Taliaferro, survived the war. Both were buried at Ware Church.

Forty miles to the west is City Point National Cemetery in Hopewell. There, row after row of headstones mark the burial sites for approximately 5,000 Union soldiers and 120 Confederate soldiers. In Virginia alone, there are eighteen national cemeteries that were created by the federal government in the years after the war.

In July 1866, when City Point National Cemetery opened, its first burials were reinterments from makeshift graveyards at seven Hopewell-area hospitals that treated wounded Union soldiers. Approximately 1,400 of City Point's graves are identified as "unknown," which, the National Park Service says, represents a low percentage for Civil War–era national cemeteries. It credits good record keeping at those Union hospitals for this variation from the norm. City Point is the only Civil War–era national cemetery in the Richmond area in which the number of known interments exceeds the number of those that are unknown.

One hundred and fifty years of wind and weather have softened the lettering on many of the headstones at City Point. A magnolia tree in the cemetery has grown so large that it presses against the headstones of Private Isaac Dennis, 130th Regiment, Ohio Infantry, on one side and Captain N.S. Ferris, 38th Regiment, Wisconsin Infantry, on the other. Both men died in 1864.

OPPOSITE, TOP A tombstone for an unidentified Confederate soldier in the churchyard of Ware Episcopal Church in Gloucester County.

OPPOSITE, BOTTOM A magnolia tree growing in City Point National Cemetery in Hopewell rubs against the headstones of Private Isaac Dennis (*left*) and Captain N.S. Ferris (*right*).

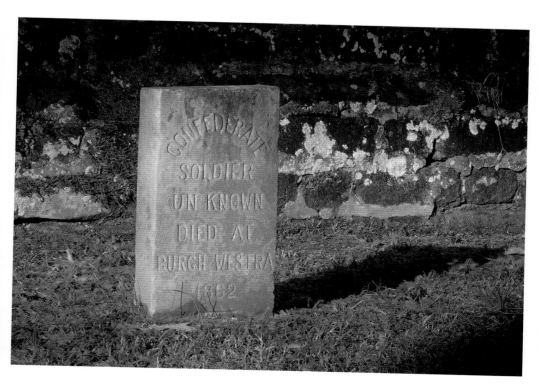

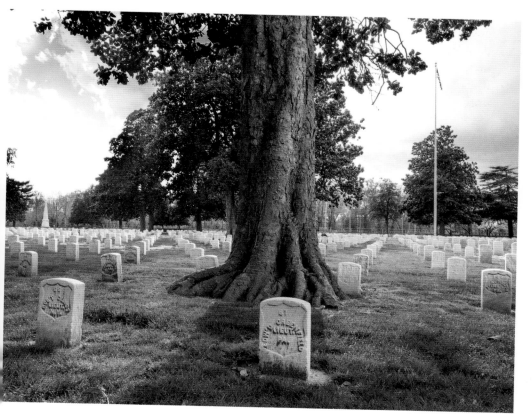

THE END OF THE WAR, PORT ROYAL

ON APRIL 14, 1865, a mere five days after Robert E. Lee's surrender at Appomattox Court House, John Wilkes Booth fatally shot President Abraham Lincoln. Booth fled through Maryland and into Virginia. He was on crutches, hobbled by a broken left leg. Midday on April 24, Booth and his fellow conspirator David Edgar Herold reached the ferry landing at Port Conway on the north shore of the Rappahannock River, twenty-one miles southeast of Fredericksburg. While waiting for the ferry, the pair met three former Confederate soldiers on horseback who were also headed south. One of the soldiers, Private Willie Jett, later told authorities that Herold revealed, "We are the assassinators of the president."

Together, the five boarded the ferry and crossed the river to Port Royal on the other side. Once on shore, ahead of the others, Jett rode his horse to the Brockenbrough-Peyton house. Jett knew the family. There, he found Sarah Jane Peyton. Without revealing Booth's identity, Jett asked if Miss Peyton could provide a place to stay for a man Jett claimed was a wounded Confederate soldier. Initially, she agreed. Booth briefly entered the house, but then, the unmarried Miss Peyton reconsidered, explaining to Jett that the man of the house, her brother Randolph Peyton, was not at home. Booth and the others continued south. Two days later, a detachment of the 16th New York Cavalry Regiment located and killed Booth, three miles south of Port Royal at the farm of Richard Garrett. They captured Herold at the same place. Less than three months later, on July 7, 1865, Herold was hanged with three other convicted Booth accomplices.

The Brockenbrough-Peyton house in Port Royal still stands, boarded up and more than a little worse for wear.

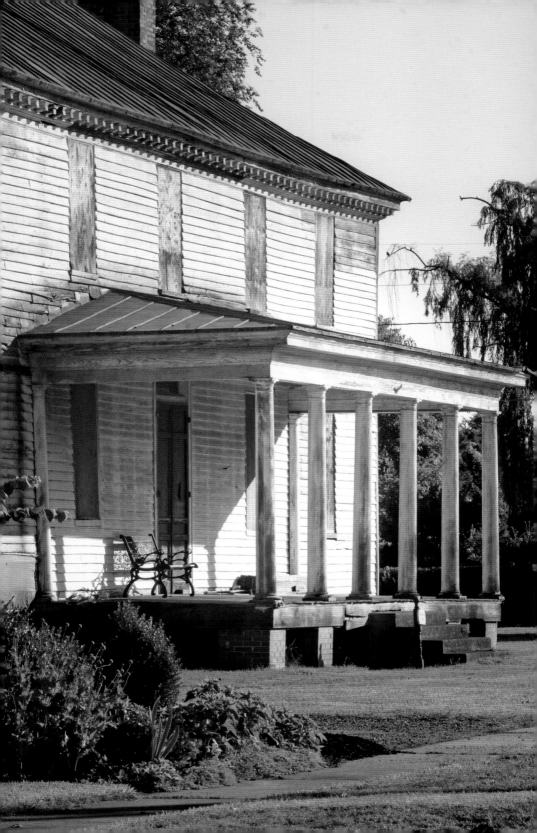

8
After the War

St. John's AME Church, Norfolk

THE PHOTOGRAPHS in this chapter are of places where former enslaved people, their children and grandchildren confronted the challenges of the post–Civil War world. These buildings—all still standing—were constructed in the segregated South of the late nineteenth and early twentieth centuries. They are places that were rarely entered by white Virginians of that period, places where Black men and women worshiped, achieved educations, and enjoyed popular culture.

In 1888, just twenty-three years after Appomattox, St. John's African Methodist Episcopal Church (frequently shortened to St. John's AME Church) in Norfolk completed the sanctuary that can be seen in the photograph to the right—an imposing space, rich in architectural detail and large enough to hold 1,500 worshipers.

The early history of St. John's begins in antebellum Norfolk. In 1840, Cumberland Street Methodist Episcopal Church, then a white

OPPOSITE The sanctuary of St. John's AME Church, completed in 1888.

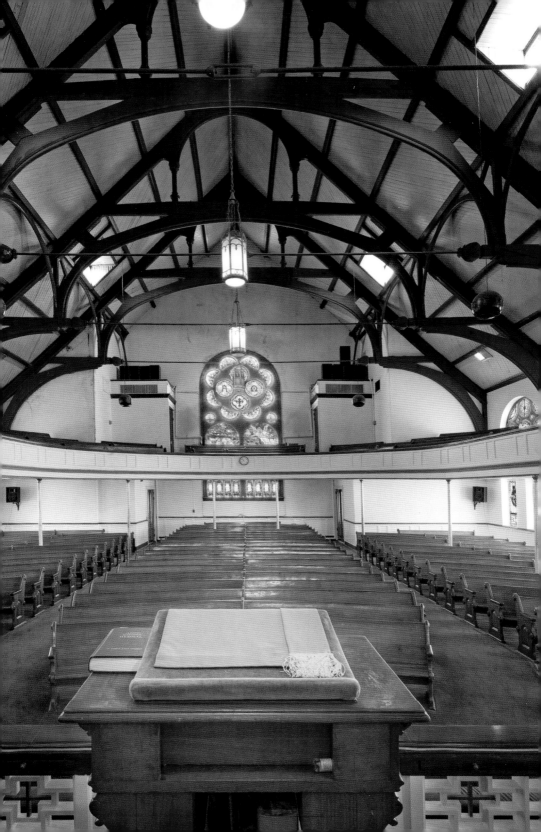

church in the heart of Norfolk, organized a mission for enslaved people, acquiring land for the mission in 1848. This is the site where St. John's AME Church now stands.

In 1863, with Norfolk occupied by the Union army, the mission broke away from Cumberland Street and became its own independent church. A year later, it aligned with the African Methodist Episcopal denomination that was founded in Philadelphia in the early nineteenth century.

In general form, the church is consistent with the Romanesque style popularized by architect H.H. Richardson of New York and Boston that prevailed in American church architecture in that period. Roof trusses dominate the sanctuary's interior, running from one end to the other. Metal rods and turnbuckles hold the wooden trusses in place. Rectangular dormers provide light and ventilation. The cluster of sixteen stained-glass windows at the rear of the church is original to the building, as are the church pews and the horseshoe-shaped balcony.

Hampton University, Hampton

GENERAL SAMUEL CHAPMAN ARMSTRONG was the driving force that shaped the early days of what is now Hampton University. Armstrong's biographer, his daughter Edith Armstrong Talbot, wrote that her father believed the "surroundings of a man" to be a critical influence in instilling good character. For Hampton's earliest "surroundings," Armstrong made a bold choice. He engaged Richard Morris Hunt, a leading New York architect, to design the school's first two buildings, Academic Hall (1870) and Virginia Hall (1874). Virginia Hall is depicted in the image on page 108.

Hunt was the first American to study architecture at the Ecole des Beaux-Arts in Paris, a school that would influence generations of American architects. His long list of prominent buildings includes the Breakers at Newport, Rhode Island, for Cornelius Vanderbilt II; Biltmore Estate in North Carolina for George W. Vanderbilt; the pedestal of the Statue of Liberty; and the Great Hall of New York's Metropolitan Museum of Art and the museum's façade facing Fifth Avenue.

Hampton stands on what had once been Little Scotland, the name of William E. Wood's farm on the eastern shore of Hampton Creek. During the Civil War, the Union army occupied the farm, making it part of the army's Camp Hamilton. At war's end, the farm's mansion and flour mill were still standing, as were the wooden buildings constructed by the army to serve as hospital barracks.

Early in the war, Union General Benjamin F. Butler at nearby Fort Monroe ordered that runaway enslaved people seeking sanctuary at the fort be treated as "contraband of war" and not returned to their Southern owners. As a result, much of the town of Hampton and its surroundings became occupied by "swarming camps of the contrabands"—General Armstrong's description of what he first saw when he arrived in 1866. He came to Hampton to head the regional office of the Freedmen's Bureau. He was twenty-seven years old. Six months earlier, while holding the rank of brevet brigadier general, Armstrong had received his discharge from the Union army.

In 1867, the American Missionary Association (AMA), at Armstrong's urging, bought Little Scotland to establish a school for freedmen. It would be called Hampton Normal and Agricultural Institute. For the job of principal of the new school the AMA's first choice declined, so they offered the post to Armstrong. It became his life's work.

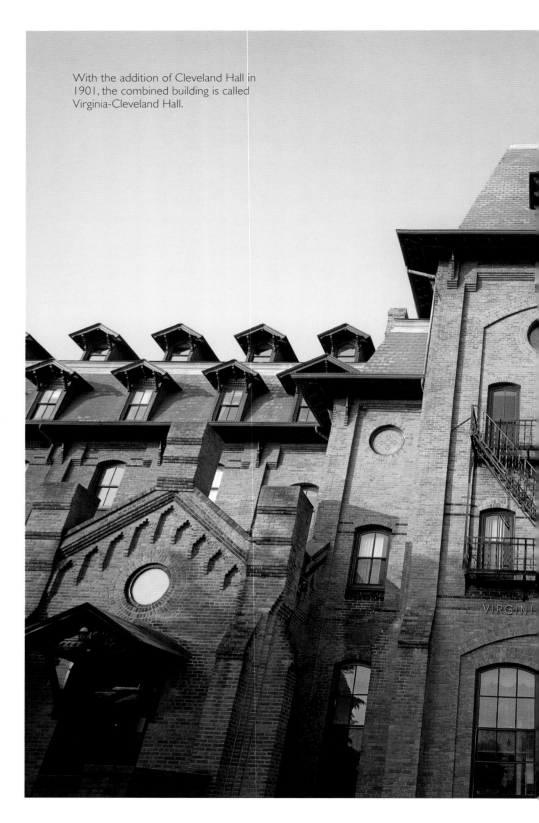

With the addition of Cleveland Hall in 1901, the combined building is called Virginia-Cleveland Hall.

Armstrong knew from the start what he wanted the school to be. "The thing to be done was clear: to train selected Negro youth, who should go out and teach and lead their people first by example." The curriculum was a mixture of academic subjects and practical skills "to replace stupid drudgery with skilled hands." All students were required to work in the school's shops or on its farm. Early histories of the school describe Virginia Hall as being "sung up" by the Hampton Singers, a student chorus. In February 1873, the Hampton Singers sang for President Grant at the White House. For two years, the group traveled to northern cites to publicize the school and entertain donors.

Virginia Hall is still a women's residence hall, one of its original functions during General Armstrong's time. In April 1930, the school removed "Normal and Agricultural" from its name and changed it again in 1984 to become Hampton University.

JULIUS ROSENWALD HIGH SCHOOL, REEDVILLE

IN THE EARLY twentieth century, Julius Rosenwald financed more than 5,000 schools for Black children across the South—382 in Virginia. For every school he funded, Rosenwald also provided architectural plans. The Northumberland County Training School near Reedville was an early Rosenwald project, a rare two-story frame example. The school opened in 1917.

Rosenwald was a part-owner and president of Sears, Roebuck and Company. Inspired by his friendship with Booker T. Washington, Rosenwald donated to Washington's Tuskegee Institute in Macon County, Alabama, and its rural school building program. Later, he created the Julius Rosenwald Fund to build more schools. He required the grants to be conditioned on promises by local Black residents to pay a portion of the construction

The Rosenwald School in Reedville has been boarded up for many years. Since this picture was taken, restored windows have been installed on the school's front side.

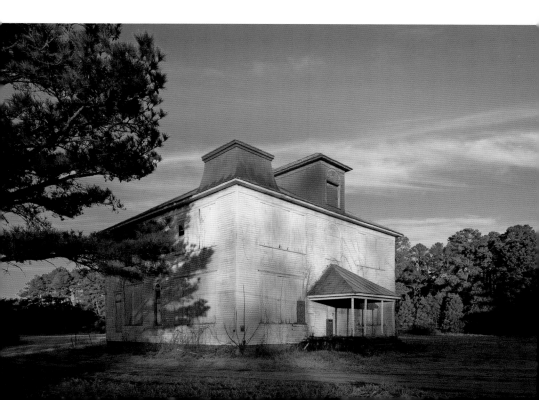

costs and by local public school authorities to do the same. Thereafter, the school authority would be required to operate the new school as part of the public school system.

At Northumberland, the school added vocational classrooms in 1928–29. It was the only secondary school for Black residents in the county. Shortly after Rosenwald's death in 1932, Northumberland County renamed the school Julius Rosenwald High School in his honor. The school closed in 1958.

In the twenty-first century, the outlook for the school has become much brighter. In 2010, the Julius Rosenwald School Foundation of Northumberland County began fundraising and planning for the restoration of the schoolhouse.

Attucks Theatre, Norfolk

THE CIVIL RIGHTS ACT of 1964 and related desegregation measures had an unintended consequence—the slow but steady decline of Black retail districts like Norfolk's Church Street. African Americans had gained a new freedom—they could spend their money in places that, for generations, had been closed to them. At the same time, this new freedom also meant that Black merchants had new competition. In the mid-twentieth century, the Attucks Theatre shared Church Street with four other movie houses, each catering to Black audiences. But today, the Attucks Theatre is the only one left standing.

The twenty-first-century operators of the Attucks Theatre claim it is the country's oldest surviving playhouse that was originally owned, designed, constructed, and financed by African Americans. The year "1919," when the building was constructed, is etched just above the theater's marquee. Twenty-six-year-old Harvey N. Johnson designed the Attucks Theatre and supervised its construction. He was a Black architect, a rarity in that profession at the time. His client was Twin Cities Amusement Corporation, which was organized by local Black businessmen to operate theaters in Norfolk and Portsmouth. Two Black financial institutions, the Brown Savings Bank and Tidewater Trust Company, put up the money.

Twin Cities named the theater after Crispus Attucks, an obscure figure from the country's colonial past—that is until nineteenth-century abolitionists began celebrating Attucks as the Black man who was the very first casualty of the American Revolution. Attucks was one of five men killed by British soldiers in a quick volley of musket fire outside of Boston's Old State House in 1770. The incident became known as the Boston Massacre. Contemporary accounts described Attucks as a "mulatto." He may have been a runaway slave. After the shooting, one British officer and eight soldiers were charged with murder. Their lawyer, none other than John Adams, argued his clients had acted in self-defense against an unruly mob. The officer and six of the soldiers were acquitted. Two were found guilty of the lesser charge of manslaughter. Presumably, the Attucks name would have been familiar to the audience Twin Cities wished to attract. By then, he had been celebrated for years as an African American hero who had stood his ground against an unpopular occupying army.

Beginning on New Year's Day 1934, new owners of the Attucks Theatre renamed it the Booker T. Theatre, which lasted until 1955, when Stark

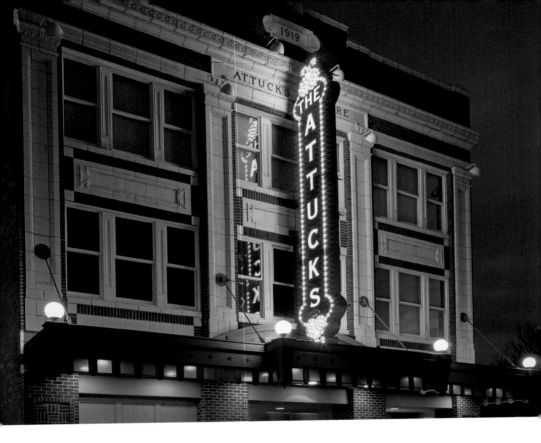

& Legum bought the property for its retail clothing business. Along with being a movie house, the Attucks and Booker T. were venues in segregated Norfolk for an impressive list of Black performers: in the 1930s, Bessie Smith; in the 1940s and 1950s, Louis Armstrong, Count Bassie, Cab Calloway, Nat King Cole, Duke Ellington, Dizzy Gillespie, Dinah Washington, Sam Cooke, and Clyde McPhatter.

The push to restore the Attucks Theatre began in the late 1980s. On opening night, October 16, 2004, the New Orleans Preservation Hall Jazz Band took the stage. The theater is now operated by Norfolk's Department of Cultural Facilities, Arts and Entertainment.

Brick and masonry detail on the front of the Attucks Theatre is original. The marquee is a reproduction that matches one appearing in photographs of the building from the 1920s.

The Virginian-Pilot

Established November 21. 1865

Norfolk and Portsmouth, Virginia

Thursday, January 1, 19

Page 4

The Year Virginia Closed the Schools

So far as the future histories of this state can be anticipated now, the year 1958 will be best known as the year Virginia closed the public schools.

This was the year when the automatic operation of Virginia law, moving precisely as the state's governmental leadership and its General Assembly had provided, reached out to shut and lock the doors of a Warren County high school in Front Royal, of two schools in Charlottesville, and of three junior high schools and three high schools in Norfolk.

By that same act the state denied nearly 13,000 boys and girls, some 10,000 of them in Norfolk, the kind of education which the people of Virginia had in mind when they wrote into their Constitution with wide approval and great confidence these words: "The General Assembly shall establish and *maintain* an efficient system of public free schools *throughout the state.*" (The italics

just ended unique in Virginia history and, save for another school-closing in Arkansas, unique in American history. That is the shame of 1958.

It is not enough to say, as the state has said in effect, that closing nine schools and kicking nearly 13,000 young people out of public education to shift for themselves is justified by the difficulties of obeying the law.

Of course the difficulties are there. Of course the changing of the customs of decades is painful. Of course perplexities exist and prejudices intrude. Of course law is a hard problem in enforcement and requires the most serious consideration when it runs counter to the deep wishes of majorities of people in a broad region of the country—and of Virginia.

No one with knowledge of Southern life thinks there is anything easy about dealing with the situations that confront us all.

But the mark of Virginia's po-

knowledge—that the statutes closing schools will be decla unconstitutional.

The punishment of innocent c dren is too severe. The deser of a doctrine of education on wl democracy itself rests runs much against basic American victions and beliefs, many of w originated or first found not of expression in Virginia. The age in prestige is too grave. loss in business, in commerc industry—in a state which jus gins to realize that it has l in new efforts in these respe is too costly even in prospec in early results. It would be trous in the long run.

The year that has run o carried Virginia, and esp Norfolk, where the penalty e has been the heaviest, far c defeatist road. We cannot co this way. The state is bou every obligation of goverr principle and human digni decency, and its own self-i to find a better policy than

THE BIG DECISION to integrate Norfolk's public schools began with a small number: seventeen.

In the summer of 1958, the Norfolk School Board initially decided that there would be no integration at all in the upcoming school year. But on August 29, responding to a federal court order, the school board assigned seventeen Black students to attend six white-only schools (three high schools and three junior high schools).

The first in the series of *Virginian-Pilot* editorials that won the Pulitzer Prize. The newspaper preserved this copy in its library.

A month later, Virginia governor J. Lindsay Almond Jr. seized control of those schools and locked their doors. As a result, ten thousand white Norfolk students suddenly had no public schools. The governor asserted that he was enforcing a state law that required the closing of any Virginia public school forced to integrate. The law was one of the "massive resistance" laws passed by the state legislature in 1956, responding to the U.S. Supreme Court's *Brown v. Board of Education* decision two years earlier. Governor Almond also closed schools in Front Royal and Charlottesville for the same reason. U.S. senator Harry F. Byrd Sr. was Virginia's most prominent critic of *Brown v. Board of Education*, and in fact, it was he who coined the phrase "massive resistance."

On January 1, 1959, the Norfolk *Virginian-Pilot* published the first of fourteen editorials by its editor Lenoir Chambers; in them, he urged the reopening of schools and an orderly acceptance of the new status quo. "The desertion of a doctrine of education on which democracy itself rests," he asserted, "runs too much against basic American convictions and beliefs, many of which originated or first found nobility of expression in Virginia." Chambers's essays won a Pulitzer Prize for Distinguished Editorial Writing.

Two courts, both issuing opinions on January 19, 1959, had the last word. The Virginia Supreme Court of Appeals ruled that the school closings violated the state constitution, and a federal district court ruled that the closings violated the U.S. Constitution. The schools reopened on February 2.

Somewhere along the way, those initial Black students became known as the "Norfolk 17." Over the years, they have told stories of the name-calling, harassment, and isolation they endured in those early days of integrated public schools. Twelve of the Norfolk 17 stayed the course and graduated from the Norfolk high schools they helped desegregate. The others graduated elsewhere. All but three earned college degrees. Five became teachers.

9

Saving History

THE MOUNT VERNON LADIES' ASSOCIATION OF THE UNION

ALL OF THE ENTRIES in this chapter follow the same story arc. Each is about a place where extraordinary people once did extraordinary things. And then history moved on. Reversals of fortune left behind disrepair and neglect. Until one day, someone decided there is something to save here, something that this place can say to a new generation.

Chronologically, the rescue of Mount Vernon was the first and has a strong claim as the most improbable. Ann Pamela Cunningham was a thirty-seven-year-old unmarried woman born to an upper-class family in South Carolina. A riding accident made her an invalid. With a letter published in the December 2, 1853 edition of the *Charleston Mercury* newspaper, she began a campaign to rescue Mount Vernon, once the home of the nation's first president. Appealing to "national and, above all, Southern honor," she signed her letter, "A Southern Matron."

Mount Vernon, on the southern bank of the Potomac River just below Alexandria, was in shambles. By then, its ownership had been passed to John Augustine Washington III, George's great-grand-nephew. Washington III tried to entice the federal government and the State of Virginia to purchase the site, but each declined.

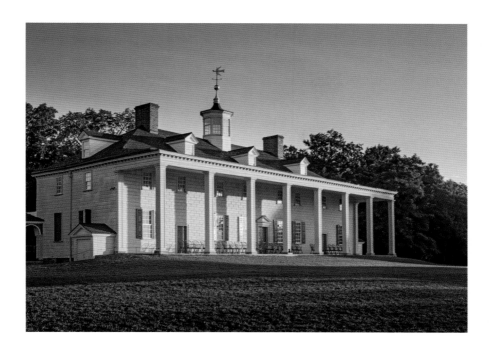

In the turbulent years before the Civil War, Ann Pamela Cunningham dropped her nom de plume, expanded her fundraising across regional lines, and founded the Mount Vernon Ladies' Association of the Union, formally incorporating it in Virginia in 1856. Two years later, she convinced John Augustine to sell the mansion and the surrounding property for $200,000. The association took possession in 1860.

ABOVE
First light on a summer morning at Mount Vernon.

OPPOSITE The "New Room" at Mount Vernon was so named by the Washingtons because it was the last addition to the mansion.

PRESERVATION VIRGINIA

AS AT MOUNT VERNON, women were the driving force in creating the Association for the Preservation of Virginia Antiquities (APVA). The association changed its name to Preservation Virginia in 2009.

In 1889, Cynthia Beverley Tucker Coleman of Williamsburg and Mary Jeffrey Galt of Norfolk formed the APVA a few months after purchasing, for $400, the Williamsburg Powder Magazine, which was still standing, though just barely. It had been used to store arms in both the Revolution and the Civil War.

The APVA was the nation's first statewide historic preservation organization. In large part, this late–nineteenth century celebration of Virginia's earlier times was a response to the devastation left by the Civil War. "We must drop the curtain over these dark and stormy days with their humiliation and pain," Ms. Coleman wrote. Speaking at an APVA meeting in 1890, Thomas Nelson Page, a Virginia writer of stories and novels that idealized the Old South, rhetorically asked, "Do you think that had the North possessed Jamestown and Williamsburg and Yorktown, it would have neglected them and have allowed the elements to wear them away?"

In 1893, the APVA acquired twenty-two and a half acres on Jamestown Island. The site contained Jamestown's one remaining structure from the colonial period, a church tower made of brick (page 121). The tower dates back to the late seventeenth century.

The late twentieth century brought an unexpected revelation. Archaeologists led by Dr. William Kelso discovered the location of the original 1607 James Fort. It was on the edge of the James River shoreline and had not been lost to erosion, as had been thought. The project is ongoing. They have discovered more than two million artifacts, including many human skeletons. So far, the most startling find has been that of the partial remains of a fourteen-year-old girl; according to archaeologists, these remains may show evidence of cannibalism. Such was the dire situation during the "starving time" of the winter of 1609–10, when the Jamestown population went from more than two hundred fifty men and women to sixty.

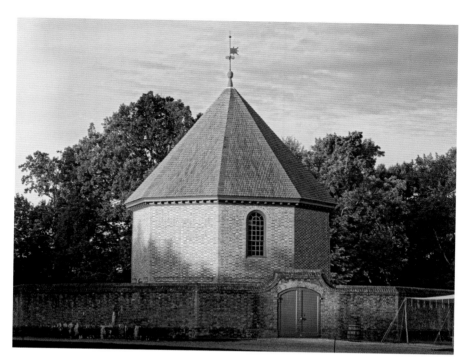

TOP On April 20, 1775, Virginia's royal governor Lord Dunmore ordered Royal Marines to empty the Williamsburg powder magazine. That act sparked talk of revolution, which intensified nine days later when the *Virginia Gazette* published news of the battles of Lexington and Concord.

BOTTOM Dr. William Kelso stands beside a brick oven in a cellar that the Jamestown archaeologists unearthed a few feet in front of the church tower. They believe the cellar dates back to the early James Fort period (1607–10).

STRATFORD HALL, ROBERT E. LEE
MEMORIAL ASSOCIATION

STRATFORD HALL PLANTATION in Westmoreland County was home to four generations of the Lee family. In the 1730s, Thomas Lee (1690–1750) built the Georgian plantation house, a symmetrical H-shaped building that sits on high ground with a view of the Potomac River a mile to the east. Two of his sons signed the Declaration of Independence (page 56). In the early nineteenth century, reversals of fortune and scandal touched this prominent family so much that the Lees lost ownership of Stratford Hall.

The problems began with Henry Lee III, who had enjoyed much notoriety and success, beginning with his time as a cavalry officer in the Revolution. His riding skills in the war resulted in his nickname "Light Horse Harry." Later, he was elected Virginia's ninth governor, and after that, was elected to Congress. But Harry had no success with money. Losses from land speculation eventually put him in debtor's prison. Henry's second wife was Anne Hill Carter of Shirley Plantation (page 172). Their fifth child, born in 1807, was Robert E. Lee. In 1811, the family left Stratford Hall for less opulent quarters in Alexandria, and thereafter, they survived on Anne's inheritance.

The plan that turned Stratford Hall into a museum house, open to the public, began in, of all places, Greenwich, Connecticut, with its local chapter of the United Daughters of the Confederacy. May Field Lanier, a woman with Southern heritage, first proposed the idea to the Greenwich chapter in 1928. Like the Mount Vernon Ladies' Association seventy-two years earlier, they incorporated and entered into an agreement to purchase the mansion and its surrounding grounds. It all happened just months before the 1929 market crash. Even so, by 1935, Stratford Hall was paid for.

A light snow falls on Stratford Hall in Westmoreland County.

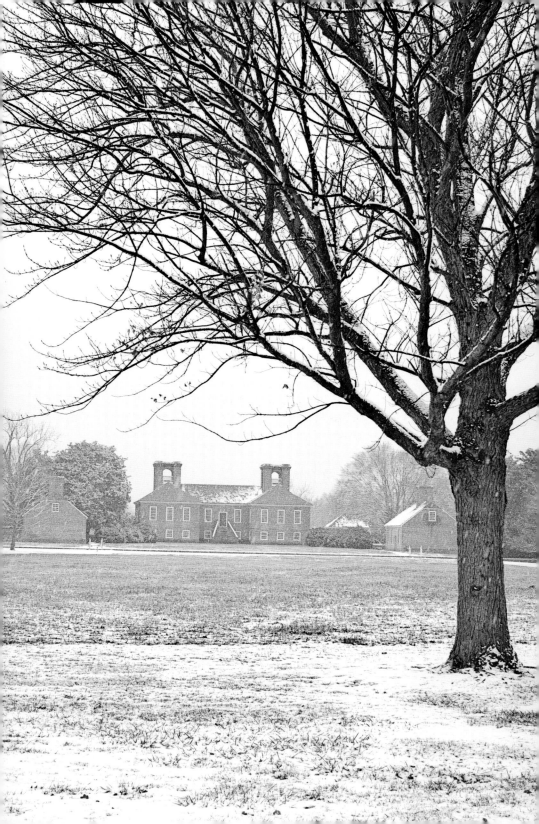

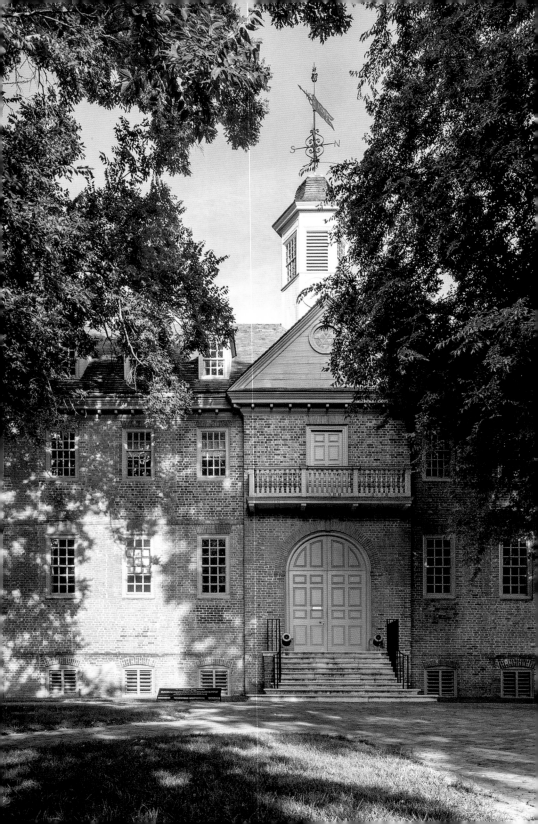

COLONIAL WILLIAMSBURG

OVER TIME, the Reverend Dr. William Archer Rutherfoord Goodwin compressed his explanation of how the restoration of Williamsburg came about to the following: "It was God who gave me the idea and Mr. Rockefeller who gave the money."

Williamsburg's decline began in 1779, when the Virginia General Assembly passed legislation, largely written by Thomas Jefferson, to move the state's seat of government to Richmond. By the early twentieth century, too many of the surviving colonial-period buildings had suffered from years of neglect. Many newer structures were out of step with colonial times. One was a garage with a bright-red sign spelling out "Toot-an-Kum-In," a play on words inspired by the widespread news coverage of the discovery in 1922 of the lavish tomb of Tutankhamun, the Egyptian pharaoh. The garage couldn't have been more prominent; it was next door to the powder magazine.

W.A.R. Goodwin is how Goodwin preferred his name to appear. He first lived in Williamsburg between 1903 and 1909, when he was rector of Bruton Parish Church. He returned in 1923, this time as a professor and director of endowments for William & Mary. Three years later, Bruton Parrish recruited him to be rector for a second time, a position he held while continuing his duties at the college. It was in Goodwin's William & Mary fundraising role, in 1924, that he first reached

"Wren" is the name this building acquired in the late 1920s, during the Rockefeller-funded restoration. The possibility that Sir Christopher Wren designed the building stems from the claim by Hugh Jones, an eighteenth-century professor of mathematics at William & Mary, that, as it was rebuilt after the 1705 fire, the structure "is not altogether unlike Chelsea Hospital." Royal Hospital Chelsea is still in operation today and is one of Sir Christopher's most celebrated buildings.

out to John D. Rockefeller Jr. to ask for money to restore three eighteenth-century campus buildings. Rockefeller's answer was no. What eventually caught Rockefeller's eye was the grander scheme Goodwin proposed in 1926—to restore the town itself. All in all, Rockefeller spent more than $68 million preserving more than eighty buildings, rebuilding the Capitol, the Governor's Palace and other structures that no longer stood.

William & Mary's Wren Building became Rockefeller and Goodwin's first major restoration project. The college was established by a royal charter from King William III and Queen Mary II, granted on February 8, 1693. Two years later, construction started. The building's exterior walls make it the oldest academic structure still in use in the United States. Those walls and the crypt below ground level are all that have survived the building's three fires—in 1705, 1859 and 1862.

The twentieth-century restorers were guided by surviving descriptions of the building's 1732 iteration, plus the newly discovered engraved printing plate that is now called the "Bodleian Plate." This copper plate, believed to be from approximately 1740, shows two views of the Wren Building, as well as views of the Governor's Palace and the Capitol. Mary F. Goodwin, Goodwin's cousin, uncovered the plate on December 21, 1929. All that Mary had to go on was a long list of copper plates appearing on page 421 of the *Guide to the Manuscript Materials for the History of the United States to 1783, in the British Museum, in Minor London Archives, and the Libraries of Oxford and Cambridge*. One description in the *Guide*—part of a collection stored in the Bodleian Library at Oxford—caught her eye: "Virginia. Buildings, probably in some town in Virginia or Carolina." So, Mary went to the Bodleian to see for herself.

THE COLONIAL NATIONAL HISTORICAL PARK, YORKTOWN

AUGUSTINE MOORE'S good fortune was that his home on the York River stood just beyond the Yorktown battlefield. On October 17, 1781, a British officer, under a white flag of truce, delivered a message from his commanding officer Lord Cornwallis, proposing "that two officers may be appointed by each side, to meet at Mr. Moore's house" to negotiate the terms of surrender. The next day, General George Washington's aide-de-camp Lieutenant Colonel John Laurens and the Viscount de Noailles of the French army met with British officers of similar rank. The terms that Washington accepted spelled out the disposition of troops, artillery and arms, care for wounded prisoners and the details of a surrender ceremony to be held the following day, October 19. The Battle of Yorktown was the last major engagement of the American Revolution.

In the late 1920s, the preservation community and Virginia's political leaders focused on Yorktown and the possibility of a road connecting it to Williamsburg and Jamestown. Horace Albright, the director of the National Park Service, toured the Tidewater sites in 1929. Albright's Virginia trip resulted in Congress creating, in 1930, the Colonial National Monument, now the Colonial National Historical Park. The park eventually purchased the battlefield, portions of Jamestown Island, and the right-of-way for a parkway between the two.

Enough of a federal presence was in place by the fall of 1931 to hold a grand celebration of the 150th anniversary of the Battle of Yorktown. That October 19 President Herbert Hoover arrived aboard the battleship USS *Arkansas*. A crowd of forty thousand was in Yorktown that day. Seventy-seven-year-old John Philip Sousa led the Marine Corp Band—just as he did at Yorktown's centennial celebration in 1881.

FOLLOWING John D. Rockefeller Jr. bought the Moore house property in 1928 and deeded it over to the National Park Service, which completed its restoration in 1934.

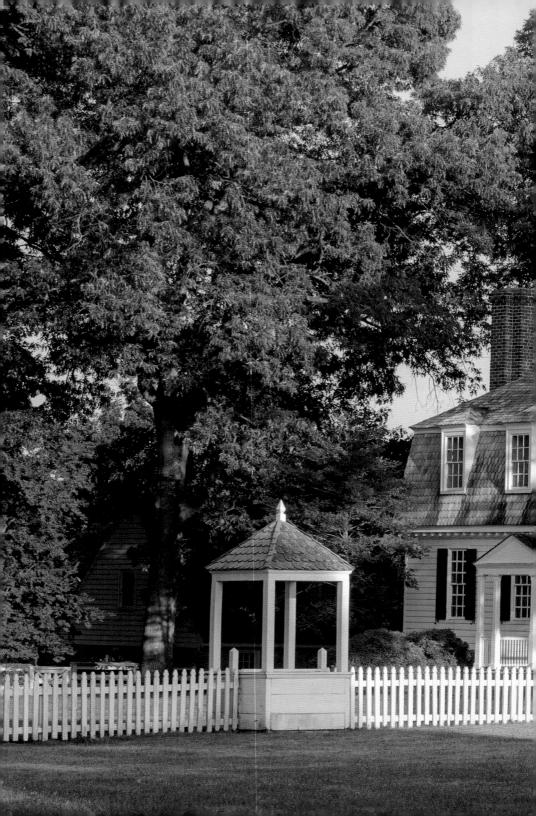

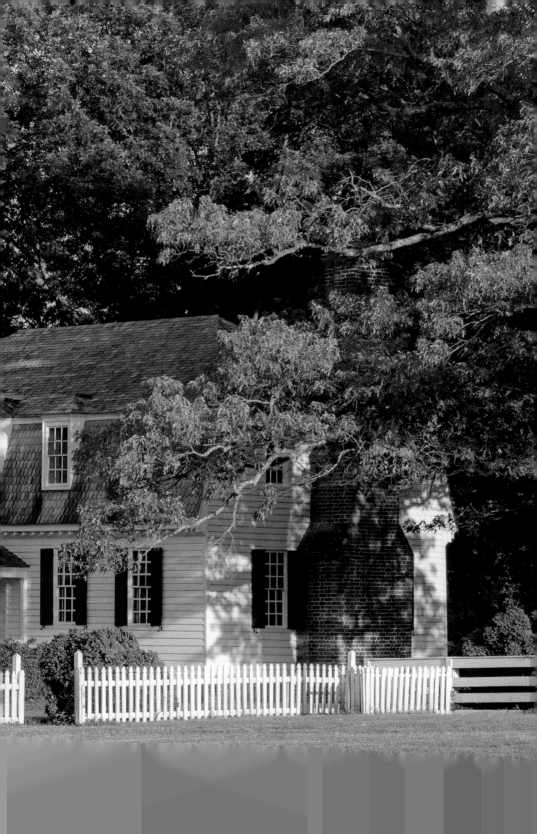

Hampton Roads

LOWER CHESAPEAKE BAY

We came to anchor here because no pilot has yet offered. Being within 15 miles of Norfolk by land, I have some thought of going ashore here in the morning, and going by and to that city.

—*Thomas Jefferson*

JEFFERSON WROTE this brief account while aboard the *Clermont*, when it was anchored in lower Chesapeake Bay, waiting not just for a pilot but also for fog to lift and a strong wind to subside. Having sailed across the Atlantic, he was returning to America after five years in Paris, where he served as a minister to France.

Jefferson's two daughters, Martha and Mary, traveled with him, as did the enslaved Sally Hemings and her brother James. Sally, then in her teens, had accompanied Mary when she sailed to Europe to join her father in 1787. As it turned out, Jefferson did not go ashore the next day. Instead, two days later, on November 23, 1789, the ship docked in Norfolk. There, Jefferson learned that President Washington had appointed him secretary of state.

Chesapeake Bay is the entryway to Hampton Roads. In the bay's deep water, modern freighters lie at anchor just as Jefferson's *Clermont* did, waiting their turn at the Hampton Roads docks a few miles to the west. The name

"Hampton Roads" does not appear on the Virginia map published in 1753 by Joshua Fry and Peter Jefferson; this suggests it was not yet a widely used term. Other familiar nautical place names are on the map—Sewells Point, Lamberts Point, Point Comfort, Elizabeth River, James River and Norfolk itself. Sewells Point is spelled "Sowels Pt.," but it's there, nonetheless. Jefferson's *Notes on the State of Virginia* makes just one mention of Hampton Roads, boasting that the James River "affords harbour for vessels of any size in Hampton Road"—leaving off the "s" in Roads. A Virginia map that was published in 1807, created in part by Reverend James Madison, identifies Hampton Roads and spells it with the "s" that we take for granted today. Reverend Madison was the president of the College of William & Mary,

Just before dawn, freighters lie at anchor east of Hampton Roads in lower Chesapeake Bay. Cape Henry Lighthouse is in the distance. Returning from France in 1789, Thomas Jefferson and his family waited in these waters for good weather and a harbor pilot before docking in Norfolk.

as well as the first bishop of the Episcopal Church in Virginia. He was also a cousin to President James Madison.

The name Hampton is widely believed to be a reference to the Third Earl of Southampton, Henry Wriothesley, a wealthy English nobleman in the early seventeenth century. Wriothesley invested in the Virginia Company, serving for a time on its council. He never traveled to the New World. In England, Wriothesley won, lost and then won again in palace intrigue. Imprisoned by Elizabeth I, he was set free by James I. He was also a patron of the arts—William Shakespeare dedicated two poems to Wriothesley.

As for *road* and *roads*, the Oxford English Dictionary tells us they are both shortened forms of the word *roadstead*, meaning "a sheltered piece of water near the shore where vessels may lie at anchor in safety." The OED adds that the plural form *roads* has gained more acceptance.

ELIZABETH RIVER

We sailed up a narrow river up the country of Chisapeack. It hath a good channel, but many shoals about the entrance.

—*Captain John Smith*

A NATIVE VILLAGE identified as Chesapeack appears on Captain Smith's famous Virginia map, on the site where Norfolk was later established. A short squiggly line indicates that Chesapeack is located on the southern shore of a river, but the map does not give the river a name.

In 1624, twelve years after publishing the Virginia map, Smith published his *Generall Historie*, which contains a brief account of exploring a "narrow river" for "six or seven miles" before reaching "Chisapeack"—an ever so slight spelling variation of the name he placed on his map. In *Generall Historie*, Smith puts the Chisapeack visit as occurring in early September 1608, during the last days of his second exploratory voyage up the bay. The unnamed "narrow river" with the "good channel" appears to be the Elizabeth River or possibly the Lafayette River, a narrower and shallower river that flows into the Elizabeth.

Smith's details about Chisapeack are sparse: "we saw two or three little garden plots with their houses, the shores overgrown with the greatest pine and fir trees we ever saw in the country." Finding no one in the village, he and his party reversed course and sailed back to the "great river"—today's Hampton Roads.

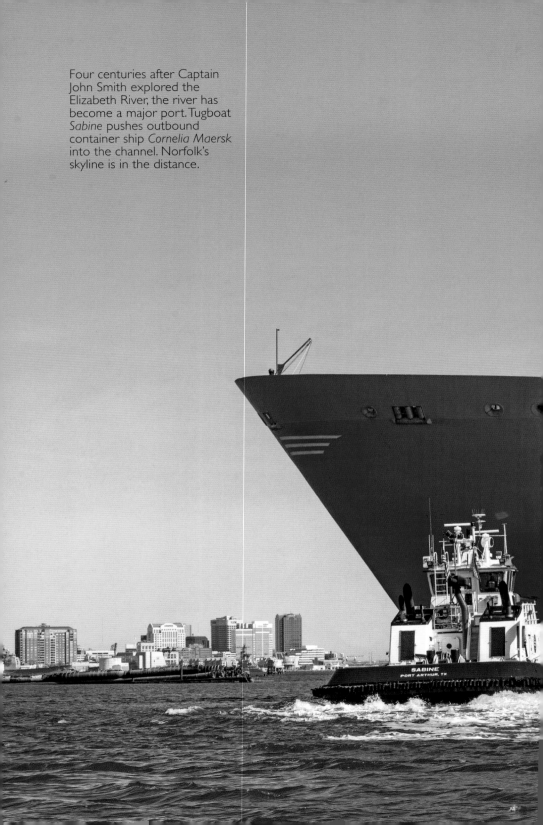

Four centuries after Captain John Smith explored the Elizabeth River, the river has become a major port. Tugboat *Sabine* pushes outbound container ship *Cornelia Maersk* into the channel. Norfolk's skyline is in the distance.

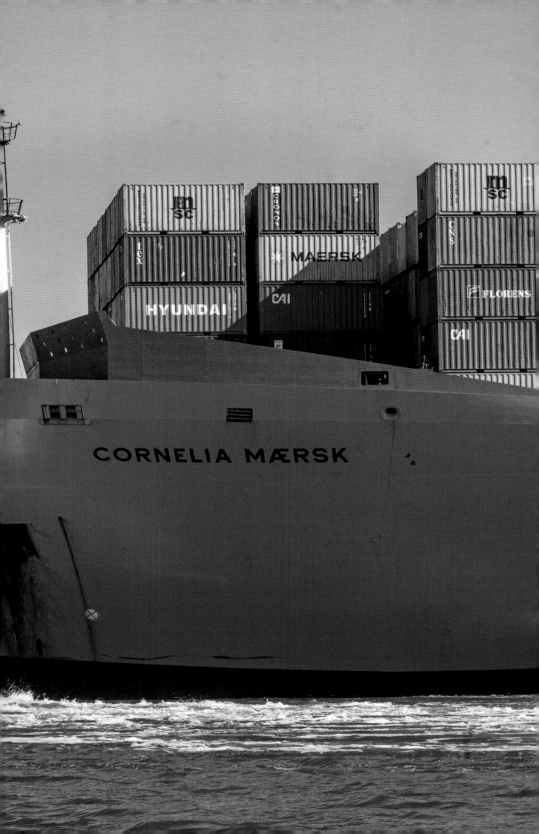

Elizabeth River, Part 2

Norfolk has most the air of a town of any in Virginia. There were then near twenty brigantines and sloops riding at the wharves, and oftentimes they have more. It has all the advantages of situation requisite for trade and navigation. There is a secure harbor for a good number of ships of any burden. Their river divides itself into three several branches, which are all navigable. The town is so near the sea that its vessels may sail in and out in a few hours.

—William Byrd II

BY 1728, when William Byrd II passed through Norfolk on his way to survey the colony's southern border, the river had long since acquired its name: "Elizabeth" for Princess Elizabeth, daughter of King James I. The visit inspired Byrd to write the vivid description of the Elizabeth River's harbor quoted at the beginning of this section.

BELOW The cruise liner *Artania*, just minutes before her scheduled 8:00 a.m. arrival, eases alongside the dock at Nauticus. Battleship *Wisconsin* is moored to the right. On the far shoreline to the left is Hospital Point in Portsmouth.

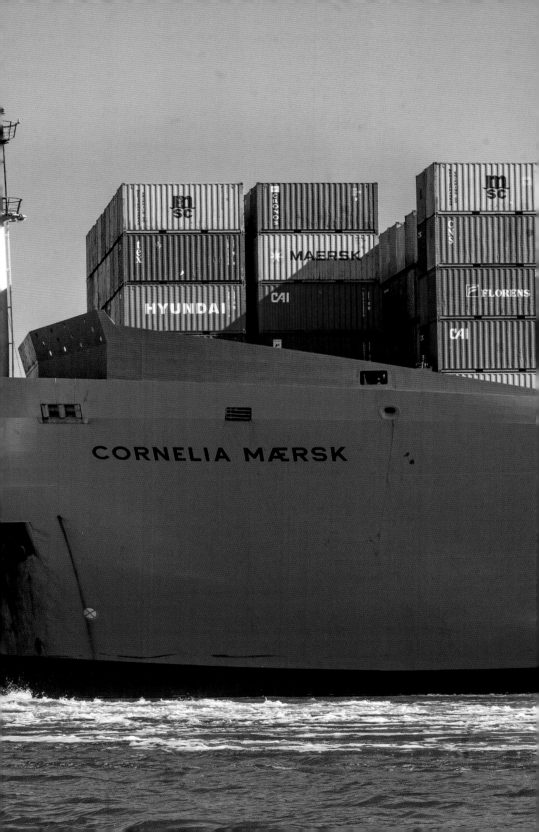

Elizabeth River, Part 2

Norfolk has most the air of a town of any in Virginia. There were then near twenty brigantines and sloops riding at the wharves, and oftentimes they have more. It has all the advantages of situation requisite for trade and navigation. There is a secure harbor for a good number of ships of any burden. Their river divides itself into three several branches, which are all navigable. The town is so near the sea that its vessels may sail in and out in a few hours.

—*William Byrd II*

BY 1728, when William Byrd II passed through Norfolk on his way to survey the colony's southern border, the river had long since acquired its name: "Elizabeth" for Princess Elizabeth, daughter of King James I. The visit inspired Byrd to write the vivid description of the Elizabeth River's harbor quoted at the beginning of this section.

BELOW The cruise liner *Artania*, just minutes before her scheduled 8:00 a.m. arrival, eases alongside the dock at Nauticus. Battleship *Wisconsin* is moored to the right. On the far shoreline to the left is Hospital Point in Portsmouth.

> ... 〈ba〉ggage, and cross'd the river with their
> servants only, for fear of making a famine in the
> town.
>
> Norfolk has most the ayr of a town, of any in Vir-
> ginia. There were then near 20 brigantines and
> sloops riding at the wharfs, and oftentimes they
> have more. It has all the advantages of situation
> requisite for trade and navigation. There is a
> secure harbour for a good number of ships of any
> burthen. Their river divides itself into 3 several
> branches, which are all navigable. The town is
> so near the sea, that its vessels may sail in and
> out in a few hours. Their trade is chiefly to the
> west-indies, whether they 〈...〉

ABOVE Byrd's manuscript *The History of the Dividing Line* is opened to the page that contains his description of Norfolk and the Elizabeth River harbor. Owned by the American Philosophical Society (APS) in Philadelphia, it is one of just two surviving full-length copies. The other belongs to the Virginia Historical Society.

Initially, the APS had no record identifying the manuscript's author. In correspondence with Thomas Jefferson beginning in November 1815, the APS asked if he could identify the author and, if possible, supply pages missing from the APS's copy. He was able to do both. Jefferson borrowed a copy from Benjamin Harrison and had a scrivener transcribe the missing text. This is one of the pages that Jefferson's scrivener created for the APS.

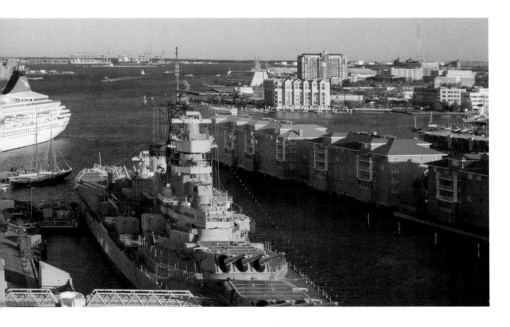

THE NAVY COMES TO NORFOLK

NAVAL STATION Norfolk sits on Sewells Point, where the Elizabeth River enters Hampton Roads. Here, layers of history run deep.

Just two days after the 1607 English travelers landed in Virginia, a contingent of those travelers explored the coastline. George Percy, one of the 1607 explorers, would later write, "We found a river on the south side running into the main." Based on Percy's brief description of that day, the "river on the south side" was likely the Elizabeth.

The name Sewells Point is a corruption of "Mr. Seawell's Pointe." Henry Seawell owned 150 acres on this site, beginning sometime after 1633. He served as a burgess (i.e., representative) in the General Assembly, the colony's legislature.

In the early twentieth century, Norfolk, aided by the surrounding Hampton Roads communities, eventually beat out Richmond to obtain the state legislature's approval to host a celebration of Jamestown's three hundredth anniversary. The grand event was called the Jamestown Ter-Centennial Exposition of 1907. In 1902, exposition planners purchased 340 acres of farmland, woods, and salt marshes at Sewells Point on which to build the exposition. The 1607 English settlers had done such a good job of finding a remote location for James Fort that, three centuries later, the actual Jamestown was viewed by all concerned as too far out of the way and without accommodations for the expected attendees.

The Jamestown Exposition opened on April 26, 1907. Mark Twain attended, so did President Theodore Roosevelt—twice. There were two lasting aspects of the exposition that shaped the future for Sewells Point: the first, that twenty states—twenty-one, if you count Virginia— accepted the exposition's invitation to celebrate their respective histories by constructing state-sponsored buildings on the exposition's grounds; the second, that the exposition lost money.

Much of the exposition's assets were purchased at a bankruptcy sale by Norfolk's Fidelity Land and Investment Corporation, which quickly began courting the federal government to buy the land. Fidelity touted the deep-water site as an ideal spot for the U.S. Navy. Washington didn't say yes until two months after the United States entered World War I.

Today, Naval Station Norfolk is the largest naval station in the world. And those state-sponsored buildings from the exposition? Many of them have retained their original names and serve as residences for the base's top brass, lining what is informally called Admirals' Row.

Flags of the United States, U.S. Navy, and West Virginia fly outside West Virginia House in the foreground. Georgia House is next door, on the left.

USS *Wisconsin*

The waters, isles, and shoals are full of safe harbors for ships of war or merchandize, for boats of all sorts, for transportation or fishing, etc.

—Captain John Smith

THE PHOTOGRAPH below is from the morning of June 7, 1990—not quite four hundred years after Captain Smith first published the above description of Virginia's "safe harbors." The battleship USS *Wisconsin* lies at anchor in Hampton Roads. It is the same harbor where the Civil War ironclads *Monitor* and *Merrimack* aimed their artillery at each other on March 9, 1862.

In 1988, after the *Wisconsin* was decommissioned for thirty years, the navy brought her back to life and modernized her to carry Tomahawk cruise missiles. On her deck, nine vintage World War II sixteen-inch guns were made operational once again. Two months after this photograph was taken, the *Wisconsin* departed from Norfolk for the Persian Gulf, where she ended up participating in the Gulf War. This was her last mission in harm's way. She was decommissioned in 1991. Today, the *Wisconsin* is on display and open to the public at Norfolk's Nauticus Museum, seven miles up the Elizabeth River from her former home port.

ABOVE The navy shares Hampton Roads with boats both big and small. On this morning back in 1990, the orange glow of dawn silhouettes USS *Wisconsin*. In the foreground, waterman Wade Moore from the Northern Neck operates the mechanical tongs on his workboat *Katy B* to bring aboard clams from below the harbor's deep water.

OPPOSITE USS *Wisconsin* on display at Nauticus.

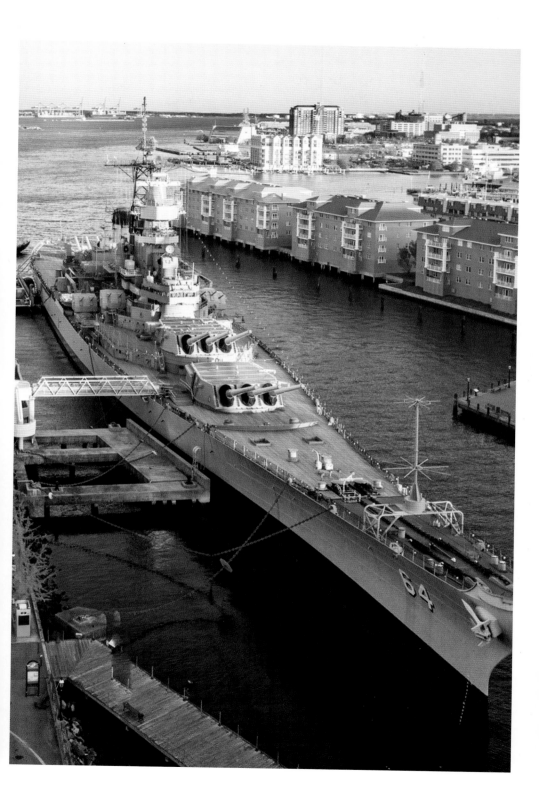

QUARTERS A AND THE MAIN OFFICE BUILDING

AT NORFOLK NAVAL SHIPYARD, the building called Quarters A dates back to the late 1830s. An early set of plans refers to it as the "commandant's house," the residence of the yard's commanding officer. Quarters A, along with Quarters B and C, stands in a row inside a high brick wall that was erected in 1803 around what was then Gosport Navy Yard. Somehow, all three quarters survived the burning of the shipyard by Union forces who were evacuating the site in 1861 and survived a second fire started by retreating Confederate forces as the Union army was taking it back the next year. Many original features remain intact.

On the other side of Hampton Roads, the Newport News shipyard has had many corporate incarnations. Today's yard is Newport News Shipbuilding, a division of Huntington Ingalls Industries. The oldest section of the shipyard's Main Office Building on Washington Avenue was completed in 1891. It still speaks of the yard's earliest days. Gold paint in an arched window spells out Newport News Shipbuilding and Dry Dock Company, the name the company gave itself in 1890. It replaced Chesapeake Dry Dock and Construction Company—the name that appears on the company's original charter from the Virginia General Assembly in 1886.

OPPOSITE Quarters A at Norfolk Naval Shipyard.

ABOVE Lettering on the Main Office Building of Newport News Shipbuilding.

Norfolk Naval Shipyard

IN 1767, Andrew Sprowle, a Scottish immigrant and successful merchant, started a shipyard on the western shore of the Southern Branch of the Elizabeth River. He called it Gosport Shipyard. There has been shipbuilding on this site ever since—and ship destruction as well because the yard itself was a military target in both the American Revolution and the Civil War. Sprowle's shipyard supplied and repaired Royal Navy and British merchant ships. When the Revolution came, he sided with the mother country, but his war was a short one.

On January 1, 1776, British ships, commanded by Virginia's colonial governor Lord Dunmore, opened fire on Norfolk (page 84). Both sides set fires that leveled Norfolk. The following May, Dunmore and his fleet retreated from the Elizabeth River to Gwynn's Island in Mathews County. A party of British loyalists, including Sprowle and his wife, Catherine, accompanied the royal governor. While at Gwynn's, the sixty-two-year-old Sprowle died, apparently of natural causes (perhaps a disease he contracted in the vessel's close quarters). On July 9, Dunmore left Gwynn's Island, retreating, this time, to British-held New York. In short order, Americans repaired Gosport Shipyard. But before the war ended, the British returned to Portsmouth in 1779 and set fire to the yard once again.

By the beginning of the Civil War, Gosport was a U.S. Navy facility. On April 20, 1861, less than a week after the war's outbreak at Fort Sumter, Union forces abandoned Gosport, setting fire to the warships they left behind, including the steam frigate USS *Merrimack*. Not until Pearl Harbor would the U.S. Navy suffer a greater loss of ships and material.

Aircraft carrier USS *Dwight D. Eisenhower* is docked in the Norfolk Naval Shipyard for maintenance. In the foreground, tugboat *Nancy McAllister* heads up the Southern Branch of the Elizabeth River.

With the Union forces displaced, Confederate naval engineers put the *Merrimack* in Gosport's Dry Dock No. 1, salvaged the ship's hull and steam engine and built a new warship covered in iron plating. She would be called CSS *Virginia*. On March 8, 1862, the *Virginia* ruled Hampton Roads harbor, sinking USS *Cumberland* and burning USS *Congress*. The next day, she returned to Hampton Roads to meet the iron-hulled steamship USS *Monitor*, which had arrived the night before from her construction site in Brooklyn. The two ships fought the first ironclad-versus-ironclad battle in naval history. The day was indecisive; neither ironclad managed to inflict significant harm to the other. Still, those two days changed naval warfare. Cannon fire from sail-powered, wooden-hulled ships was no match for the ironclads.

Not rendered obsolete was Dry Dock No. 1. It is still in service today. The Confederate operation of the yard was short lived. Norfolk and the surrounding area fell to Union forces on May 10, 1862. The Gosport name itself became a war casualty. The navy replaced it with U.S. Navy Shipyard, Norfolk. Today, its official name is Norfolk Naval Shipyard.

SS UNITED STATES

THESE DAYS, Newport News Shipbuilding gets most of its attention by building the largest aircraft carriers afloat—attention-grabbing, yes, but not the yard's most glamorous ship. That distinction belongs to ocean liner SS *United States*. Her passengers in the 1950s and 1960s included celebrities and royalty. In this picture, taken in 1991, the *United States* is docked on the James River, out of service and facing an uncertain future—one that few could have predicted on June 23, 1951, when Newport News Shipbuilding launched her less than a mile upriver from this site.

During her heyday, the *United States* was the fastest ocean liner crossing the Atlantic. The advent of trans-Atlantic jet airplanes in the late-1950s changed everything. More and more travelers took to the sky, flying in Boeing 707s. Her last crossing, as well as her last coat of paint, was in 1969. Since then, she has been tied to one dock after another, bought and sold many times, with each owner searching for a way to do something with her other than send to her to the scrapyard.

Currently, she is owned by the nonprofit SS United States Conservancy and is docked in Philadelphia. At this point, virtually no one believes that the ship will ever be commercially viable for a return to the high seas. So, the conservancy is hard at work, preserving her as a stationary floating attraction, likely to become a floating hotel.

BELOW Waterman James Hall glides his workboat *Kimberly Ann* by the SS *United States*, docked on the James River in Newport News.

Captain Adam Halstead climbs up the pilot ladder of the Panamanian ship *Costanza*, lying at anchor in lower Chesapeake Bay, inbound for Newport News. Shannon Holloway watches from his post on the bow of the pilot launch *Virginia*.

PILOTS

VIRGINIA HARBOR pilots meet the big ships bound for Hampton Roads as they pass through the Virginia Capes. A ladder made of wood and rope, aptly called a "pilot's ladder," dangles from topside for the pilot to climb aboard. For ships headed out to sea, this process works in reverse; the pilot boards dockside, guides the ship through the harbor into the Chesapeake's deep water. Then, it's down the wood-and-rope ladder to a pilot boat that has pulled alongside. It's been this way since colonial times. The only apparent variation to this practice is that some modern ladders substitute plastic or other hard surfaces for the wooden steps.

In 1661, the House of Burgesses enacted its first statute to regulate pilots and appointed Captain William Oewin as "chief pilot of James River." Early Virginia statutes followed the pattern of English law dating back to King Henry VIII's royal charter in 1514, which granted an English guild called Trinity House the authority to pilot ships on the River Thames. "Branch" is Trinity House's name for the licenses it grants guild members, signifying they are authorized to pilot ships. Virginia's House of Burgesses used the same term in regulating Virginia pilots. An act of the legislature in 1762 gave courts in the counties along the colony's navigable rivers the extra duty of appointing examiners to award pilot branches. That model is still in place today. State courts in Norfolk, Portsmouth, and Hampton each appoint members to the state Board for Branch Pilots.

In the nineteenth century, the overarching issue of slavery very much touched the lives of pilots. The pilot act of 1802, passed by the Virginia General Assembly, prohibited a "negro or mulatto" from obtaining a pilot branch but provided that "any such person" already holding a branch could continue practicing his craft. In 1856, a new Virginia law added the role of "inspector" to a pilot's duties—to search for runaway slaves possibly hidden aboard a boat, owned by "any citizen or resident of another state," that was outbound for "any port or place north and beyond the capes of Virginia."

In late 1865, Samuel W. Wood, a returning Confederate veteran and a pilot before the war, began organizing what became the Virginia Pilot Association. Wood and other returning pilots lobbied the postwar session of the Virginia General Assembly to amend pilot laws to favor local branch pilots who had apprenticed in local waters.

11
Lighthouses

CAPE HENRY

The cape on the southside is called Cape Henry in honor of our most noble Prince. The show of the land there is a white hilly sand like unto the Downs, and along the shores, great plenty of pines and firs.

—*Captain John Smith*

THERE IS MUCH in Captain John Smith's description of Cape Henry that a modern visitor would recognize. It still carries the name the English gave it on their fourth day in Virginia. They thought it prudent to name the site for King James I's eldest son, Henry, Prince of Wales, just as it was prudent to name Jamestown for the king himself. Smith's mention of "the Downs" is a reference to the English Channel, where it skirts the shoreline of Kent.

The two Cape Henry lighthouses photographed in early morning light; the active lighthouse is on the right. Somewhere on this beach, based on the writings of Captain Smith and colonist George Percy, is where the 1607 settlers first went ashore (page 26).

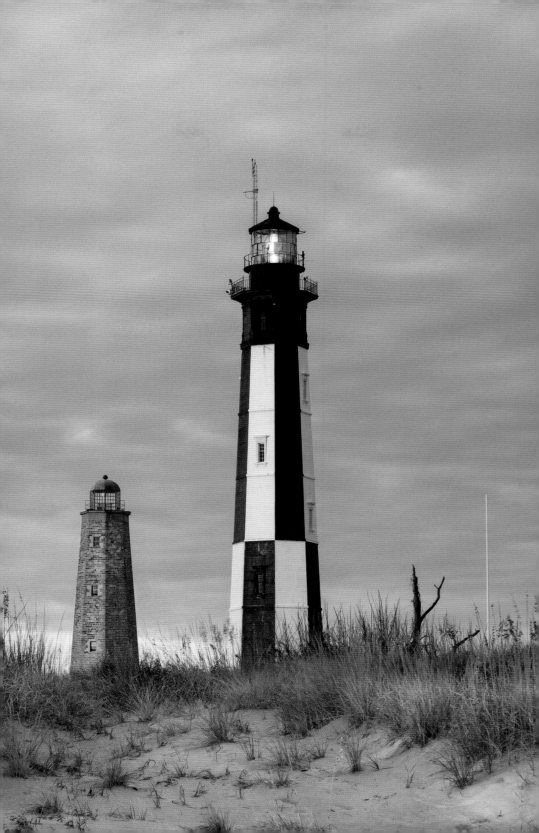

In the photograph on the previous page, the stone building on the left is the original lighthouse—the first one constructed by the federal government in the early days following ratification of the Constitution. "Old" Cape Henry Lighthouse was completed in October 1792; it was built on fifty-six feet of stone and drifting sand to give it extra height. Eighty years later, perhaps because of this sandy location, an inspector found cracks in six of the lighthouse's eight walls. "A new one must be built," he recommended. And so they did. The new lighthouse went up just 350 feet away; this one made of cast-iron and put into service on December 15, 1881.

The light in the new lighthouse is perched 164 feet above mean high water. The red glass to the right warns ships of shoals inside the bay. Both lighthouses are located on the Fort Story army base, which, in 2009, combined with the navy's Little Creek base to form the Joint Expeditionary Base Little Creek-Fort Story. Notwithstanding the 1872 inspector's dire prediction, the old lighthouse still stands, though no longer in navigational service. It is open to the public and owned by Preservation Virginia.

CAPE CHARLES

Leaving the Phoenix at Cape Henry, they crossed the Bay to the eastern shore and fell with the isles called Smith's Isles after our captain's name.

—*Captain John Smith*

CAPE CHARLES LIGHTHOUSE stands on Smith Island, a tiny barrier island that can trace its name back to Captain John Smith's first exploration up the Chesapeake Bay. With a party of seven "gentlemen," one of whom was a doctor, and seven soldiers, Smith left Jamestown on June 2, 1608, traveling in what he called a "barge"—a small vessel propelled by oars or by a sail attached to a mast. Smith provided no details about this portion of the journey. Scholars believe the barge left Jamestown towed behind the supply ship *Phoenix*, which was headed out to sea to return to England. The two vessels parted "at Cape Henry." There, the barge carrying Smith and his fourteen men crossed the Chesapeake Bay to reach a group of small islands called Smith's Isles, "after our captain's name." The captain's famous map (pages 20 and 21) identifies the islands as a group and does not give specific names to the individual islands. Today's Smith Island is the easternmost barrier island at the southern tip of Eastern Shore.

Construction of the current lighthouse—the island's third—began in 1893, only to stop in the summer of 1894 because the swarms of mosquitoes were so severe. Work didn't resume until that November. The lighthouse began operation ten months later on August 15, 1895. The structure is a hollow iron column. Eight iron skeletal legs hold the column in place, reinforced by an elaborate pattern of braces from top to bottom. The 1892 date above the lighthouse door is a bit of a mystery. It is not the year the lighthouse went into service; instead, it is the year the government acquired the Smith Island site by right of eminent domain. The "U.S.L.H.E." above the door stands for United States Lighthouse Establishment.

In May 2013, the U.S. Coast Guard published in its weekly "Local Notice to Mariners" that the status of Cape Charles Light had been changed to "LT EXT," the abbreviation for "light extinguished." The Coast Guard has no plans to bring the lighthouse back into service.

FOLLOWING Cape Charles Lighthouse on Smith Island at the southern tip of Eastern Shore.

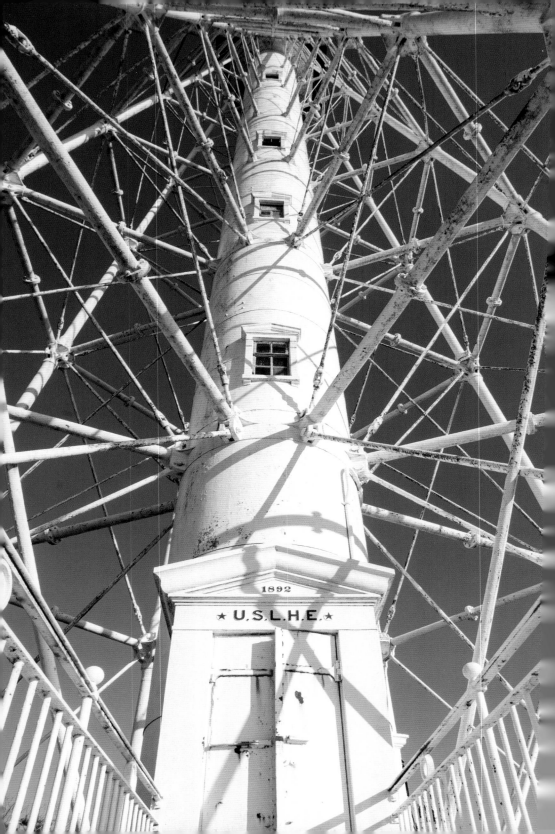

Assateague

LIKE CAPE HENRY, Assateague Island has had two lighthouses. The first, built in 1833, was a brick tower standing 45 feet tall. In 1867, the United States Lighthouse Board replaced it with the lighthouse that is still in service today. A conical brick tower with horizontal red and white stripes, it stands 145 feet tall on a natural bluff 22 feet above sea level. In 1852, the Lighthouse Board succeeded the Lighthouse Establishment as the federal agency responsible for construction and maintenance of lighthouses and navigation aids.

The first light in the 1867 structure was an oil-burning lamp in a fixed Fresnel lens; it was replaced in 1933 by three one-hundred-watt battery-powered electric lights. An onsite electric generator ran fifteen hours a week to recharge the batteries. In 1961, when electric power lines finally reached the island, the U.S. Coast Guard installed a directional beacon consisting of two large drums, each with a one-thousand-watt bulb. Beginning at sunset, the lamps light up, and the drums rotate to create a pattern of two white flashes every five seconds.

ABOVE Assateague's tower tapers from a diameter of twenty-eight feet at its base to eighteen feet at the lantern room.

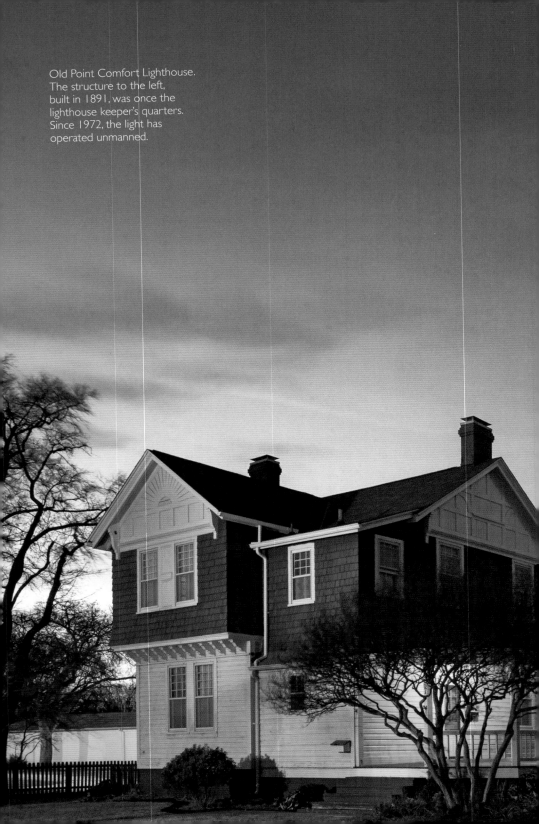

Old Point Comfort Lighthouse.
The structure to the left,
built in 1891, was once the
lighthouse keeper's quarters.
Since 1972, the light has
operated unmanned.

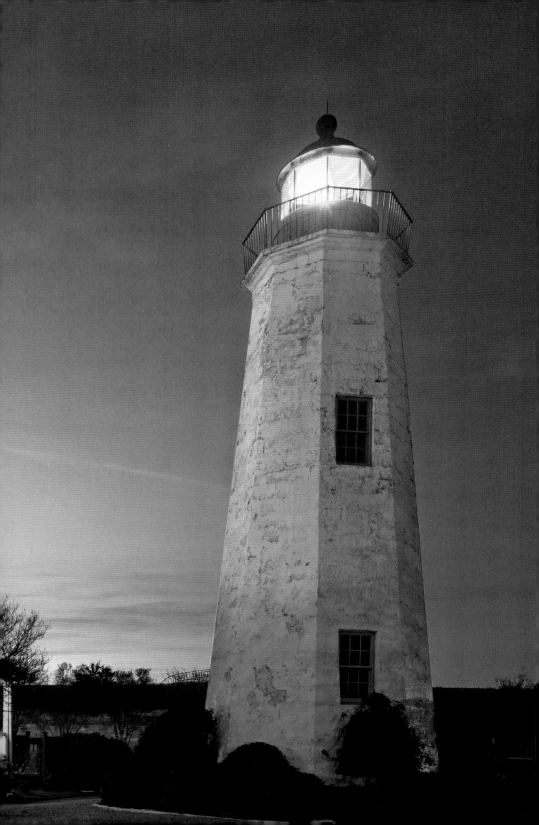

OLD POINT COMFORT

JOHN SMITH'S 1612 map gives the name "Poynt comfort" to the northern shoreline where Hampton Roads flows into the Chesapeake. By 1803, when the lighthouse was completed, Poynt comfort had undergone the ever so slight name change to Old Point Comfort. This was done to distinguish it from New Point Comfort a few miles up the bay in Mathews County. The U.S. Lighthouse Establishment, created by the nation's first Congress to construct and oversee lighthouses, hired stonemason Elzy Burroughs of Stafford County to build this lighthouse and, later, a nearly identical one for New Point Comfort.

Think about how new the country was back then. In 1803, Thomas Jefferson was in his first term as president. Not for another sixteen years would construction begin on the U.S. Army's Fort Monroe. Thereafter, both the lighthouse and the fort would share Old Point Comfort. Named for James Monroe, the nation's fifth president, the fort's purpose was to prevent future invading navies from having an unchallenged route up the Chesapeake Bay to the nation's seat of government in Washington. That was the nautical path the British had taken in the War of 1812, when they burned Washington, including the Capitol Building and the White House.

Old Point Comfort Lighthouse is still in service, but Fort Monroe is not—it was decommissioned in 2011. Later that year, President Barack Obama signed a proclamation designating portions of the fort as a national monument. Other portions are now owned by the State of Virginia and managed by the state's Fort Monroe Authority.

12

Watermen

CRABBING, CHESAPEAKE BAY

WHEN I WAS a boy growing up in Hampton, I watched the watermen in their workboats go up and down Hampton Creek. Chesapeake Bay watermen are a close-knit community. Some are watermen, just like their fathers before them, and for some, just like their fathers and their grandfathers. Eventually, I got the nerve to introduce myself and ask to spend a day on the water with them.

I was aboard Pete Freeman's workboat many times. Pete and his crew would bring aboard a crab pot, shake out the crabs inside, put in fresh bait, toss the baited crab pot overboard, then steer ahead about fifty yards to the next crab pot to do it all over again. The photograph on the following two pages was taken in November, in the waning days of crabbing season. We were in the lower Chesapeake Bay.

FOLLOWING Pete Freeman crabbing in Chesapeake Bay.

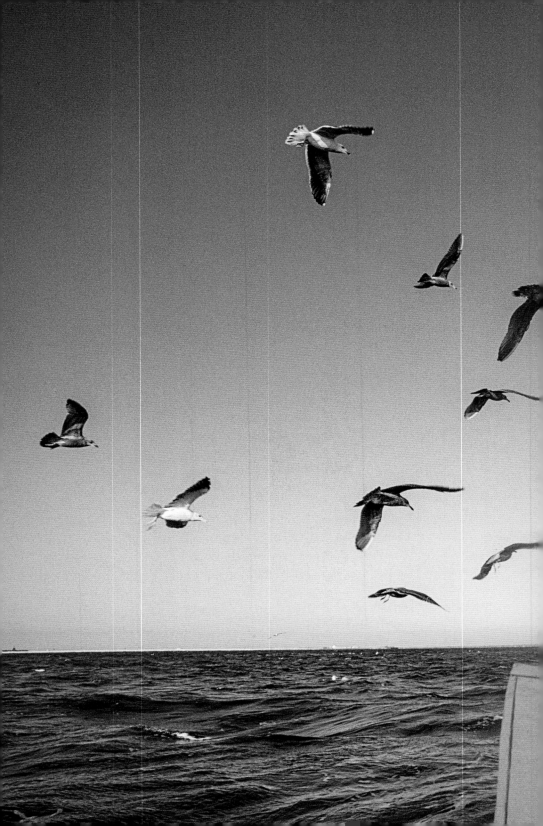

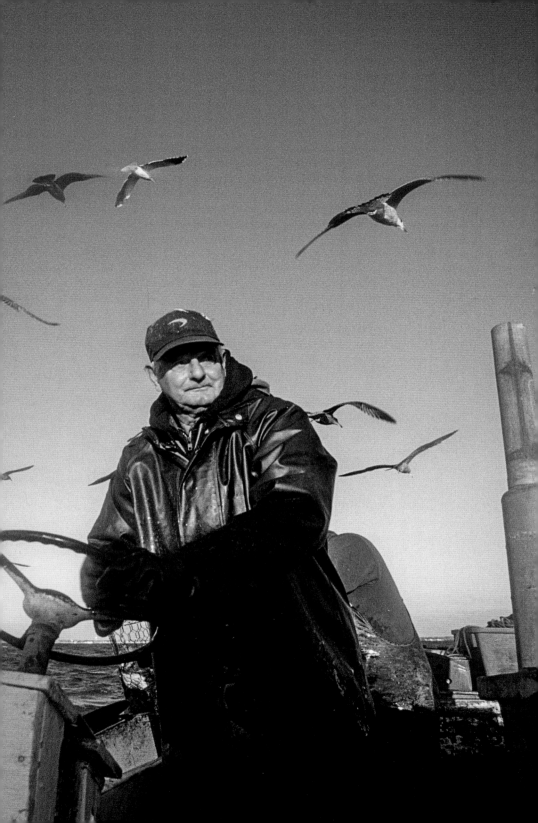

Tonging for Oysters, James River

Oysters as savory and well-tasted as those from Colchester or Walfleet, and had the advantage of them, too, by being much larger and fatter.
—William Byrd II

THE EUROPEAN SETTLERS fell in love with the oysters they discovered in the New World. In early colonial times, it was easy to harvest oysters in shallow water. At low tide, some oyster reefs would rise above the water line.

In the previous quoted passage, William Byrd II tells of an oyster bed in water near the beach where he and his party began their 1728 survey of the Virginia–North Carolina border. Byrd's line is still Virginia's southern border. The first generations of New World settlers depleted the easy-to-harvest shoreline oysters that Byrd describes. Subsequent oyster harvesters resorted to "oyster tongs"—a long scissor-like tool with metal rakes on the ends to harvest oyster beds in deeper water. Modern Chesapeake Bay watermen frequently call oyster tongs "hand tongs" to distinguish them from hydraulic "patent tongs" that are used to rake the bottoms of even deeper bodies of water.

The late twentieth and early twenty-first centuries have seen the oyster industry shrink to just 5 percent of the production levels of its glory days. But a hardy collection of watermen still hand tong for oysters in the Rappahannock and James Rivers.

OPPOSITE A Sunday afternoon during oyster season at Deep Creek in Newport News. The oyster beds are closed to the watermen and their workboats until sunrise on Monday.

FOLLOWING During oyster season, watermen on the James River begin their day at sunrise with their workboats positioned over the public oyster beds. Later in the day, William "Bubba" Bonniville (*left*) and Ellis West (*right*) will sell their catch dockside at Deep Creek harbor in Newport News.

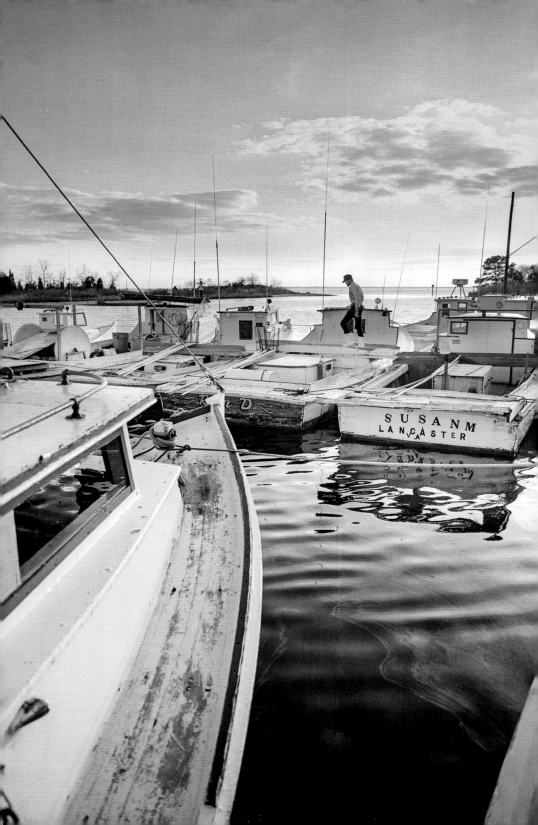

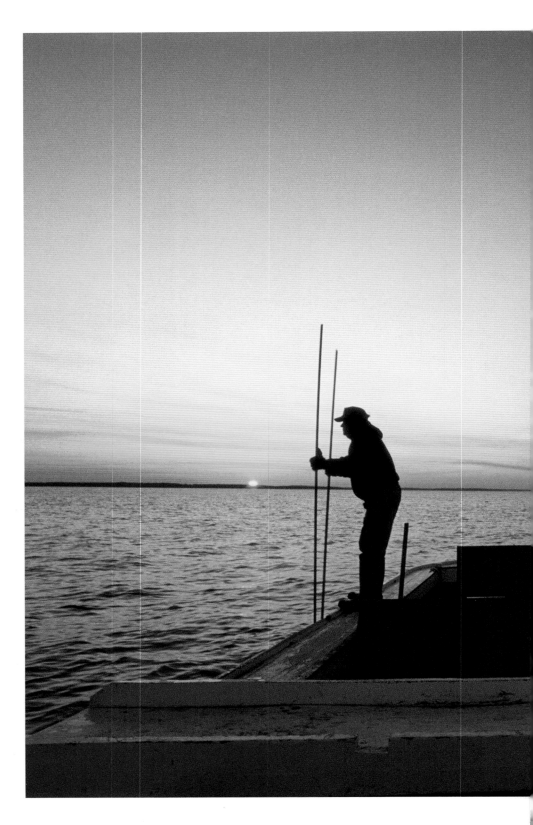

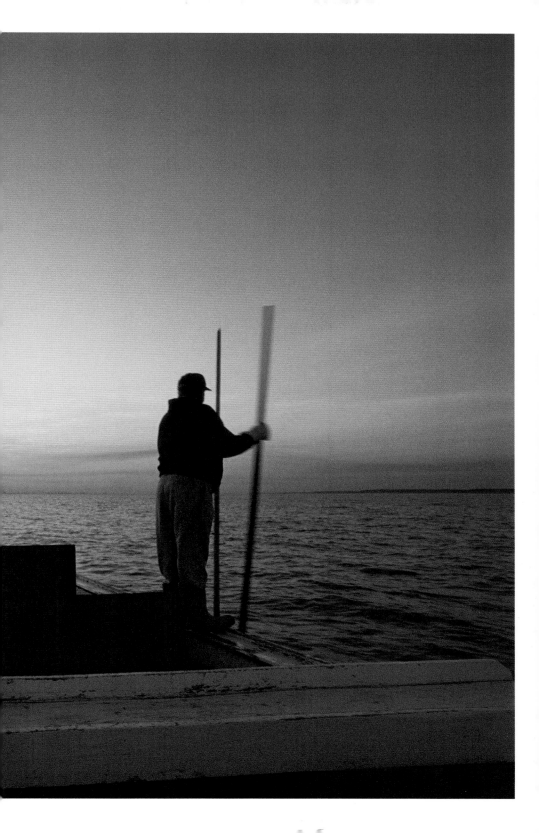

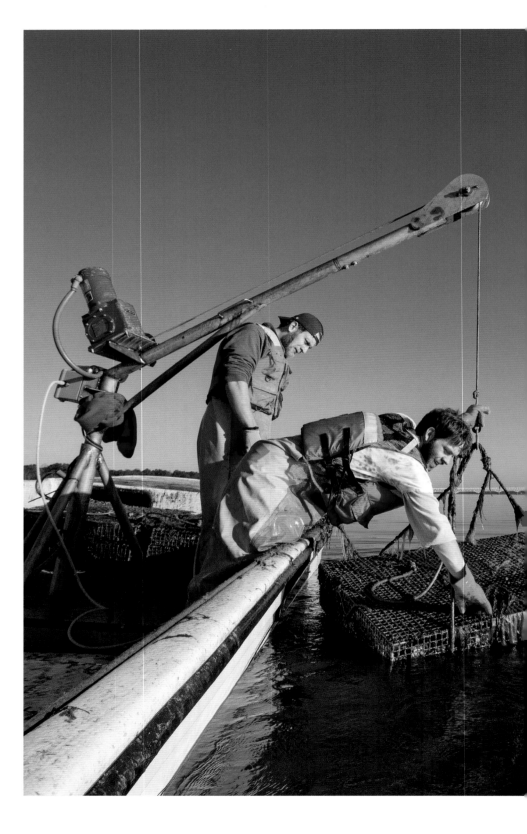

OYSTER FARMING,
MIDDLESEX COUNTY

Pd. (by B.F.R.) to Casey. Slippers	*2.50*
Lee tallow & beef	*12.05*
Isaacs cheese	*5.67*
Jones books	*9.75*
Garrett oysters	*13*
Cash	*.53*
	43.50

—*Thomas Jefferson*

THOMAS JEFFERSON'S entry in his Account Book for March 29, 1826, lists five purchases at Monticello, one of which was thirteen dollars for oysters. All in all, the Account Books have thirty-three entries recording oyster purchases—the first at Shadwell on February 13, 1768. The March 1826 oyster entry was Jefferson's last, a little more than three months before his death on July 4, 1826.

The twenty-first century has brought us a phrase that Thomas Jefferson would never have used: "farm-raised" oysters. Oysters harvested by the traditional methods of dredging or tonging in public or private oyster beds are now called "wild" oysters. Oyster farming—the transplanting of larvae spawned in hatcheries to small floats in shallow water or to cages that rest on the bottom—has pumped new life into the Virginia oyster business, resulting in a tenfold increase in Virginia's total oyster harvest between 2001 and 2011. Many oyster farmers sell their oysters directly to restaurants in Virginia and out of state. Virginia has become the leader among East Coast states in oyster production.

OPPOSITE Thomas Licht (*left*) and Chris Pitts (*right*) bring an oyster cage aboard. Rappahannock Oyster Company leases oyster beds at the entrance of Locklies Creek on the southern edge of the Rappahannock River.

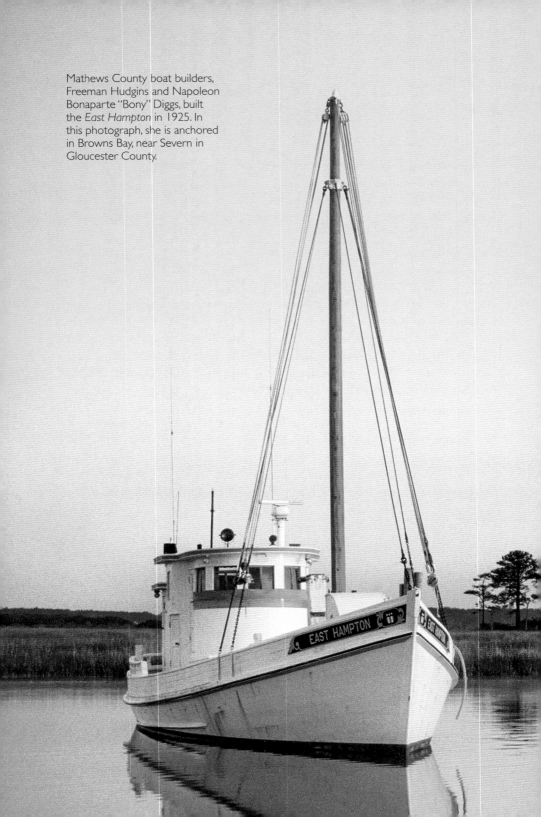

Mathews County boat builders, Freeman Hudgins and Napoleon Bonaparte "Bony" Diggs, built the *East Hampton* in 1925. In this photograph, she is anchored in Browns Bay, near Severn in Gloucester County.

BUYBOATS, GLOUCESTER COUNTY

IN THIS IMAGE, buyboat *East Hampton* faces the rising sun on Browns Bay in Gloucester County. In the late twentieth and early twenty-first centuries, the Chesapeake Bay buyboat, a once-familiar design, all but disappeared from commercial service. And it happened with none of the fanfare that accompanied the ebbing tide of working skipjacks—the bay's celebrated sail-powered commercial fishing boats. The "buy" portion of the buyboat's name comes from its role in "buying" seafood, particularly oysters, from tongers and dredgers near their oyster beds, thereby saving them a trip to the market. Buyboats had other functions as well. In the summer, they carried freight and hauled watermelons, and in the winter months, they dredged for crabs hibernating on the muddy bottom of the bay's deep water. Conservation concerns forced that longstanding winter practice to end in 2008.

Today, almost all of the surviving buyboats are owned by museums or by a hardy band of new owners for whom the buyboat is, of all things, a pleasure boat.

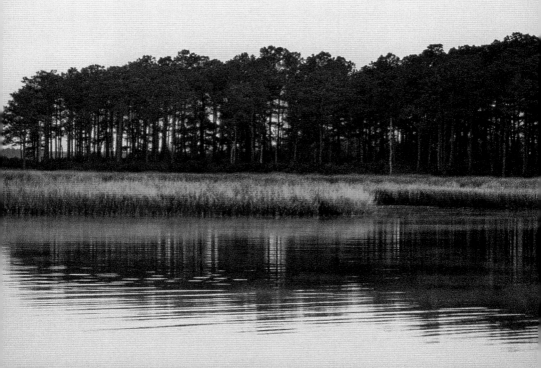

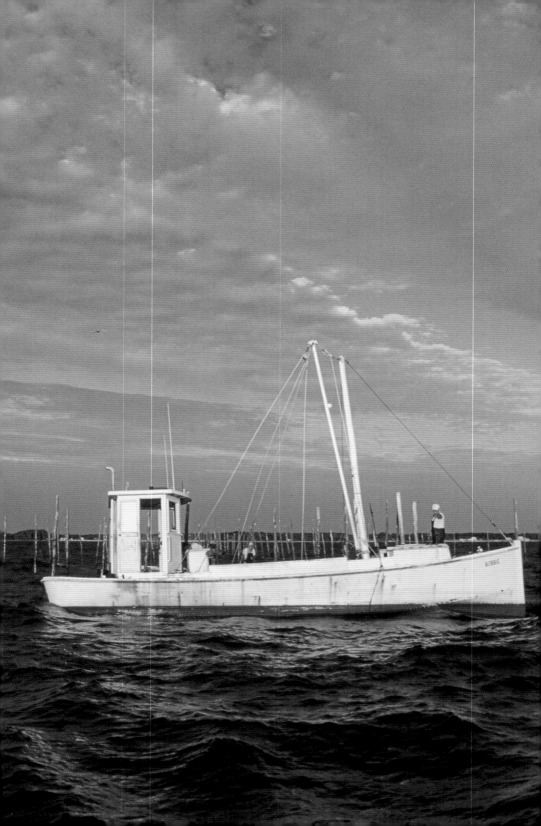

POUND NETS, POTOMAC RIVER

The fourth river is called Patawomeke and is 6 or 7 miles in breadth. It is navigable 140 miles, and fed as the rest with many sweet rivers and springs, which fall from the bordering hills. These hills many of them are planted, and yield no less plenty and variety of fruit than the river exceeded with abundance of fish.

—*Captain John Smith*

CAPTAIN SMITH'S "Patawomeke" is our Potomac River—which is easier to pronounce and much easier to spell. In the photograph on the left, waterman Eddie Gaskin and his crew, out of Ophelia on the Northern Neck, work a pound net on the Potomac to bring in their own "abundance of fish."

Pound nets funnel fish into small netted areas, where they become trapped. Their origin on the Chesapeake Bay can be traced back with remarkable precision. According to Larry Chowning, an Urbanna native, who has written about all manner of Chesapeake Bay subjects, George Snediker brought this innovation with him when he moved to Mathews County from his home at Gravesend, New York, now a part of Brooklyn, in 1875. His pound net proved so efficient that local fishermen became alarmed. Taking matters into their own hands, they sawed off the wooden stakes that were supporting Snediker's pound nets, removed the nets, and eventually forced Snediker to leave Mathews, never to return. In time, the locals themselves started using this unwelcomed northerner's pound net technique. As for Snediker, he found a more hospitable reception when he moved to the Chesapeake's Eastern Shore.

Pound netting on the Potomac.

13
Farmers

SHIRLEY PLANTATION, CHARLES CITY COUNTY

IN THIS CHAPTER, we will see that farming remains widespread in Tidewater—some of it on the same land where seventeenth- and eighteenth-century English settlers first grew their crops.

They call it The Great House. The historic house at Shirley Plantation, completed in 1738, is a commanding presence on the north shore of the James River. There is much to tell about the family that has lived there and worked its fields for eleven generations—twelve if you count the twins who were born in 2016. Charles Hill Carter III, his wife, Lauren Murphy, and their twins, Charles IV and Lela Grace, live upstairs, while tourists are invited to visit the rooms on the first floor.

The Carters say that Shirley Plantation is the oldest family-owned business in North America, dating back to Edward Hill who established a farm there in 1638. To put this into perspective, this longevity has occurred despite the following hardships, each played out on Shirley Plantation's many acres:

- Bacon's Rebellion in 1676: The family sided with the royal governor; Bacon's men ransacked the house that was then standing on the property.

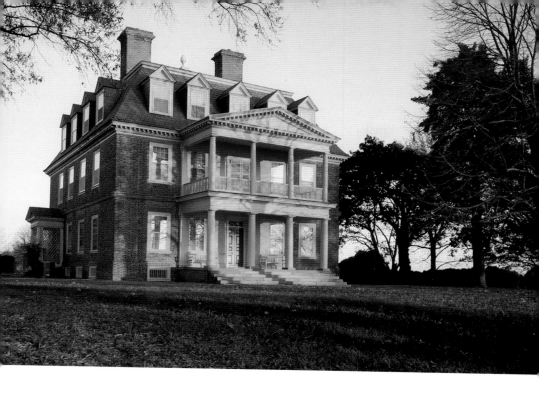

- The American Revolution: The family sided with the colonists; Shirley Plantation was a supply depot for Lafayette's troops bound for Yorktown.
- The American Civil War: The family men fought for the Confederacy; one died at Chancellorsville. In 1862, General McClellan's Union soldiers, marching south after the battle of Malvern Hill, set up a field hospital on the Shirley property.
- Facing financial pressures in 1928, the family tightened its belt and sold to John D. Rockefeller Jr. a Charles Willson Peale portrait of George Washington that had hung in the dining room for generations; today, the painting's owner is Colonial Williamsburg.

My day at Shirley occurred on a mild fall afternoon, followed by a twilight with a warm glow that lingered on the horizon. Shirley Plantation is very much a working farm. Janet Appel, Shirley Plantation's director and manager, had one more chore to do after showing me around; we said goodbye, and she was off to feed the goats.

ABOVE Late afternoon light at Shirley Plantation. Another image of Shirley appears on page 13.

CORN, CHARLES CITY COUNTY

I cultivate in my own garden here Indian corn for the use of my own table, to eat green in our manner.

—*Thomas Jefferson*

THE GARDEN Jefferson was writing about in the previous quote was not the one he grew at Monticello—it was one he kept in Paris while serving as a minister to France. The phrase "to eat green in our manner," according to Jefferson scholar Peter J. Hatch, may mean that Jefferson's Paris staff prepared "Indian corn" unshucked in a hot kitchen hearth to be eaten as corn on the cob. Hatch was a leader on the team that restored the garden at Monticello in the 1980s.

The corn in the photograph below is growing on Westover Plantation, once the celebrated 4,700-acre holding of William Byrd II. Byrd's diary reveals that he was as much at home in his cornfields as in his library—a

ABOVE Cornfields border the tree-lined entrance to Westover mansion.

OPPOSITE The mansion at Westover Plantation holds a mystery about its construction date (page 210). Was it built by William Byrd II or William Byrd III?

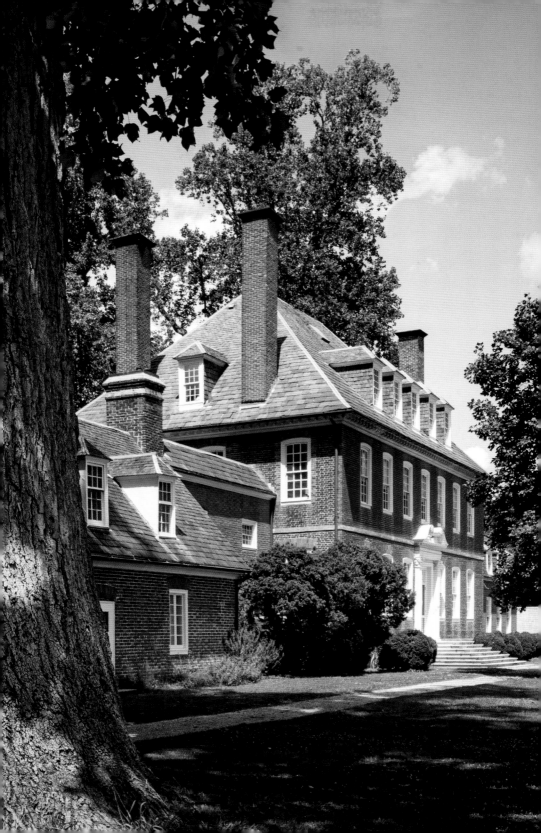

library that was without an equal in colonial America for its diversity and perhaps its size, with 2,345 titles according to the catalogue created after Byrd's death. The scholarly master of Westover Plantation recorded in his diary entry for June 18, 1711, "It rained almost all the morning. In the afternoon, I read French." One sentence later, he transforms into a plain-speaking farmer, observing how the day's weather treated his crops, "I took a walk about the plantation and saw my corn, which was in good condition and was much the better for that rain."

Today, Westover Plantation is home to Andrea and Rob Erda and their three children. Andrea's great-grandparents acquired the plantation in 1921. Like most Virginia commercial corn growers, the Erdas grow a hybrid corn, developed in the nineteenth century, called dent corn. Roughly half of Virginia's total corn acreage is raised on Tidewater farms.

WHEAT, GOVERNOR'S LAND, JAMES CITY COUNTY

Our farms produce wheat, rye, barley, oats, buck wheat, broom corn, and Indian corn.

—*Thomas Jefferson*

THE ABOVE QUOTE from *Notes on the State of Virginia* is a portion of Jefferson's list of crops growing on "our farms." Elsewhere in *Notes*, Jefferson admitted that the "culture" of tobacco in Virginia was in decline "and that of wheat taking its place." In the twenty-first century, tobacco scarcely grows at all in Tidewater—only on a few farms in Prince George and Sussex Counties, where Tidewater borders the Virginia Piedmont region.

The wheat in the photograph on the following pages is growing less than two miles north of Jamestown Island. The site is a portion of a tract of land that the colonists marked off in 1618 to comply with a set of instructions— often called the Great Charter. The Virginia Company of London issued the instructions to the colony's new governor Sir George Yeardley. One of the instructions ordered the governor to set aside three thousand acres for his own use and for that of future governors—to be called Governor's Land. The tenants would work the fields of Governor's Land, sharing with the governor "half part of the profits."

Preservation Virginia claims that the 214 acres of remaining farmland on Governor's Land is the longest continuously operated farm in the United States. James City County Economic Development Authority has owned the property since 1999 and has leased it out for farming.

Undoubtedly, the Great Charter's instruction of most lasting significance is the one that required the governor to include "burgesses" (i.e., representatives) elected from various settlements to serve alongside a company-appointed advisory "council of state" in a "general Assemblie." The elected burgesses gave the colonists a role they had never had before in fashioning laws for the colony. That first General Assembly met in Jamestown on July 30, 1619, with twenty-two burgesses in attendance. It was the first form of representative government in the New World.

FOLLOWING Wheat growing on Governor's Land in James City County.

BARLEY, WESTMORELAND COUNTY

Those who labour in the earth are the chosen people of God, if ever he had a chosen people, whose breasts he has made his peculiar deposit for substantial and genuine virtue. It is the focus in which he keeps alive that sacred fire, which otherwise might escape from the face of the earth.

—Thomas Jefferson

THE PRECEDING Jefferson quote is lifted from his response in *Notes on the State of Virginia* to query 19, which asked about "the present state of manufactures, commerce, interior and exterior trade." Jefferson begins his answer by admitting: "We never had an interior trade of any importance." Instead, "we have an immensity of land courting the industry of the husbandman." *Husbandman*, Jefferson's word for farmer, has grown out of favor in our time. What has not changed is that much of Virginia's land remains cultivated. With respect to barley alone, twenty-first-century Tidewater farmers plant roughly one-third of the total Virginia barley acreage, based on figures from the U.S. Department of Agriculture.

The barley George Washington grew in the last years of his life became an ingredient in the whiskey he distilled in his own distillery just a few miles away from the mansion at Mount Vernon. A fire destroyed the original building in 1814. A replica stands on the site today; it was built in 2007 by The Mount Vernon Ladies' Association (page 117). Washington's whiskey recipe has never been found. But a review of his business ledgers provides a clue. Using a fifteen-month period between 1798 and 1799, the Ladies' Association totaled the amounts of different grains Washington milled in his gristmill and then sent to his distillery. From these figures, they calculated that Washington's whiskey was 60 percent rye, 35 percent corn and 5 percent malted barley. This is the recipe that the association relies on for the whiskey it sells at Mount Vernon shops—whiskey distilled in George Washington's reconstructed distillery.

OPPOSITE George Washington grew his barley at Mount Vernon, roughly fifty miles north of this barley field on the Northern Neck, near Montross. The blue blossoms are bachelor's buttons. They grow wild in some cultivated fields. A late afternoon sun made them sparkle.

PEANUTS,
ISLE OF WIGHT COUNTY

65 hills of peendars have yielded 16½ lb weighed green out of the ground which is ¼ lb each. It was about 1½ peck.
—*Thomas Jefferson.*

"PEENDARS" is Jefferson's word for peanuts. The opening quote is from his October 7, 1794 entry in his Garden Book. Peendars was one of the "many unusual delicacies for an eighteenth-century garden" that Jefferson grew, according to Jefferson scholar Peter J. Hatch.

Our modern peanut industry has its roots in the early days following the Civil War. Nineteenth-century Norfolk produce merchant Thomas B. Rowland was "the man who 'discovered' peanuts," a bit of colorful exaggeration that appeared in a long article about peanuts in the December 1913 issue of *McClure's* Magazine. In 1867, Rowland began shipping Virginia peanuts to merchants in New York.

Another peanut pioneer was P.D. Gwaltney. In 1870, Gwaltney moved to Smithfield from nearby Surry County and began buying and cleaning local peanuts, rather than shipping them as they were delivered from the farms. In 1890, the Bain Peanut Company, started by country store proprietor L. Franklin Bain in Wakefield,

Johnny Stallings in the foreground and Tommy Darden (*right*) guide their tractors down rows of peanut plants, unearthing the peanuts that have grown beneath the surface in Isle of Wight County.

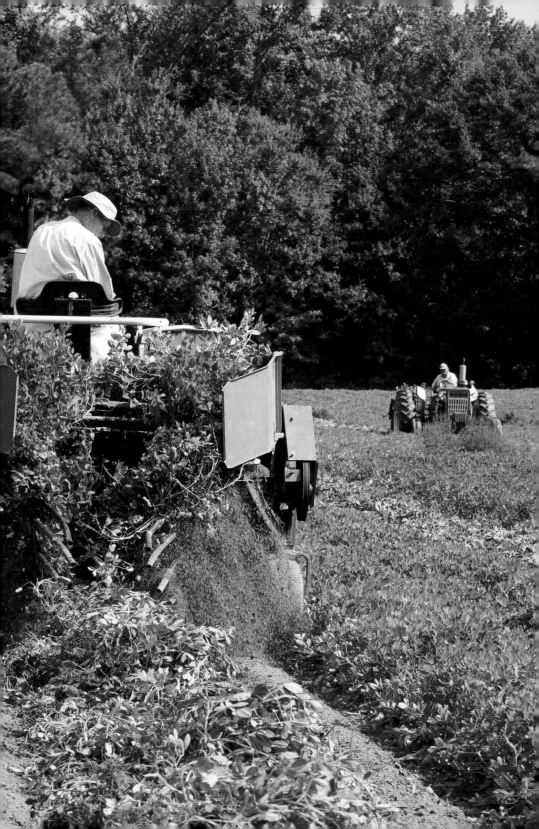

refitted an abandoned cotton mill into a peanut cleaning plant. John Pretlow, a peanut farmer near Franklin, built a peanut-cleaning plant in Suffolk.

Undoubtedly, the greatest peanut success story belongs to Italian immigrant Amedeo Obici. In 1896, he went into business selling roasted peanuts from a horse-drawn cart to shopkeepers in Wilkes-Barre, Pennsylvania. With fellow immigrant Mario Peruzzi, Obici formed the Planters Peanut Company in 1906. In 1913, the company relocated part of its operation to Suffolk to be closer to the Virginia peanut farms. Planters, now a part of Minnesota-based Hormel Foods, has been a major presence in Suffolk ever since.

The loose sandy loam soil in Virginia's peanut belt—Dinwiddie, Greensville, Isle of Wight, Prince George, Southampton, Sussex, and Surry Counties and the city of Suffolk—allows young peanut plants to burrow back in the ground, where they mature. The vast majority of Virginia-grown peanuts are "Virginia type"—the largest of all peanut types. They have the largest kernels and account for most of the peanuts that are roasted and processed in-the-shell.

COTTON, SOUTHAMPTON COUNTY

VIRGINIA IS ON the northern edge of North America's cotton belt. In the years leading up to the Civil War, many Southampton County farmers loaded their cotton crops into horse-drawn wagons and traveled north, up the Jerusalem Plank Road, to Petersburg's cotton market roughly forty miles away. Cotton dominated the world's economy in the nineteenth century. Virginia State Route 35, a modern hard surface road, traces the old plank road. Stretches of Route 35 still carry the Jerusalem Plank Road name. Jerusalem was the name of Southampton's county seat until 1888, when town fathers discarded it in favor of a far less colorful replacement, Courtland. It's been Courtland ever since.

In the twentieth century, the boll weevil emerged as the most vexing challenge faced by cotton growers. The destructive beetle feeds on cotton buds and flowers. First found in Virginia in 1922, the initial decline in Virginia cotton acreage was insignificant; more pronounced in the 1940s, more still in the 1950s and 1960s, until Virginia cotton acreage dipped

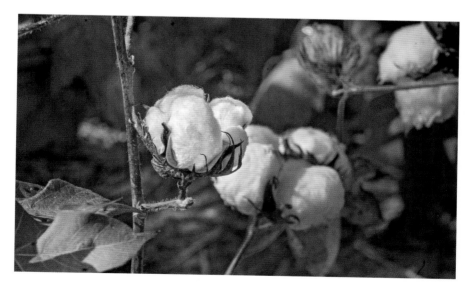

ABOVE Cotton growing near Smithfield.

FOLLOWING A pot of gold must be on the other side of this cotton field near Windsor.

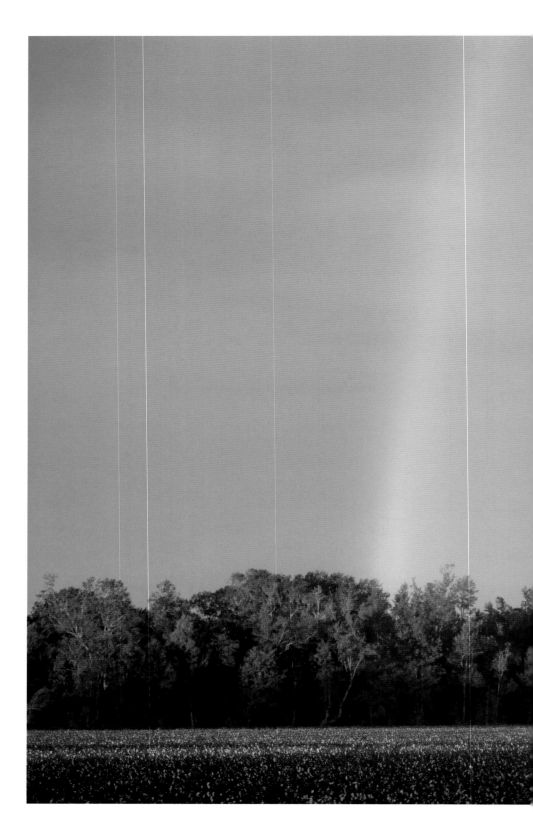

to a mere two hundred acres in 1978. The tide turned in the late 1970s, when the Department of Agriculture launched the National Boll Weevil Eradication Program, targeting the region around the Virginia–North Carolina border. Relying on chemicals to eliminate boll weevils' breeding grounds, the program was a success. It was copied throughout the North American cotton belt.

The leading producer of Virginia cotton in the twenty-first century is Southampton County, just as it was in the nineteenth century, followed by Isle of Wight, the city of Suffolk, Greenville, and Sussex.

14

Open Spaces

The novelty of being shut up so close quite spoiled our rest, nor did we breathe so free by abundance, as when we lay in the open air.

—*William Byrd II*

In this chapter, let's put aside the all too obvious evidence that the intervening centuries have gobbled up most of the "open air" spaces that prompted William Byrd to write the short passage above. Instead, we will concentrate on a few of the open spaces that remain. Sprinkled throughout Tidewater, these protected spaces begin with False Cape State Park, snug against the North Carolina border on the Atlantic shoreline, and run north to Eastern Shore's Chincoteague National Wildlife Refuge, which straddles the Virginia–Maryland line.

FOLLOWING An aerial view of Eastern Shore, the Atlantic laps against the coastline of Hog Island.

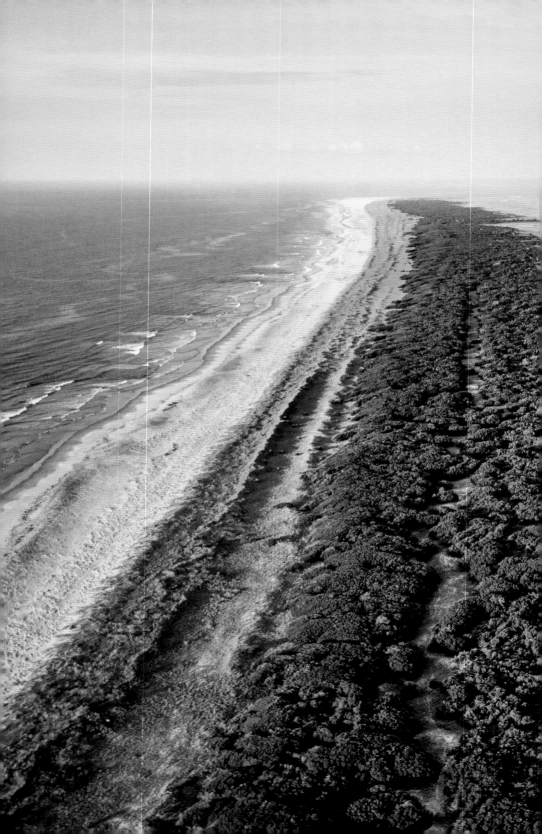

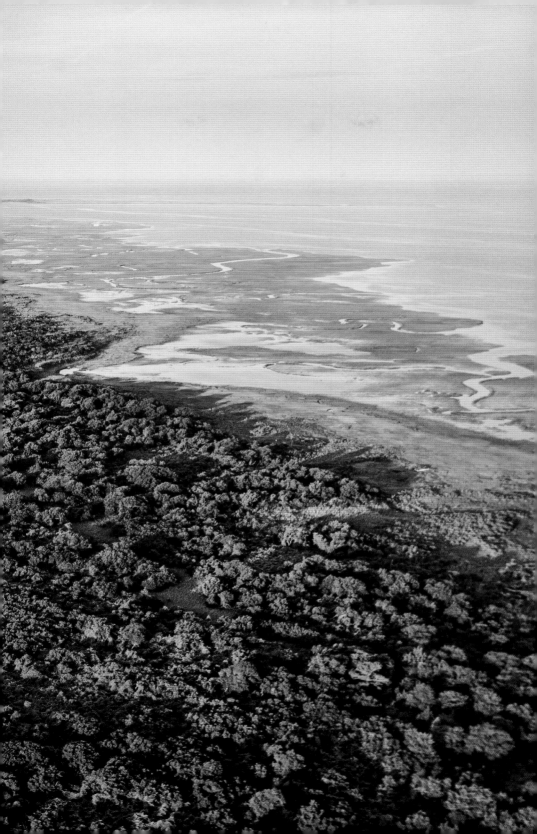

Volgenau Virginia Coast Reserve

VIRGINIA'S barrier islands are "the thin first line of defense against the ever-restless Atlantic Ocean"—a description penned by William Warner, the writer best known for *Beautiful Swimmers*, his celebrated book about the Chesapeake's blue crabs.

The Nature Conservancy is the primary landowner on nine of the Virginia barrier islands, managing them as part of its Volgenau Virginia Coast Reserve. The islands are the longest stretch of naturally existing barrier islands that remain on America's East Coast—running from Metompkin Island, fifteen miles south of the Maryland border, to Smith Island, just shy of Eastern Shore's southern tip.

The Nature Conservancy started buying Eastern Shore properties with Godwin Island in 1970. That same year, New York investors, calling themselves the Smith Island Development Corp., were busy promoting elaborate plans to develop Smith, Myrtle and Ship Shoal islands, complete with a four-thousand-foot-long airstrip on Smith. The project failed, and the conservancy stepped in and bought the three islands.

Ending in the late 1970s, the conservancy's purchases brought to a close a colorful history of humans seeking to tame these islands. Following the Civil War, travelers from the North discovered Eastern Shore as a new destination in the South. A new railroad added to this new prosperity. The New York, Philadelphia & Norfolk Railroad, completed in 1884, ran down the center of the Eastern Shore peninsula. On the islands, hotels, boardinghouses, private hunt clubs, and cottages opened. Cobb's Island Hotel, accommodating over one hundred guests, was the most famous. Hunting by visiting sportsmen and locals alike devastated flights of shorebirds and waterfowl.

Nature waited her turn to have the final say. A series of hurricanes and shoreline migrations in the late 1890s leveled all but the hardiest manmade structures. A quarter-century later, a devastating hurricane in 1933 destroyed most of the remaining barrier island structures that catered to tourists and hunters south of Chincoteague. Over time, that hurricane acquired the name, "the '33 storm." It blew through the Chesapeake on August 23, 1933, seventeen years before the weather service began naming hurricanes. Finally, the ocean encroached on Broadwater, a Hog Island settlement dating back two centuries. It was abandoned in 1941—the last community of barrier island dwellers south of the federal lands on Assateague and Wallops islands.

Today, the lighthouse on Smith (page 153) and a few small structures are the only manmade objects that remain on the Volgenau Virginia Coast Reserve barrier islands.

ASSATEAGUE ISLAND

Virginia is bounded on the East by the Atlantic: on the North by a line of latitude, crossing the Eastern Shore through Watkins's Point, being about 37°. 57 'North latitude.

—*Thomas Jefferson*

JEFFERSON BEGINS *Notes on the State of Virginia* with a long recitation of the state's boundaries. The portion quoted above describes the state's northern border with Maryland on Eastern Shore.

Jefferson's father, Peter Jefferson, was an accomplished surveyor. Working with Joshua Fry, Peter Jefferson produced *A Map of the Inhabited Part of Virginia*—commonly called the Fry-Jefferson map. It was first published in 1753 when Thomas was a boy. Years later, a mature Thomas called it "the first accurate map of Virginia which had ever been made." One unexpected inaccuracy in the Fry-Jefferson map—and one not of their own making—turned out to be the Maryland–Virginia border "crossing the Eastern Shore through Watkins's Point." Just above the border, as it appears on the Fry-Jefferson map (page 196), the small print reads, "This line was run 27 May 1688"—a reference to a survey that was done by Philip Calvert and Edmund Scarborough.

A subsequent survey of the Calvert-Scarborough line in the nineteenth century found it to be far off the mark, roughly four miles north of the site that was most likely to have been Watkins's Point, the boundary landmark identified in Charles I's charter to Lord Baltimore in 1632. And the Calvert-Scarborough line doesn't even run due east as it was supposed to. Instead, it veers to the northeast by about five degrees, a problem probably caused by failing to correct compass readings from magnetic north to true north.

The boundary dispute lingered until Maryland and Virginia submitted their claims for arbitration. The arbitrators' ruling, announced in 1877, has been the controlling law for this boundary ever since. The arbitrators decided that the original Calvert-Scarborough line, although erroneously surveyed, would continue to be the borderline from the Atlantic coast, west to the Pocomoke River. From there, they fashioned a revised border that turns south, down the center

FOLLOWING This fisherman on Assateague Island surfcasts into the Atlantic, roughly eleven miles south of the Virginia–Maryland border that was agreed to in 1877.

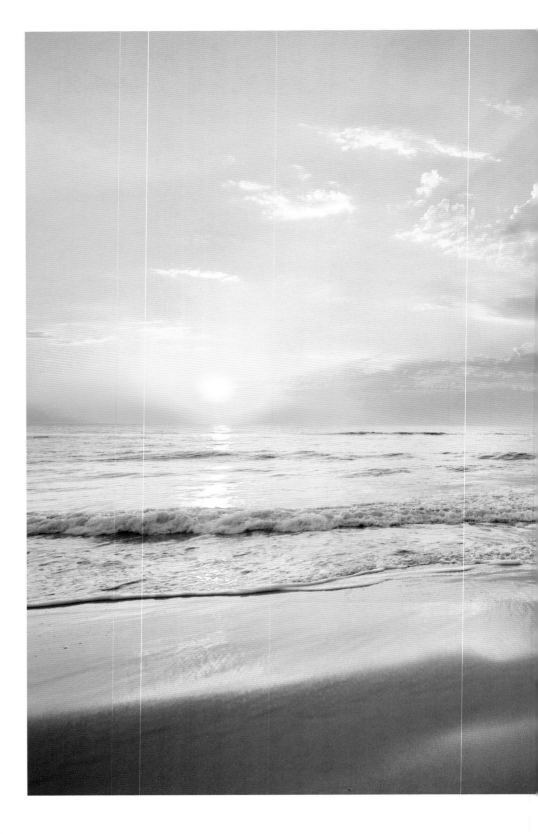

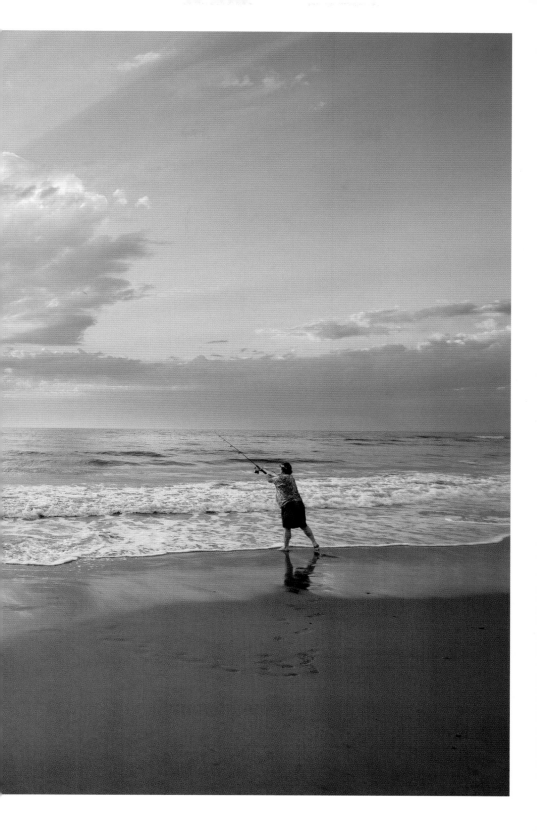

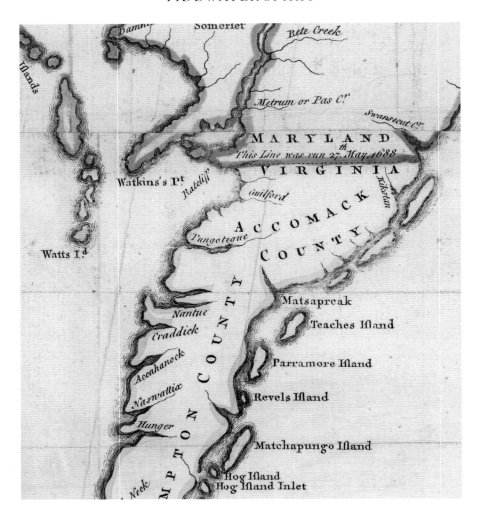

Damn...
Somerset
Bete Creek
Islands
Metrum or Pas C.?
Swansecut C.?
MARYLAND
This Line was run 27th May 1688.
VIRGINIA
Watkins's P.t
Ratcliff
Guilford
Kikotan
ACCOMACK
COUNTY
Watts I.d
Pungoteague
Matsapreak
Teaches Island
Nantue
Craddick
Accahanock
Parramore Island
Naswattix
Revels Island
Hunger
Matchapungo Island
Neck
Hog Island
Hog Island Inlet
MPTON COUNTY

of the river, then zigzags west across Pocomoke Sound and Chesapeake Bay.

Assateague Island, in the accompanying photograph, straddles the Maryland–Virginia border. It is the largest part of the Chincoteague National Wildlife Refuge, originally established in 1943 to provide a habitat for migratory birds.

ABOVE Detail from the Fry-Jefferson map of Virginia.

196

FALSE CAPE STATE PARK

We fixed our beginning about that distance north of the inlet and there ordered a cedar post to be driven deep into the sand.

—*William Byrd II*

THE SOUTHERN BORDER of False Cape State Park is Virginia's southern border, the very line that William Byrd's party surveyed in 1728 (page 23). For a spot so close to population centers, the state line, where it begins on the Atlantic shore, remains very remote.

The state park opened in 1980. It is a narrow barrier spit of land between the ocean and Back Bay. An early explanation of False Cape's name appears in an 1860 report by the superintendent of the U.S. Coast Survey. "During strong easterly gales," says the report, ship masters could easily mistake the sand dunes and trees there for similar terrain at Cape Henry. "Hence it is called 'False Cape' or the 'False Cape of the Chesapeake.'"

Let's return to William Byrd's survey. King Charles II's 1665 charter for the Province of Carolina provided that the province's border with Virginia would be a "straight westerly line" running from "the north end of Currituck River or Inlet" on the Atlantic shoreline. On the designated day, March 5, 1728, Byrd's party met its counterpart, the North Carolina delegation, at the mouth of Currituck Inlet. Two days later, following what Byrd called "a warm debate," the surveyors began the survey line, not on the inlet's north shoreline, which would have complied with the clear terms of the 1665 charter, but at a point two hundred yards farther north. "We were willing for peace's sake to make them that allowance," Byrd wrote, responding to the North Carolina delegation's claim that the Currituck's "ever-shifting" north shoreline had advanced south in recent years.

The cedar post they drove into the sand to mark the spot proved to be a temporary marker. In 1887, subsequent surveyors could find no trace of it. Over time, the inlet has become completely filled in. Much of False Cape State Park still resembles Byrd's description of the swatch of Atlantic coastline he encountered. Just off the shoreline is a maritime forest of oak, cedar, yaupon, Spanish moss, loblolly, and longleaf pines.

FOLLOWING False Cape State Park has 5.9 miles of Atlantic beachfront extending to the North Carolina line.

LAKE DRUMMOND IN THE GREAT DISMAL SWAMP

Hoping to gain immortal reputation by being the first of mankind to venture through the Great Dismal.

—*William Byrd II*

LAKE DRUMMOND is a mere twenty miles from downtown Norfolk and a world apart. The lake fills the horizon, stretching out for 3,100 acres. Bald cypress trees grow on the shoreline and in the lake itself. The lake is the centerpiece of the Great Dismal Swamp National Wildlife Refuge. Did this extraordinary place sidestep the last four hundred years of civilization? Not at all. But the natural qualities of Great Dismal Swamp have proven to be very resilient.

Let's start with William Byrd's time here. On March 13, 1728, seven days into their dividing line survey, Byrd's party reached the eastern edge of the "Great Dismal." Byrd writes that his party members were eager to be "the first of mankind" to go from one end of it to the other—a phrase that suggests they assumed the Indian people had no need for such a journey or too much common sense to attempt one.

The North Carolina border is only two miles south of Lake Drummond, but for some reason, Byrd's writings make no mention of the lake. How did he not know about it? Also, he is uncharacteristically inaccurate when he says: "toward the middle of the Dismal, no beast or bird or even reptile can live." In fact, there can be little doubt that the swamp was teaming with animal life. Just thirty-five years after Byrd's survey, George Washington called it "a glorious paradise." He and other investors formed a company called the Adventurers for Draining the Great Dismal Swamp not just to drain it but to harvest its lumber and farm the new dry land. Totally draining the swamp never materialized. After Washington's time, the logging continued for nearly two centuries, all but depleting the stand of cedar trees that Byrd's surveyors had found. The logging finally ended in 1973, when Union Camp Corporation donated its holding of 49,100 acres, leading to the creation of the Dismal Swamp National Wildlife Refuge.

Yes, civilization has left its mark on Dismal Swamp and crept deep into its edges. The wildlife refuge comprises 112,000 acres—an enormous place—but it is no longer the one million acres of Byrd's time. Bald cypress and white cedar trees make up less than 20 percent of Dismal's forest, where they once dominated. On the other hand, there are over two hundred species of birds in the refuge along with all manner of other species from big black bears to tiny mosquitoes.

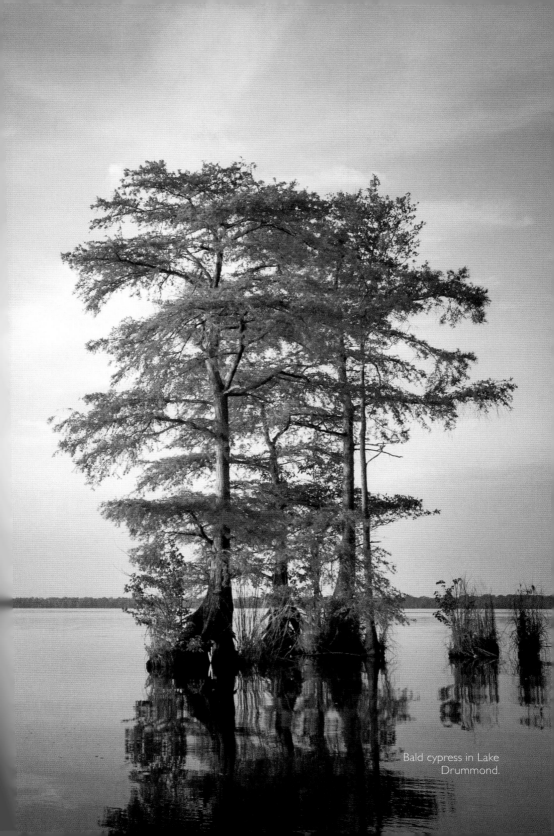

Bald cypress in Lake Drummond.

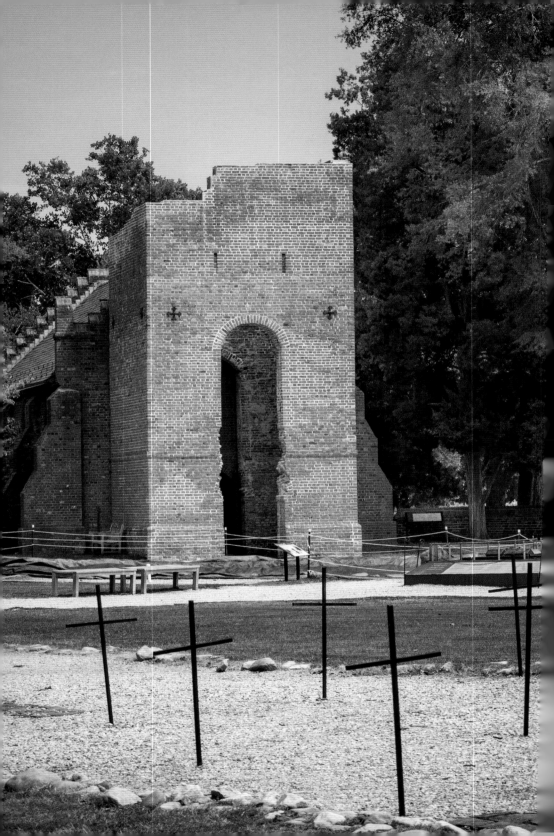

JAMESTOWN ISLAND

The name of this river they call Powhatan according to the name of a principal country that lieth upon it. The mouth of this river is near three miles in breadth.
—Captain John Smith

WHEN THE ENGLISH settlers arrived in 1607, the land they chose for James Fort was a peninsula that jutted into the James River from the north shore. Over time, the narrow isthmus that linked Jamestown to the mainland washed away, forming the modern-day island.

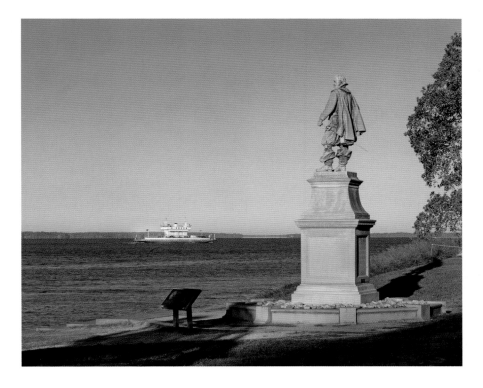

OPPOSITE The church tower is Jamestown's last surviving aboveground structure from the seventeenth century. In the foreground, crosses mark where the ongoing archaeology dig has found bodies buried inside James Fort.

ABOVE The statue of Captain John Smith has stood on Jamestown Island since 1909. In the distance, a ferry crosses the James River. The rural landscape of Surry County is on the far side of the river.

William Couper's statue of Captain John Smith faces southwest, gazing across the river that Captain Smith learned the Indian people called "Powhatan." Smith's 1612 Virginia map identifies the river as "Powhatan flu." The name of every river on the map includes "flu," an abbreviation of *fluvius*, the Latin word for river. A number of the Native names for rivers on Smith's map survive or can at least be recognized when compared with current spellings. "Patawomeck flu" is our Potomac River; "Sasquesahanough flu" is the Susquehanna. The river name "Powhatan" did not survive. According to colonist George Percy's record of their first months in Virginia, "King's River" is the name the English gave the river in May 1607. "We proclaimed James King of England to have the most right unto it." Not so on Captain Smith's map. He identified rivers by their Indian names, just as he identified towns along the shoreline (page 20).

The base of the Smith statue is made of green granite, carved by Couper Marble Works, a Norfolk firm that was started in 1848 by John Couper, the sculptor's father. William Couper kept his ties to the family business but left Norfolk to be a sculptor first in Florence, later in New York. A view of the front of Couper's *John Smith* appears on page 11.

In the sculpture, Smith's left hand rests on the hilt of his sword, and his right holds a book—a pose chosen to represent Smith's dual roles as explorer and writer. The statue was unveiled on May 13, 1909.

"... tideland streams winding through marshes"

THE WRITER William Styron was born in Newport News in 1925. In the opening paragraphs of his 1951 novel *Lie Down in Darkness*, he describes a tidal marsh as seen through the window of a southbound train from Richmond to "Port Warwick," the novel's fictional city that Styron modeled on Newport News:

> ...*you look out once more at the late summer landscape and the low, sorrowful beauty of tideland streams winding through marshes full of small, darting, frightened noises and glistening and dead silent at noon, except for a whistle, far off, and a distant rumble on the rails.*

Did Styron have a specific site in mind when he penned this description? Who can say? In the photograph on page 206, the "tideland streams winding through marshes" are at Messick Point in Poquoson—roughly nine miles east of the railroad tracks entering Newport News. At the very tip of Messick Point, watermen dock their workboats. To the north, wetlands stretch to the horizon.

In 1917, the Department of War acquired those marshlands and promptly began using them as a target range. Calling the site Plum Tree Island Range, its value to the War Department was its proximity to Langley Field, established by the army a few months earlier in 1917 and is now called Langley Air Force Base. As the years went by, practice bombing, aerial machine gun fire, and air-to-

LEFT A first-edition copy of *Lie Down in Darkness.*

FOLLOWING Messick Point, looking north toward Plum Tree Island National Wildlife Refuge.

205

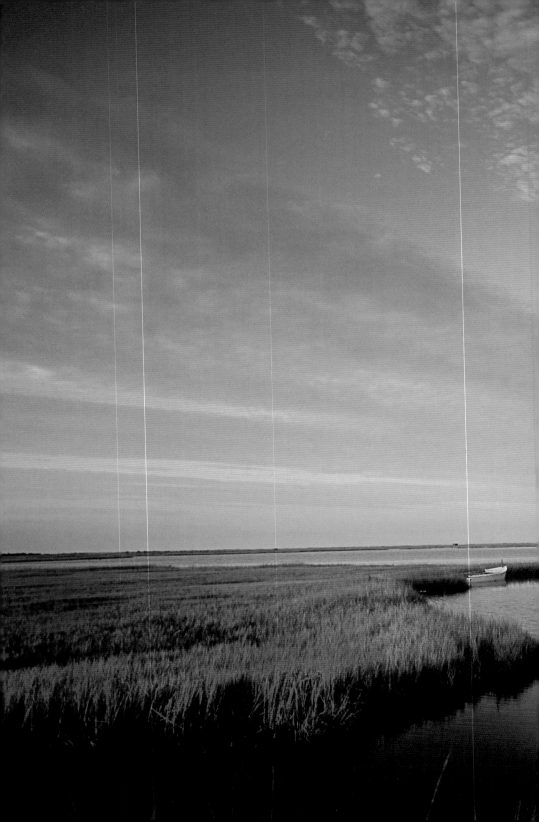

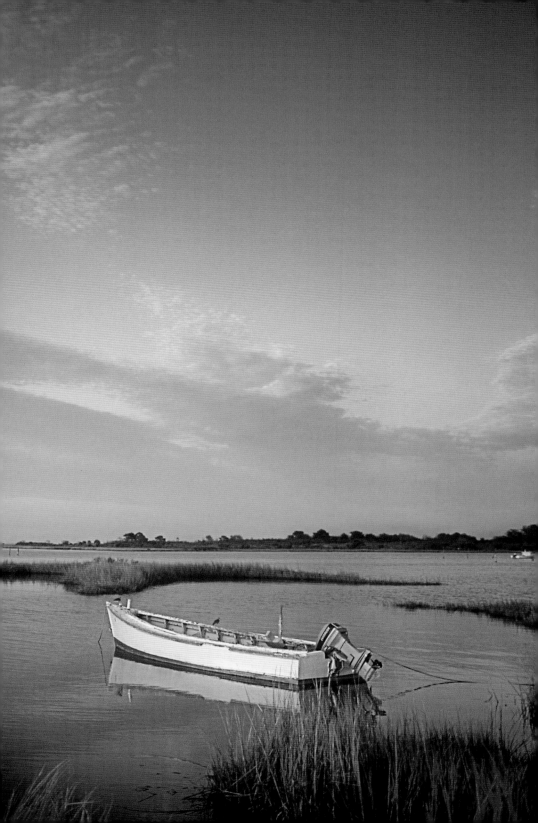

ground rockets all rained down on Plum Tree Island. It remained an active range into the late 1950s and has long been closed to the public because of the danger of unexploded artillery that is likely still on the site.

This strange twentieth-century history has kept Plum Tree beyond the reach of commercial developers, and as a consequence, made it a stopover for migratory birds, a safe breeding habitat for threatened and endangered species. In 1972, the government transferred the site to the U.S. Fish and Wildlife Service, establishing it as the Plum Tree Island National Wildlife Refuge. Plum Tree's marshland continues to be closed to the public—but not to Styron's "small, darting, frightened noises."

OPPOSITE One hundred or more seagulls wait out a steady rain. Their perch is what remains of the Tappahannock steamboat landing.

Steamboat Landing, Tappahannock

THE PILINGS in the photograph below are stubborn reminders that there was once a steamboat wharf here. They start just off the Tappahannock shoreline about fifty feet into the Rappahannock River, and continue another two hundred feet or so to the river's channel.

The rhythm of steamboat arrivals and departures determined when the mail would come and when many in Tidewater could travel to another town. At the turn of the nineteenth century and into the twentieth, the peak of steamboat travel, there were three hundred landings on the Chesapeake Bay and its tributaries. Fifty-two steamers listed Baltimore as their home port. Roughly half that number were homeported in Norfolk, the same for Washington.

Henry Ford and the others who gradually made the automobile a practical transportation alternative changed everything. The '33 storm, with its coastline destruction throughout the Chesapeake region (page 192), further hastened the decline of steamboat travel. Many landings were never rebuilt.

On September 12, 1937, the *Anne Arundel*, bound for Baltimore, sailed away from this Tappahannock landing for the last time. She was the last steamer on the Rappahannock. Steamboats continued making the overnight runs between Norfolk and Baltimore for another twenty-five years. Finally, the Baltimore Steam Packet Company, nicknamed the Old Bay Line, ended passenger service in the fall of 1961 and freight service the following spring.

Westover

TWO MYSTERIES

BYRD II OR BYRD III?

WE WILL END this volume with a thank-you to Captain John Smith, William Byrd II, and Thomas Jefferson for the descriptions of their Virginia that appear on many of these pages. My goal was for these brief quotations to prompt us to see with fresh eyes how history overlays contemporary Virginia.

Byrd's Westover Plantation in Charles City County holds two mysteries. The first is: who built the extraordinary Georgian mansion that stands today on the James River shoreline (an exterior view of the mansion appears on page 175). Was it William Byrd II or his son William Byrd III?

Byrd II inherited the land after the death of William Byrd I in 1704. Surviving correspondence shows that, no later than 1712, Byrd II built a detached building to house his remarkable library, and between 1729 and 1735, he supervised the construction of a house. But no contemporary record describes this house. Five years after Byrd II's death in 1744, the *Virginia Gazette* reported "the house of Wm. Byrd, Esqr at Westover...took fire & was burned to the ground, with the loss of all the furniture, clothes, plate, liquore."

OPPOSITE Rocaille plaster ceiling ornaments grace the entrance hall (shown here) and the drawing room of the Westover mansion.

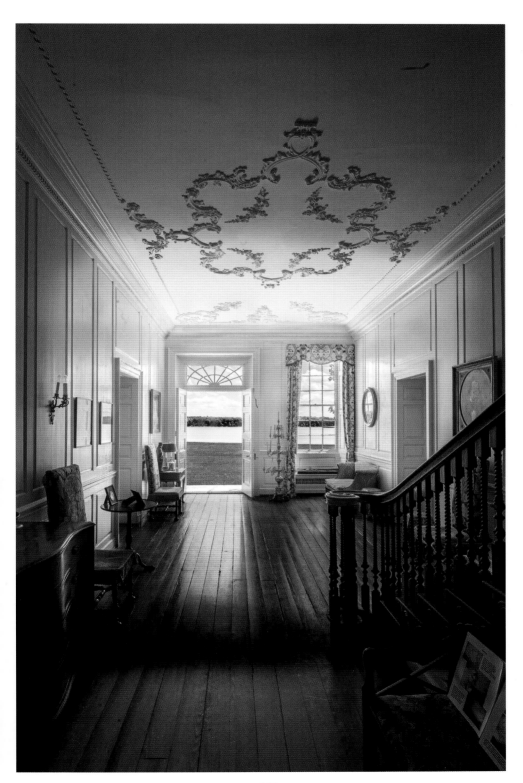

Did Byrd II's house in fact burn "to the ground"? Did the *Gazette* exaggerate the actual damage? Was the current mansion rebuilt from surviving portions of Byrd's 1735 structure? Does the current mansion incorporate design elements of the original? The possibility—now considered the probability—that Byrd III built much or all of the mansion became more widely accepted after dendrochronological testing (i.e., counting the rings of timbers) was conducted in the early twenty-first century. It confirmed that the timbers selected for testing from the house dated back to circa 1750.

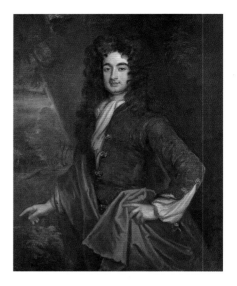

This portrait of William Byrd II, now owned by Colonial Williamsburg, was painted in London between 1700 and 1704 by Sir Godfrey Kneller, the royal court's official painter.

What is so uncomfortable about giving Byrd III sole credit for the design and construction of the mansion is that he was neither the scholar nor the accomplished man that his father was. He gambled away much of the Byrd fortune. On January 1 or 2, 1777, at age forty-eight, he committed suicide.

We turn to Westover's second mystery in the following section.

"Here lieth the Honourable William Byrd Esq . . ."

I have a library to entertain me within doors and gardens to amuse me without.
—*William Byrd II*

THE OTHER Westover Plantation mystery concerns the stone obelisk in the garden that memorializes Byrd II's burial site. We know from numerous diary entries and letters that Byrd took great pride and pleasure in his garden. The opening quote, "gardens to amuse me," comes from a letter Byrd wrote in June 1729.

What we don't know is who wrote the long epitaph that is etched into the stone. No historical record survives to give us that answer. The epitaph stretches across the north and south faces of the monument. Both were needed to make room for a long list of milestones in Byrd's life and for much colorful swagger—like the boast that Byrd was "eminently fitted for

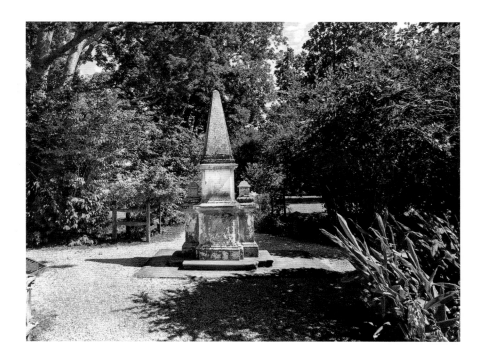

The monument marking William Byrd II's tomb is in the center of the garden at Westover.

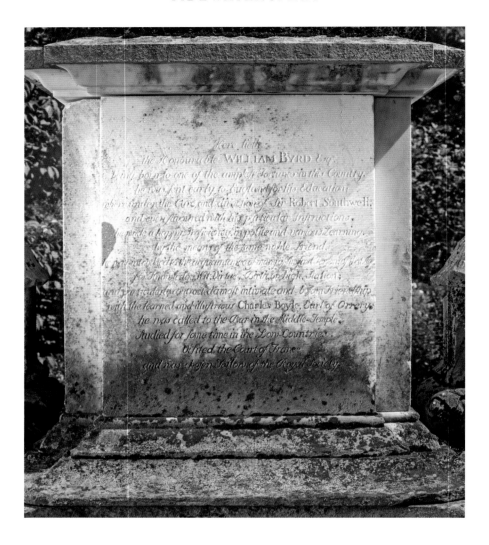

the service and ornament of his Country." All of this has prompted some scholars to speculate that Byrd himself must be the author.

The epitaph's full text appears in the endnotes.

William Byrd II's epitaph begins on the monument's north face shown here. Exposed to the elements, the epitaph has grown faint.

Acknowledgments

I am grateful to a very long list of people who answered yes when I sought their kindness, talent, knowledge and hard work. Without their help, *Tidewater Spirit* would not be the book that it is, and likely would not be a book at all.

I am grateful that Kate Jenkins at The History Press thought there was value in this material and saw it through to publication. Robert Wilson wrote the foreword with a masterful touch.

The following Virginia scholars graciously read many of the pages relevant to their fields of study and offered wise counsel: Stephen C. Ausband (William Byrd II and the dividing line survey), W. Hamilton Bryson (colonial Virginia law), Alan B. Flanders (Norfolk Naval Shipyard and Virginia pilots), Edward Wright Haile (the early Jamestown period), Wythe Holt (colonial and revolutionary period) and Helen C. Rountree (Virginia Indians).

Judith Hatchett, Robert Hitchings (Chesapeake Public Library) and Yvonne Marceau read countless draft pages as this project took shape. Robert Keefe has been generous with his knowledge of book design and publishing.

Both the author and the book have benefitted from the steadfast encouragement of Isabel and Philip Hatchett, Edward Bryan Hatchett, Tom and David Host (T. Parker Host), Nancy Knewstep, Patrick B. McDermott, Herbert H. Bateman Jr. and Pam Luke (special collections section of the Hampton Public Library). Karen Parks was tireless in helping me photograph Christ Church, Lancaster and many other locations.

ACKNOWLEDGMENTS

Whitey Schmidt wrote eleven books filled with recipes and other information about eastern Virginia and Maryland. I shared with Whitey an early version of *Tidewater Spirit*, but sadly, he didn't live long enough to see the book you hold in your hand. Visits to Whitey's were filled with talk about places I had photographed and places where he had eaten crabs, found a recipe or made a friend.

The list of acknowledgments continues, organized by chapters.

CHAPTER 1. *Captain John Smith* and *Thomas Jefferson:* Heather Moore Riser (Albert and Shirley Small Special Collections Library, University of Virginia); *William Byrd II*: Cameron Swain and Brian Ehrenfried (False Cape State Park), Valerie-Anne Lutz (American Philosophical Society Library).

CHAPTER 2. *Powhatan Indians*: Merry Outlaw (Jamestown Rediscovery), Claudia A. Jew, Page Stooks, Jason Copes, Jennifer Anielski (Mariners' Museum).

CHAPTER 3. *Daffodils*: Brent and Becky Heath (Brent and Becky's Bulbs), Elsa Cooke Verbyla and Betty Wrenn Day (*Gloucester-Mathews Gazette-Journal*), W. Robert Kelly Jr. (Gloucester Museum of History); *Azaleas:* Peggy Cornett and Mia Magruder (Thomas Jefferson Foundation), Brian D. O'Neil, Theresa Augustin and Kelly Welsh (Norfolk Botanical Garden).

CHAPTER 4. *Southern Magnolia:* Tammy Radcliff and Malcolm Jamieson (Berkeley Plantation).

CHAPTER 5. *Wythe House*: Penna Rogers and Albert O. Louer (Colonial Williamsburg); *Stratford Hall*: Jim Schepmoes (Stratford Hall); *From Monticello to Williamsburg*: Anna Berkes, Mia Magruder and Madeleine Rhondeau (Thomas Jefferson Foundation), Anna J. Clutterbuck-Cook (Massachusetts Historical Society); *Berkeley Plantation*: Tammy Radcliff and Malcolm Jamieson (Berkeley Plantation); *Elsing Green*: Virginia Lafferty (Lafferty Foundation).

CHAPTER 6. *St. Luke's Church*: Carl Lounsbury (Colonial Williamsburg Foundation); *Christ Church, Lancaster County*: Robert Teagle (Foundation for Historic Christ Church); *Christ Church, Alexandria:* Meredith Bracco (Christ Church Alexandria); *St. Paul's Church "Borough Church"*: Robert Hitchings (Wallace Memorial History Room, Chesapeake Public Library); *Mathews*

ACKNOWLEDGMENTS

Baptist Church: Cathy Rowe (Mathews Baptist Church); *Old Presbyterian Meeting House*: Donald C. Dahmann (church member and historian).

CHAPTER 7. *William B. Selden House*: Dr. Albert Roper; *"Gone for Soldiers Every One"*: Lee Brown (Ware Episcopal Church, member).

CHAPTER 8. *St. John's AME Church*: Reverend John D. Burton (St. John's AME Church); *Hampton University*: Thelma Robins Brown (architectural historian); *Norfolk 17*: Maureen P. Watts (*Virginian-Pilot*); *Attucks Theatre*: Denise Christian (Seven Venues).

CHAPTER 9. *Mount Vernon: The Mount Vernon Ladies' Association of the Union*: Dawn Bonner (Mount Vernon); *Stratford Hall*: Jim Schepmoes (Stratford Hall).

CHAPTER 10. *Elizabeth River*: Captain Kevin Eley (Independent Docking Pilots Inc.); *Elizabeth River, Part 2*: Thomas P. Host III and David F. Host (T. Parker Host, Inc.); *The Navy Comes to Norfolk*: Terri K. Davis (Naval Station Norfolk), Lieutenant Matthew A. Stroup (Navy Office of Information East); *Quarters A*: Alan B. Flanders; *Main Office Building*: Christie Miller (Huntington Ingalls Industries); *Pilots*: Captain J. William Cofer, Captain J.W. Whiting Chisman III (Virginia Pilot Association), Christopher D. Byrne (William & Mary Law School).

CHAPTER 11. *Cape Charles Lighthouse*: Philip Hatchett, John Holt, Chuck Lollar, Pat Piper (photographer's assistants and travel companions to Smith Island).

CHAPTER 12. *Oyster Farming*: Andrew Button (Virginia Marine Resources Commission), Karen L. Hudson and David Malmquist (Virginia Institute of Marine Science), Patrick Oliver (Rappahannock Oyster Co.).

CHAPTER 13. *Corn*: Ben Rowe (Virginia Grain Producers Association), Herman Ellison (U.S. Department of Agriculture), *Wheat*: Alain Outlaw (author of *Governor's Land: Archaeology of Early Seventeenth-Century Virginia Settlements*), Jeff Hula of Renwood Farms, a multigenerational family farm, in Charles City County); *Peanuts*: Tommy Darden (Darden's Country Store, Isle of Wight County); *Cotton*: Elaine Lidholm and Gail Moody Milteer (Virginia Department of Agriculture and Consumer Services); *Shirley Plantation*: Janet L. Appel and Robert Randolph Carter (Shirley Plantation).

CHAPTER 14. *Volgenau Virginia Coast Reserve*: Alexandra Wilke (Volgenau Virginia Coast Reserve), Dave Bright (commercial pilot, Accomack County Airport), Laura Vaughn (Eastern Shore of Virginia Barrier Islands Center); *False Cape State Park*: Brian Ehrenfried and Cameron Swain (False Cape State Park); *Lake Drummond in the Great Dismal Swamp*: Chuck Lollar (boat captain); *The Steamboat Landing in Tappahannock*: David Jett (Essex County Museum & Historical Society).

CHAPTER 15. *Byrd II or Byrd III?*: Andrea Erda graciously opened her home for the photograph of Westover's hallway.

Endnotes

INTRODUCTION

1. "There is but one entrance by sea...": "A Map of Virginia" in John Smith, *The Complete Works*, vol. I (with spelling modernized), 144. A slightly different version appears in Smith, *Generall Historie*, vol. II, 101.
2. "wild honeysuckle in our woods open": Thomas Jefferson, *Thomas Jefferson's Garden Book, 1766–1824*, 1.
3. "oysters as savory...": William Byrd II, *The History of the Dividing Line*, entry for March 6.

CHAPTER 1. PRIMARY SOURCES: THREE EARLY VIRGINIA BOOKS

Captain John Smith

1. New England: In 1616, Smith published *A Description of New England*, the first work to apply the term "New England" to that portion of the North America.

2. "extracted": Smith, *Generall Historie* in Smith, *The Complete Works*, vol. II, 136.
3. Captain John Smith: Martha McCartney, "John Smith (bap. 1580–1631)," Encyclopedia Virginia, www.encyclopediavirginia.org.
4. *The Proceedings of the English Colonie in Virginia*: Haile, *Jamestown Narratives*, 215–17. According to Haile, "What Smith wrote and when is a complicated subject, insofar as he rewrote the same material again and again."

William Byrd II

1. William Byrd II: Thomas L. Long, Martin H. Quitt and the Dictionary of Virginia Biography. Encyclopedia Virginia, "William Byrd (1674–1744)," www.encyclopediavirginia.org.
2. Monument No. 1: "Report of W.D. Pruden, Boundary Line Commissioner." The twenty-eight granite monuments were put in place in 1888.
3. wild horses and the modern coastline: Stephen C. Ausband, *Byrd's Line: A Natural History*. 24–25.

Thomas Jefferson

1. Jefferson: Robert P. Forbes, Encyclopedia Virginia, "*Notes on the State of Virginia* (1785)," www.encyclopediavirginia.org.
2. "Indeed I tremble for my country…": Jefferson, *Notes on the State of Virginia*, 173.

CHAPTER 2. THE POWHATAN INDIANS

1. "The first land they made…": *Generall Historie* in Smith, *The Complete Works*, vol. II (with spelling modernized), 138. A slightly different version appears in *Proceedings* in Smith, vol. I, 205.
2. Powhatan Indians:
 i. Helen C. Rountree and E. Randolph Turner III, *Before and after Jamestown*, 1, 3, 143, 145; 149–56.

ii. Helen C. Rountree, *The Powhatan Indians of Virginia*, 7.
3. *A briefe and true report*:
 i. Michael G. Moran, Encyclopedia Virginia, "John White (d. 1593)," www.encyclopediavirginia.org.
 ii. Natalie Zacek, *"A briefe and true report of the new found land of Virginia (1588),"* Encyclopedia Virginia, www.encyclopediavirginia.org.

CHAPTER 3. SPRING AND SUMMER

Daffodils

1. Gloucester Courthouse: Gloucester Downtown Historic District, National Register of Historic Places #10001063.
2. John Clayton: Marianne E. Julienne and the Dictionary of Virginia Biography. Encyclopedia Virginia, "John Clayton (1695–1773)," www.encyclopediavirginia.org.
3. daffodils: Gloucester Daffodil Festival, "Wild About Daffodils—Gloucester County Virginia," www.daffodilfestivalva.org.

Dogwood Trees

1. "Several of our men had intermitting fevers…": William Byrd II, *The History of the Dividing Line*, entry for September 22.
2. St. John's Episcopal Church: James Tormey, *How Firm a Foundation*, v, 7–8, 49–50.

Azaleas

1. "Wild honeysuckle in our woods open": Jefferson, *Thomas Jefferson's Garden Book, 1766–1824*, 1.
2. "Upright honeysuckle, Azalea nudiflora": Jefferson, *Notes on the State of Virginia*, 38.
3. *Rhododendron periclymenoides*: correspondence with Peggy Cornett, curator of plants at Monticello.

4. Norfolk Botanical Garden, "History—Norfolk Botanical Garden," www. norfolkbotanicalgarden.org.

...it's the humidity

1. "The summer is hot as in Spain...": *A Map of Virginia* in Smith, *The Complete Works*, vol. I (with spelling modernized), 143. An identical version appears in *Generall Historie* in Smith, vol. II, 101.
2. "the mercury in Farenheit's thermometer was at 98°": Jefferson, *Notes on the State of Virginia*, 86.
3. "the mercury in Farenheit's thermometer was at 90° at Monticello..." and "the difference between Williamsburgh...": Jefferson, *Notes on the State of Virginia*, 83.

CHAPTER 4. AUTUMN AND WINTER

Gloucester County

1. "From September until..." and the other Smith quotes in this section: *A Map of Virginia* in Smith, *The Complete Works*, vol. I, 156–57 (with spelling modernized). An identical version appears in *Generall Historie* in Smith, vol. II, 112.

Hurricanes and Hard Rains

1. "we sometimes saw the land by the flashes of fire...": *Generall Historie* in Smith, *The Complete Works*, vol. II (with spelling modernized), 178. A slightly different version appears in *Proceedings* in Smith, vol. I, 233.
2. "discovered, and cried LAND!": William Strachey, *A True Reportory*, included in Haile's *Jamestown Narratives*, 390.
3. *Sea Venture*: Lorri Glover, "*Sea Venture*," Encyclopedia Virginia, www. encyclopediavirginia.org.

Southern Magnolia

1. "I must refer to the…": Jefferson, *Notes on the State of Virginia*, 40.
2. "our birds": Jefferson, *Notes on the State of Virginia*, 71.

Snow

1. "The elderly inform me…" and "Both heats and colds are become much more moderate…": Jefferson, *Notes on the State of Virginia*, 88.
2. "Farenheit's thermometer" and "York river, at York town, was frozen over…": Jefferson, *Notes on the State of Virginia*, 86. ("Farenheit," "York town," and "Patowmac" appear as Jefferson spelled them in *Notes on the State of Virginia*.)

Christmas

1. "The next night being lodged at Kecoughtan…": *Generall Historie* in Smith, *The Complete Works*, vol. II (with spelling modernized), 194. A slightly different version appears in *Proceedings* in Smith, vol. I, 245.
2. Jefferson's "fiddle": Dumas Malone, *Jefferson the Virginian*, 79.

CHAPTER 5. HOMES OF THE VIRGINIA SIGNERS OF THE DECLARATION OF INDEPENDENCE

The Virginia Gazette, *July 26, 1776*

1. *Virginia Gazette*: Wilford Kale, "*Virginia Gazette* printed parts of Declaration of Independence on July 19, 1776," *Daily Press* (Newport News, VA), May 23, 2018.
2. Monticello: Hugh Howard and Roger Straus, *Thomas Jefferson, Architect*. 28–29, 49.

Wythe House, Williamsburg

1. George Wythe: Alonzo Thomas Dill, *George Wythe, Teacher of Liberty*.

Stratford Hall, Westmoreland County

1. Stratford Hall: The Stratford Hall website, www.stratfordhall.org, is the source for much of the information in the text.
2. "tall, spare…masterly man": David McCullough, *John Adams*, 85.
3. "absolved of all allegiance to the British Crown": McCullough, *John Adams*, 118.
4. Robert E. Lee's family connection to the two Lee signers: Douglas Southall Freeman, *R.E. Lee: A Biography*, vol. I, 12, 164–65.

From Monticello to Williamsburg

1. "On the fringe of western settlement": Malone, *Jefferson The Virginian*, 3–4.
2. Account Book entries: Jefferson, *Jefferson's Memorandum Books*, vol. 1, 265–66, 285–86. The editors' annotations in this work decipher Jefferson's entries and add context.
3. "on a shelf behind some books": Sarah Nicholas Randolph, *The Domestic Life of Thomas Jefferson*, 45 (quoting her grandmother Martha Jefferson Randolph).
4. "startled the silence of the night with song and merry laughter": Sarah Nicholas Randolph, *Domestic Life*, 45.

Berkeley Plantation, Charles City County

1. "die in a few minutes and be with the angels": Benjamin Rush, *Letters of Benjamin Rush*, vol. II, 1,089–90.
2. "Jealousies and divisions": John Adams, *The Works of John Adams*, vol. III, 31–32.
3. Benjamin Harrison: Howard W. Smith, *Benjamin Harrison and the American Revolution*.

Nelson House, Yorktown

1. Thomas Nelson Jr.: Emory G. Evans, *Thomas Nelson of Yorktown: Revolutionary Virginian*.
2. "Nelson is a fat man": Adams, *Diary and Autobiography of John Adams*, vol. 2, 172.

3. "Never spare a particle": George Washington Custis, *Recollections and Private Memoirs of Washington*, 337 (Custis is quoting a remark by Lafayette made during his visit to America).
4. Yorktown and Nelson House: Jerome A. Greene, *The Guns of Independence the Siege of Yorktown, 1781*, 214–15.

Elsing Green, King William County

1. Carter Braxton: Alonzo Thomas Dill, *Carter Braxton, Virginia Signer*.
2. "contemptible little tract": J. Kent McGaughy, *Richard Henry Lee of Virginia: A Portrait of an American Revolutionary*, 124.
3. Lafferty Foundation, "About Elsing Green," www.elsinggreen.com.

CHAPTER 6. CHURCHES

Bruton Parish Church, Williamsburg

1. "The present state of…": Jefferson, *Notes on the State of Virginia*, 167–68.
2. the number of seventeenth- and eighteenth-century churches: Don W. Massey and Sue Massey, *Colonial Churches of Virginia*.
3. Bruton Parish, "A Brief History of Bruton Parish Church," www. brutonparish.org.
4. established church in Virginia:
 i. Carl H. Esbeck, "Protestant Dissent and the Virginia Disestablishment, 1776–1786," 51, 65–89.
 ii. John Ragosta, "Virginia Statute for Establishing Religious Freedom (1786)," Encyclopedia Virginia, www.encyclopediavirginia.org.

St. Luke's Church, Isle of Wight County and St. Peter's Church, New Kent County

1. James Scott Rawlings, *Virginia's Colonial Churches*, 7, 31, 33, 34, 42, 49.
2. Dell Upton, *Holy Things and Profane: Anglican Parish Churches in Colonial Virginia*, 58–65 (Upton calls St. Luke's "Virginia's oldest surviving church" dating it to "the fourth quarter of the seventeenth century").

3. Oxford Dendrochronology Laboratory, "The Tree-Ring Dating of Timbers from Newport Parish Church (St. Luke's or Old Brick Church), Smithfield, Isle of Wight County, Virginia." (This report was provided to the author by Carl Lounsbury, senior architectural historian at Colonial Williamsburg Foundation).

Christ Church, Lancaster County

1. Robert "King" Carter: Edmond Berkeley Jr., and the Dictionary of Virginia Biography, "Robert Carter (ca. 1664–1732)," Encyclopedia Virginia, www.encyclopediavirginia.org.
2. Christ Church:
 i. Rawlings, *Virginia's Colonial Churches*, 120–22, 127.
 ii. Christ Church, "Historic Christ Church," www.christchurch1735.org.

Christ Church, Robert "King" Carter's Tomb

1. epitaph translation: William Meade, *Old Churches, Ministers and Families of Virginia*, vol. II, 122–23.

Christ Church, Alexandria

1. Christ Church, Alexandria, "History," www.historicchristchurch.org.

St. Paul's Church "Borough Church," Norfolk

1. January 1, 1776: Amy Waters Yarsinske, *The Elizabeth River*, 136–39 (the destruction of Norfolk resulted from fires started by the British Navy and by Virginia forces).
2. cannonball:
 i. William Meade, *Old Churches, Ministers and Families of Virginia*, vol. I, 277. Bishop Meade wrote in 1857: "There is still to be seen a considerable indentation in the corner of one of them made by a ball from the frigate Liverpool and the ball itself may also be seen in the vestry-room…").

ii."Damn near missed it": George Holbert Tucker, *Norfolk Highlights*, 36–37.

Mathews Baptist Church, Mathews County

1. Mathews Baptist Church, *The History of Mathews Baptist Church 1776–2011*. *The History* identifies David Tinsley as the first church pastor beginning in 1776.

Old Presbyterian Meeting House, Alexandria

1. Lucy Grymes Nelson: Evans, *Thomas Nelson of Yorktown*, 52 (Ms. Nelson also attended her first Catholic service while in Philadelphia).
2. The Old Presbyterian Meeting House: Old Presbyterian Meeting House, www.opmh.org.

Swain Memorial Church, Tangier Island

1. Eastern Shore Methodists: Kirk Mariner, *Revival's Children: A Religious History of Virginia's Eastern Shore*, 20, 24, 49, 51, 65, 600, 600–1.
2. "I told them…": Adam Wallace, *The Parson of the Islands: A Biography of the Rev. Joshua Thomas*, 146.

CHAPTER 7. REMEMBERING THE WAR

Fort Monroe, Hampton

1. Fort Monroe: John V. Quarstein and Dennis P. Mroczkowski, *Fort Monroe: The Key to the South*.
2. Algernourne Oak: Nancy Ross Hugo and Jeff Kirwan, *Remarkable Trees of Virginia*, 22.

ENDNOTES

Franklin and Armfield Office, Old Town Alexandria

1. Franklin and Armfield: Steven Deyle, *Carry Me Back: The Domestic Slave Trade in American Life*, 4–5, 100–4.
2. Northern Virginia Urban League, "Freedom House Museum," www. nvulypn.wildapricot.org.

William B. Selden House, Norfolk

1. Dr. William B. Selden:
 i. West Freemason Street Area Historic District, National Register of Historic Places #72001512.
 ii. *Encyclopedia of Virginia Biography*, vol. IV, 408–9 (republished 1998), s.v. "Dr. William Selden."
2. Lee in Norfolk 1870: Freeman, R.E. Lee: A Biography, vol. IV, 457–67, 492.

"...Gone for Soldiers Every One," Gloucester and Hopewell

1. "…Gone for Soldiers Every One": From the third verse of "Where Have All the Flowers Gone," written by Pete Seeger ©1961 and 1977, Fall River Music, Inc.
2. Ware Episcopal Church: Ware Church, "Gravestones in the Cemetery," www.warechurch.org.
3. Numerous National Park Service websites have detailed information on Virginia Civil War era cemeteries including: National Park Service, "City Point National Cemetery Hopewell, Virginia," www.nps.gov.

The End of the War, Port Royal

1. "We are the assassinators of the President," statement of Willie S. Jett, May 6, 1865, Lincoln Assassination Suspects File, Microcopy M-599, National Archives.
2. Sara Jane Peyton: The Statement of Willie S. Jett, described above, also contains the following: "I went to Miss Sara Jane Peyton or Miss Lucy Peyton—I think Miss Sarah Jane—and told her that we had a wounded Marylander."

228

CHAPTER 8. AFTER THE WAR

St. John's AME Church, Norfolk

1. "under the supervision": St. John's African Methodist Episcopal Church, Norfolk, Virginia, National Register of Historic Places #86003441.

Hampton University, Hampton

1. "surroundings of a man": Edith Armstrong Talbot, *Samuel Chapman Armstrong; a Biographical Study*, 195.
2. "swarming bands…": Francis Greenwood Peabody, *Education for Life*, 92.
3. "The thing to be done…" and "to replace stupid drudgery…": S.C. Armstrong, "From the Beginning," in Armstrong League of Hampton Workers, *Memories of Old Hampton*, 11.
4. Armstrong, Hampton and Virginia Hall:
 i. Thelma Robins Brown, "Memorial Chapel: The Culmination of the Development of the Campus of Hampton Institute, Hampton, Virginia, 1867–1887," 9, 151.
 ii. Robert Francis Engs and the *Dictionary of Virginia Biography*, "Samuel Chapman Armstrong (1839–1893)," Encyclopedia Virginia, www. encyclopediavirginia.org.
5. General Benjamin F. Butler: Alice Matthews Erickson, *A Chronicle of Civil War Hampton, Virginia*, 62, 79–82, 125–131.

Julius Rosenwald High School, Reedville

1. Phyllis McClure, "Rosenwald Schools in the Northern Neck," *Virginia Magazine of History and Biography*, 114, 116–17, 119, 120–21.
2. Julius Rosenwald School Foundation of Northumberland County, www. facebook.com.

Attucks Theatre, Norfolk

1. Church Street movie theaters: Carver Theater, Gem Theatre, Lenox Theatre, and Regal were the other theaters in 1950. www. cinematreasures.org.

2. Attucks Theatre, "The Attucks Theatre," www.nrha.us.
3. Boston Massacre: McCullough, *John Adams*, 65–68.

The Norfolk 17

1. "Norfolk 17":
 i. "School Desegregation in Norfolk, Virginia," www.dc.lib.odu.edu.
 ii. Denise M. Watson, "The Norfolk 17 Face a Hostile Reception as Schools Reopen," *Virginian-Pilot*, October 3, 2008.
 iii. Denise M. Watson and Miranda Mulligan, "The Norfolk 17: What Happened to Them?" *Virginian-Pilot*, October 3, 2008.
2. Lenoir Chambers: Paul R. Clancy, *Hampton Roads Chronicles*, 144–46.

CHAPTER 9. SAVING HISTORY

The Mount Vernon Ladies' Association of the Union

1. The Mount Vernon website, www.mountvernon.org, is the source for most of the information in the text.

Preservation Virginia

1. APVA: James Michael Lindgren, *Preserving the Old Dominion: Historic Preservation and Virginia Traditionalism*.
2. "We must drop the curtain…": Lindgren, *Preserving the Old Dominion*, 46.
3. "Do you think that had the North…": Lindgren, *Preserving the Old Dominion*, 53.
4. remains of the fourteen-year-old girl: Historic Jamestowne, "Jane," www.historicjamestowne.org.
5. "starving time": The phrase "starving time" is from "A True Relation," written by George Percy, governor in the Jamestown settlement from September 1609 to May 1610. It is included in Haile, *Jamestown Narratives*, 497–519.

ENDNOTES

Stratford Hall, Robert E. Lee Memorial Association

1. Stratford Hall: The Stratford Hall website, www.stratfordhall.org, is the source for most of the information in the text.

Colonial Williamsburg

1. "It was God who gave me": Montgomery, *Link Among the Days*, ix.
2. Wren Building: Schlesinger, "Summary Architectural Report."
3. Bodleian plate: Andrews and Davenport, *Guide*, 421.
4. Goodwin and Rockefeller: Montgomery, *Link Among the Days*, vii, xv–xvi, 18–19, 41, 107–13, 136, 168, 194, 201, 232–33.

The Colonial National Historical Park, Yorktown

1. Moore House: Jerome A. Greene, *Guns of Independence*, 282–89.
2. "That two officers may be appointed": Greene, *Guns of Independence*, 283.
3. Colonial National Historical Park: Montgomery, *Link Among the Days*, 231, 250.
4. 150th anniversary: Parke Rouse Jr., "Sousa's March to Yorktown," *Daily Press* (Newport News, VA), October 13, 1996.

CHAPTER 10. HAMPTON ROADS

Lower Chesapeake Bay

1. "We came to anchor…": Jefferson, *The Papers of Thomas Jefferson*, vol. 15, 552–53 (letter from Jefferson to William Short, November 21, 1789).
2. Jefferson's arrival in Norfolk: Dumas Malone, *Jefferson and the Rights of Man*, 243.
3. "affords harbour for vessels…": Jefferson, *Notes on the State of Virginia*, 3.
4. 1807 map: William Wooldridge, *Mapping Virginia: From the Age of Exploration to the Civil War*, 199–205.
5. *Encyclopedia of Virginia Biography*, vol. I, 22–23 (republished 1998), s.v. "Wriothesley, Henry."

ENDNOTES

Elizabeth River

1. "Chesapeack": This is the spelling of the village of Chesapeack as it appears on Smith's map. On the copy of the Smith map, published by Willem Blaeu and appearing on page 20, the village is spelled "Chesapeeck."
2. "we sailed up a narrow river…," "six or seven miles," "we saw two or three little garden plots…," and "great river": *Generall Historie* in Smith, *The Complete Works*, vol. II (with spelling modernized), 178.
3. unnamed river:
 i. Many scholars read Smith's map and his account in *The Generall Historie* to indicate he and his men traveled up the Elizabeth: Helen Rountree, Wayne Clark and Kent Mountford, *John Smith's Chesapeake Voyages, 1607–1609*, 133; Tucker, *Norfolk Highlights*, 3; Yarsinske, *The Elizabeth River*, 29–30.
 ii. Historian Edward Wright Haile believes it is the Lafayette. Chesapeake Conservancy, www.chesapeakeconservancy.org.

Elizabeth River, Part 2

1. "Norfolk has most the air…": Byrd, *The History of the Dividing Line*, entry for March 1.
2. American Philosophical Society manuscript: Maude H. Woodfin, "Thomas Jefferson and William Byrd's Manuscript Histories of the Dividing Line," *William & Mary Quarterly* (1944), 363–73.
3. River named for Princess Elizabeth: Yarsinske, *The Elizabeth River*, 70.

The Navy Comes to Norfolk

1. "We found a river:" George Percy, *Observations*, included in Haile's *Jamestown Narratives*, 90.
2. Elizabeth River in 1607: A timeline prepared by Philip L. Barbour, the editor of John Smith's *The Complete Works*, says that Percy's river is likely the "modern Elizabeth River." Smith, *The Complete Works*, vol. I, 16–22.
3. Henry Seawell: Tucker, *Norfolk Highlights*, 6.
4. Exposition houses: Clancy, *Hampton Roads Chronicles*, 94–96.

USS Wisconsin

1. "The waters, isles…": *A Map of Virginia* in Smith, *The Complete Works*, vol. I (with spelling modernized), 159. An identical version appears in *Generall Historie* in Smith, vol. II, 113.
2. USS *Wisconsin*, "USS *Wisconsin* BB-64," www.usswisconsin.org.

Quarters A and the Main Office Building

1. Quarters A: Quarters A, B and C, Norfolk Naval Shipyard, National Register of Historic Places no. 74002242.
2. Newport News: William L. Tazewell, *Newport News Shipbuilding, The First Century*, 46, 49.

Norfolk Naval Shipyard

1. Gosport: Alan B. Flanders, *Bluejackets on the Elizabeth: A Maritime History of Portsmouth and Norfolk, Virginia from the Colonial Period to the Present.*

SS United States

1. SS *United States*, "SS United States Conservancy," www.ssusc.org.

Pilots

1. Virginia pilot laws:
 i. W.W. Hening, *Virginia Statutes at Large*:
 • 1661 law: vol. II, 35. Captain Oewin is identified in the statute by name as "capt. William Oewin"; his post is spelled "cheife pilott of James river."
 • 1762 law: vol. VII, Chapter 23, 580.
 ii. *Acts Passed at a General Assembly of the Commonwealth of Virginia*, begun and held on December 7, 1801, chapter 3, 5–8.

iii. *Acts of the General Assembly of Virginia*:
 • Passed in 1855–56, chapter 47, 38–41.
 • Passed in 1865–66, chapter 47, 161–64.
iv. current statute: VA Code § 54.1–901.
2. Trinity House, "branch," and nineteenth century laws:
 i. Alan B. Flanders and Arthur C. Johnson, *Guardians of the Capes*, 4, 14.
 ii. Marion Vernon Brewington, "The Chesapeake Bay Pilots," 112–13.
3. Virginia Pilot Association: Alexander Crosby Brown, ed., *Newport News' 325 Years*, 306–7.

CHAPTER 11. LIGHTHOUSES

Cape Henry

1. "The cape on the southside…": *A Map of Virginia* in Smith, *The Complete Works*, vol. I (with spelling modernized), 144. A slightly different version appears in *Generall Historie* in Smith, vol. II, 101.
2. the Downs: Haile, *Jamestown Narratives*, 223, note 1.
3. Cape Henry Lighthouses:
 i. "New Cape Henry Lighthouse," www.lighthousefriends.com.
 ii. "Old Cape Henry Lighthouse," www.lighthousefriends.com.

Cape Charles

1. "leaving the *Phoenix* at Cape Henry…," "barge," and "gentlemen": *Generall Historie* in Smith, *The Complete Works*, vol. II (with spelling modernized), 163. A slightly different version appears in *Proceedings* in Smith, vol. I, 224. *Proceedings* credits Walter Russell, Anas Todkill, and Thomas Momford—all crew members on Smith's first voyage up the Chesapeake Bay—as the writers of the portion of *Proceedings*, which describes this exploration.
2. Smith's Isles: Rountree, Clark and Mountford, *John Smith's Chesapeake Voyages, 1607–1609*, 79–81.
3. Cape Charles Lighthouse: Linda Turbyville, *Bay Beacons*, 126–29.

ENDNOTES

Assateague

1. "Assateague Lighthouse," www.lighthousefriends.com.

Old Point Comfort

1. Old Point Lighthouse: Turbyville, *Bay Beacons*, 110.
2. United States Lighthouse Establishment: United States Coast Guard Historian's Office, "TIMELINE 1700's–1800's," www.history.uscg.mil.

CHAPTER 12. WATERMEN

Tonging for Oysters, James River

1. Oysters as savory…": Byrd, *The History of the Dividing Line*, entry for March 6.

Oyster Farming, Middlesex County

1. "Pd. (by B.F.R.)…": Account Book entry for March 29, 1826, Jefferson, *Jefferson's Memorandum Books*, vol. 2, 1416.

Buyboats, Gloucester County

1. buyboats: Larry S. Chowning, *Chesapeake Bay Buyboats*, 3.
2. *East Hampton* builders: Chowning, *Deadrise and Cross-planked*, 106.

Pound Nets, Potomac River

1. "The fourth river…": *A Map of Virginia* in Smith, *The Complete Works*, vol. I (with spelling modernized), 147–48. An identical version appears in *Generall Historie* in Smith, vol. II, 104.
2. George Snediker: Chowning, *Chesapeake Bay Buyboats*, 110–13.

CHAPTER 13. FARMERS

Shirley Plantation, Charles City County

1. Shirley history: Elinor Warren and Jean Fripp, *Shirley Plantation: Home to a Family and a Business for 11 Generations*.
2. Washington portrait: Colonial Williamsburg, "Easy, Erect, and Noble," www.history.org. Rockefeller purchased the painting in 1928.

Corn, Charles City County

1. "I cultivate in my own garden…": Jefferson, *The Papers of Thomas Jefferson*, vol. 12, 134–36 (letter from Jefferson to Nicholas Lewis, September 17, 1787).
2. corn-on-the-cob: Peter J. Hatch, *"A Rich Spot of Earth": Thomas Jefferson's Revolutionary Garden at Monticello*, 129.
3. Byrd Library: Kevin J. Hayes, *The Library of William Byrd of Westover*, ix, 73.
4. "It rained…": Diary entry for June 18, 1711. William Byrd II, *The Secret Diary of William Byrd of Westover, 1709–1712*, 362.
5. Andrea and Rob Erda: Westover Plantation, "Welcome to Westover Plantation," www.westover-plantation.com.

Wheat, Governor's Land, James City County

1. "Our farms produce…": Jefferson, *Notes on the State of Virginia*, 40.
2. "taking its place" and "culture": Jefferson, *Notes on the State of Virginia*, 178.
3. The Great Charter: Brendan Wolfe, "Virginia Company of London," Encyclopedia Virginia, www.encyclopediavirginia.org.
4. "half part…": *Encyclopedia Virginia*, "Instructions to George Yeardley," *www.encyclopediavirginia.org*.
5. archaeology excavations: Alain C. Outlaw, "Governor's Land: A Stewardship Legacy," *Historic Virginia Land Conservancy Newsletter* (2010).
6. "burgesses" and "general Assemblie": Jamestown Settlement, "The 'Great Charter' and The First General Assembly," www.historyisfun.org.

Barley, Westmoreland County

1. "Those who labour…": Jefferson, *Notes on the State of Virginia*, 175.
2. "the present state of…," "We never had…," and "we have an immensity…": Jefferson, *Notes on the State of Virginia*, 174.
3. Washington's distillery: Dennis J. Pogue, *Founding Spirits: George Washington and the Beginnings of the American Whiskey Industry*, 200.

Peanuts, Isle of Wight County

1. "65 hills…": Jefferson, *Thomas Jefferson's Garden Book, 1766–1824*, 211.
2. "many unusual…": Hatch, *"A Rich Spot of Earth": Thomas Jefferson's Revolutionary Garden at Monticello*, 23.
3. "the man who 'discovered' peanuts": Edward Mott Woolley, "Tom Rowland—Peanuts," 184.
4. peanut pioneers: Andrew F. Smith, *Peanuts: the Illustrious History of the Goober Pea*, 22–25, 49–52.

Cotton, Southampton County

1. Cotton in Southampton County: Daniel W. Crofts, *Old Southampton: Politics and Society in a Virginia County, 1834–1869*.
2. nineteenth-century world economy: Sven Beckert, *Empire of Cotton: A Global History*, xvi.
3. Boll weevil.
4. Virginia Department Of Agriculture And Consumer Services press release, December 16, 2016.
5. National Cotton Council, "History of the Eradication Program." www.cotton.org.

CHAPTER 14. OPEN SPACES

Introduction

1. "the novelty of…": Byrd, *The History of the Dividing Line*, entry for March 13.

Volgenau Virginia Coast Reserve

1. "the thin first line of defense…": Brooks M. Barnes and Barry R. Truitt, eds., *Seashore Chronicles: Three Centuries of the Virginia Barrier Islands*, x.
2. Nature Conservancy purchase of the barrier islands: Curtis J. Badger, *The Wild Coast: Exploring The Natural Attractions of the Mid-Atlantic*, 102.

Assateague Island

1. "Virginia is bounded…": Jefferson, *Notes on the State of Virginia*, 1.
2. "the first accurate…": Jefferson, *The Autobiography of Thomas Jefferson, 1743–1790*, 4.
3. 1877 arbitration: The arbitration became known as the Black-Jenkins Award. See VA Code § 1-308 (Boundary with Maryland).

False Cape State Park

1. "We fixed our beginning…," "a warm debate," " We were willing for peace' sake…," and "ever shifting": Byrd, *The History of the Dividing Line*, entry for March 6.
2. "straight westerly line" and "the north end of Currituck River or Inlet": Byrd, *The History of the Dividing Line*, appendix.
3. "During strong easterly gales," and "Hence it is called 'False Cape'…": *Report of the Superintendent of the Coast Survey: Showing the Progress of the Survey during the Year 1859*, 59.

Lake Drummond in the Great Dismal Swamp

1. "hoping to gain immortal reputation…": Byrd, *The History of the Dividing Line*, entry for March 13.
2. "toward the middle of the Dismal…": Byrd, *Secret History*, entry for March 23.
3. "a glorious paradise": Washington quoted in Ausband, *Byrd's Line*, 48.
4. Lake Drummond and the Wildlife Refuge: U.S. Fish and Wildlife Service, "Great Dismal Swamp," www.fws.gov.

Jamestown Island

1. "The name of this river…": *A Map of Virginia* in Smith, *The Complete Works*, vol. I (with spelling modernized), 145.
2. "King's River": Percy, "Observations gathered out of a Discourse of the Plantation of the Southern Colony in Virginia by the English, 1606," included in Haile, *Jamestown Narratives*, 97.
3. Jamestown church: Historic Jamestowne, www.historicjamestowne.org.
4. William Couper: Greta Elena Couper, *An American Sculptor on the Grand Tour*.

"…tideland streams winding through marshes"

1. "you look out once more…": Styron, *Lie Down in Darkness*, 10.
2. Plum Tree Island National Wildlife Refuge: U.S. Fish and Wildlife Service, "Plum Tree Island," www.fws.gov.

Steamboat Landing, Tappahannock

1. Tappahannock landing: David Jett, Curator of the Essex County Museum & Historical Society, used photographs in the museum's collection to confirm that the existing pilings were once part of the steamboat landing.
2. Tappahannock and steamboats: David C. Holly, *Chesapeake Steamboats: Vanished Fleet*.

CHAPTER 15. WESTOVER—TWO MYSTERIES

Byrd II or Byrd III?

1. The existing mansion
 i. Mark R. Wenger, "Westover," 9.
 ii. Carson and Lounsbury, eds., *Chesapeake House*, 35, 408.
 iii. Camille Wells, "Dendro-Dating." Wells says without reservation that the house completed in 1735 by Byrd II is the house that burned.
2. "Burned to the ground": The fire on January 7, 1749, was reported in the *Virginia Gazette* on January 12, as reprinted in "Personal Items," *William & Mary Quarterly*, 20, no. 1 (1911): 17.

"Here lieth the Honourable William Byrd Esq."

1. "I have a library…": Letter to [Jacob?] Senserff, circa June 25, 1729, in Marion Tinling, ed., *The Correspondence of the Three William Byrds of Westover, Virginia: 1684–1776*, vol. I, 410.
2. epitaph authorship: Kevin Berland, editor of *The Dividing Line Histories of William Byrd II of Westover*, 4. Berland adds his own speculation: "I conclude Byrd composed the epitaph; he was certainly capable of 'warm admiration' for himself." Berland's phrase "warm admiration" is a playful reference back to earlier speculation by John Spencer Bassett, editor of *The Writings of "Colonel William Byrd of Westover in Virginia, Esqr.* that "some warm admirer" wrote the epitaph.
3. epitaph: copied from the Westover Plantation website, "About Westover Plantation," www.westover-plantation.com.

 [Epitaph begins on the north side of the monument.]
 Here lieth the Honourable William Byrd Esq being born to one of the amplest fortunes in this country he was sent early to England for his Education where under the care and instruction of Sir Robert Southwell and ever favored with his particular instructions he made a happy proficiency in polite and various learning; by the means of the same noble friend he was introduced to the acquaintance of many of the first persons of that age for knowledge, wit, virtue, birth, or high station, and particularly attracted a most close and bosom friendship with the learned and illustrious Charles

Boyle Earl of Orrey. He was called to the bar in the Middle Temple, studied for some time in the low countries, visited the court of France and was chosen Fellow of the Royal Society.

[It continues on the south side of the monument.]

Thus eminently fitted for the service and ornament of his Country, he was made Receiver general of his Majesty's revenues here, was thrice appointed publick agent to the Court and ministry of England, and being thirty-seven years a member at last became President of the council of this Colony to all this were added a great elegancy of taste and life, the well-bred gentleman and polite companion the splendid Oeconomist and prudent father of a family with the constant enemy of all exhorbitant power and hearty friend to the liberties of his Country, Nat: Mar. 28 1674 Mort. Aug. 26 1744 An. AEtat 70.

Bibliography

Books

Adams, John. *Diary and Autobiography of John Adams*. Vol. 2. 1771–1781. Edited by L.H. Butterfield. Cambridge, MA: Belknap Press of Harvard University Press, 1961.

———. *The Works of John Adams, Second President of the United States with a Life of the Author, Notes and Illustrations*. Edited by Charles Francis Adams. Boston: Little, Brown and Company, 1856.

Andrews, Charles McLean, and Frances G. Davenport. *Guide to the Manuscript Materials for the History of the United States to 1783 in the British Museum, in Minor London Archives, and in the Libraries of Oxford and Cambridge*. Washington, D.C.: Carnegie Institution of Washington, 1908.

Armstrong League of Hampton Workers. *Memories of Old Hampton*. Hampton, VA: Institute Press, 1909.

Ausband, Stephen C. *Byrd's Line: A Natural History*. Charlottesville: University of Virginia Press, 2002.

Badger, Curtis J. *The Wild Coast: Exploring the Natural Attractions of the Mid-Atlantic*. Charlottesville: University of Virginia Press, 2005.

Barnes, Brooks Miles, and Barry R. Truitt, eds. *Seashore Chronicles: Three Centuries of the Virginia Barrier Islands*. Charlottesville: University Press of Virginia, 1999.

Beckert, Sven. *Empire of Cotton: A Global History*. New York: Knopf, 2015.

BIBLIOGRAPHY

Brown, Alexander Crosby, ed. *Newport News' 325 Years, A Record of the Progress of a Virginia Community; A Collection of Historical Articles.* Newport News, VA: Newport News Golden Anniversary Corporation, 1946.

Byrd, William. *The Dividing Line Histories of William Byrd II of Westover.* Edited by Kevin Berland. Chapel Hill, NC: Published for the Omohundro Institute of Early American History and Culture, Williamsburg, Virginia, by the University of North Carolina Press, 2013.

———. *Prose Works; Narratives of a Colonial Virginian.* Edited by Louis B. Wright. Cambridge, MA: Belknap, of Harvard UP, 1966.

———. *The Secret Diary of William Byrd of Westover, 1709–1712.* Edited by Marion Tinling and Louis B. Wright. Richmond, VA: Dietz Press, 1941.

———. *The Writings of "Colonel William Byrd of Westover in Virginia, Esqr."* Edited by John Spencer Bassett. New York: Doubleday, Page & Co., 1901.

Carson, Cary, and Carl R. Lounsbury, eds. *The Chesapeake House: Architectural Investigation by Colonial Williamsburg.* Chapel Hill, NC: Published in association with the Colonial Williamsburg Foundation by the University of North Carolina Press, 2013.

Chowning, Larry S. *Chesapeake Bay Buyboats.* Centreville, MD: Tidewater Publishers, 2003.

———. *Deadrise and Cross-planked.* Centreville, MD: Tidewater Publishers, 2007.

Clancy, Paul R. *Hampton Roads Chronicles: History from the Birthplace of America.* Charleston, SC: The History Press, 2009.

Couper, Greta Elena. *An American Sculptor on the Grand Tour: The Life and Works of William Couper (1853–1942).* Los Angeles: TreCavalli Press, 1988.

Crofts, Daniel W. *Old Southampton: Politics and Society in a Virginia County, 1834–1869.* Charlottesville: University Press of Virginia, 1992.

Custis, George Washington Parke. *Recollections and Private Memoirs of Washington.* Edited by Mary Randolph Custis Lee and Benson John Lossing. New York: Derby & Jackson, 1860.

Deyle, Steven. *Carry Me Back: The Domestic Slave Trade in American Life.* New York: Oxford University Press, 2005.

Dill, Alonzo Thomas. *Carter Braxton, Virginia Signer: A Conservative in Revolt.* Lanham, MD: University Press of America, 1983.

Erickson, Alice Matthews. *A Chronicle of Civil War Hampton, Virginia: Struggle and Rebirth on the Homefront.* Charleston, SC: The History Press, 2014.

Evans, Emory G. *Thomas Nelson of Yorktown: Revolutionary Virginian.* Williamsburg, VA: Colonial Williamsburg Foundation, 1975.

Flanders, Alan B. *Bluejackets on the Elizabeth: A Maritime History of Portsmouth and Norfolk, Virginia from the Colonial Period to the Present*. White Stone, VA: Brandylane Publishers, in cooperation with the Friends of the Portsmouth Naval Shipyard Museum, 1998.

Flanders, Alan B., and Arthur C. Johnson. *Guardians of the Capes: A History of Pilots and Piloting in Virginia Waters from 1611 to the Present*. Lively, VA: Brandylane, 1991.

Freeman, Douglas Southall. *R.E. Lee: A Biography*. 4 vols. New York: C. Scribner's Sons, 1934–1935.

Greene, Jerome A. *The Guns of Independence: The Siege of Yorktown, 1781*. New York: Savas Beatie, 2005.

Haile, Edward Wright, ed. *Jamestown Narratives: Eyewitness Accounts of the Virginia Colony, the First Decade, 1607–1617*. Champlain, VA: RoundHouse, 1998.

Hatch, Peter J. *"A Rich Spot of Earth": Thomas Jefferson's Revolutionary Garden at Monticello*. New Haven, CT: Yale University Press, 2014.

Hayes, Kevin J. *The Library of William Byrd of Westover*. Madison, WI: Madison House, 1997.

The History of Mathews Baptist Church 1776–2011. Hudgins, VA: Mathews Baptist Church, 2011.

Holly, David C. *Chesapeake Steamboats: Vanished Fleet*. Centreville, MD: Tidewater Publishers, 1994.

Howard, Hugh, and Roger Straus. *Thomas Jefferson, Architect: The Built Legacy of Our Third President*. New York: Rizzoli International Publications, 2003.

Hugo, Nancy Ross, and Jeff Kirwan. *Remarkable Trees of Virginia*. Earlysville, VA: Albemarle Books, 2008.

Jefferson, Thomas. *The Autobiography of Thomas Jefferson, 1743–1790*. Edited by Paul Leicester Ford. Philadelphia: University of Pennsylvania Press, 2005.

———. *Jefferson's Memorandum Books: Accounts, with Legal Records and Miscellany, 1767–1826*. Edited by James A. Bear Jr. and Lucia C. Stanton. Princeton, NJ: Princeton University Press, 1997.

———. *Notes on the State of Virginia*. Philadelphia: Printed and sold by Pritchard and Hall, 1788. www.docsouth.unc.edu.

———. The Papers of Thomas Jefferson. Vols. 12 and 15. Edited by Julian P. Boyd. Princeton, NJ: Princeton University Press, 1956, 1958.

———. *Thomas Jefferson's Garden Book, 1766–1824: With Relevant Extracts from His Other Writings*. Edited by Edwin Morris Betts. Philadelphia: American Philosophical Society, 1944.

BIBLIOGRAPHY

Lindgren, James Michael. *Preserving the Old Dominion: Historic Preservation and Virginia Traditionalism*. Charlottesville: University Press of Virginia, 1993.

Malone, Dumas. *Jefferson the Virginian*. Vol. 1 of *Jefferson and His Time*. Boston: Little, Brown and Company, 1948.

———. *Jefferson and the Rights of Man*. Vol. 2 of *Jefferson and His Time*. Boston: Little, Brown and Company, 1951.

Mariner, Kirk. *Revival's Children: A Religious History of Virginia's Eastern Shore*. Salisbury, MD: Peninsula Press, 1979.

Massey, Don W., and Sue Massey. *Colonial Churches of Virginia*. Charlottesville, VA: Howell Press, 2003.

McCullough, David G. *John Adams*. New York: Simon & Schuster, 2001.

McGaughy, J. Kent. *Richard Henry Lee of Virginia: A Portrait of an American Revolutionary*. Lanham, MD: Rowman & Littlefield Publishers, 2004.

Meade, William. *Old Churches, Ministers and Families of Virginia*. Vol. 2. Philadelphia: J.B. Lippincott & Co., 1861.

Montgomery, Dennis. *A Link Among the Days: The Life and Times of the Reverend Doctor W.A.R. Goodwin, the Father of Colonial Williamsburg*. Richmond, VA: Dietz Press, 1998.

Peabody, Francis Greenwood. *Education for Life: The Story of Hampton Institute, Told in Connection with the Fiftieth Anniversary of the Foundation of the School*. Garden City, NY: Doubleday, Page & Company, 1918.

Pogue, Dennis J. *Founding Spirits: George Washington and the Beginnings of the American Whiskey Industry*. Buena Vista, VA: Harbour Books, 2011.

Quarstein, John V., and Dennis P. Mroczkowski. *Fort Monroe: The Key to the South*. Charleston, SC: Arcadia Publishing, 2000.

Randolph, Sarah N. *The Domestic Life of Thomas Jefferson*. New York: Harper & Brothers, 1871.

Rawlings, James Scott. *Virginia's Colonial Churches, An Architectural Guide; Together with Their Surviving Books, Silver & Furnishings*. Richmond, VA: Garrett & Massie, 1963.

Rountree, Helen C. *The Powhatan Indians of Virginia: Their Traditional Culture*. Norman: University of Oklahoma Press, 1989.

Rountree, Helen C., and E. Randolph Turner. *Before and after Jamestown: Virginia's Powhatans and Their Predecessors*. Gainesville: University Press of Florida, 2005.

Rountree, Helen C., Wayne E. Clark and Kent Mountford. *John Smith's Chesapeake Voyages, 1607–1609*. Charlottesville: University of Virginia Press, 2007.

Rush, Benjamin. *Letters of Benjamin Rush*. Edited by L.H. Butterfield. Princeton, NJ: American Philosophical Society, 1951.

Smith, Andrew F. *Peanuts: The Illustrious History of the Goober Pea*. Urbana: University of Illinois Press, 2007.

Smith, Howard W. *Benjamin Harrison and the American Revolution*. Williamsburg: Virginia Independence Bicentennial Commission, 1978.

Smith, John. *The Complete Works of Captain John Smith (1580–1631)*. Edited by Philip L. Barbour. Chapel Hill: Published for the Institute of Early American History and Culture, Williamsburg, Virginia, by the University of North Carolina Press, 1986.

Styron, William. *Lie Down in Darkness*. Indianapolis: Bobbs-Merrill, 1951.

Talbot, Edith Armstrong. *Samuel Chapman Armstrong: A Biographical Study*. New York: Doubleday, Page & Company, 1904.

Tazewell, William L. *Newport News Shipbuilding, the First Century*. Newport News, VA: Mariners' Museum, 1986.

Tinling, Marion, ed. *The Correspondence of the Three William Byrds of Westover, Virginia: 1684–1776*. Vol. I. Charlottesville: University Press of Virginia, 1977.

Tormey, James. *How Firm a Foundation: The 400-Year History of Hampton Virginia's St. John's Episcopal Church, The Oldest Anglican Parish in the Americas*. Richmond, VA: Dietz Press, 2009.

Tucker, George Holbert. *Norfolk Highlights, 1584–1881*. Norfolk, VA: Norfolk Historical Society, 1972.

Turbyville, Linda. *Bay Beacons: Lighthouses of the Chesapeake Bay*. Annapolis, MD: Eastwind, 1995.

Upton, Dell. *Holy Things and Profane: Anglican Parish Churches in Colonial Virginia*. New York: Architectural History Foundation, 1986.

Wallace, Adam. *The Parson of the Islands: A Biography of the Rev. Joshua Thomas*. Cambridge, MD: Tidewater Publishers, 1961.

Warren, Elinor, and Jean Fripp. *Shirley Plantation: Home to a Family and a Business for 11 Generations*. Charles City, VA: Shirley Plantation LLC, 2010.

Wooldridge, William C. *Mapping Virginia: From the Age of Exploration to the Civil War*. Charlottesville: University of Virginia Press, 2012.

Yarsinske, Amy Waters. *The Elizabeth River*. Charleston, SC: The History Press, 2007.

Yetter, George Humphrey. *Williamsburg Before and After: The Rebirth of Virginia's Colonial Capital*. Williamsburg, VA: Colonial Williamsburg Foundation, 1988.

ARTICLES

Brewington, Marion Vernon. "The Chesapeake Bay Pilots." *Maryland Historical Magazine* 68, no. 2 (1953): 109–33.

Esbeck, Carl H. "Protestant Dissent and the Virginia Disestablishment, 1776–1786." *Georgetown Journal of Law & Public Policy* 7 (2009): 51–103.

McClure, Phyllis. "Rosenwald Schools in the Northern Neck." *Virginia Magazine of History and Biography* 113, no. 2 (2005): 114–45.

Outlaw, Alain C. "Governor's Land: A Stewardship Legacy," a newsletter of the Williamsburg Land Conservancy, (Winter 2010): 3–5.

"Personal Items, 1746–1749." *William & Mary Quarterly* 20, no. 1 (1911): 15–18.

Woodfin, Maude H. "Thomas Jefferson and William Byrd's Manuscript Histories of the Dividing Line." *William & Mary Quarterly* 1, no. 4 (1944): 363–73.

Woolley, Edward Mott. "Tom Rowland—Peanuts." *McClure's Magazine*, December 1913.

OTHER SOURCES

Brown, Thelma Robins. "Memorial Chapel: The Culmination of the Development of the Campus of Hampton Institute, Hampton, Virginia, 1867–1887." Master's thesis, University of Virginia, 1971.

"Report of the Superintendent of the Coast Survey: Showing the Progress of the Survey during the Year 1859." Washington, D.C.: G.P.O., 1860, (regarding False Cape name).

"Report of W.D. Pruden, boundary line commissioner." To His Excellency, Alfred M. Scales, Governor of North Carolina. December 27, 1888.

Schlesinger, Catherine Savedge. "Wren Building at the College of William & Mary Restored: Summary Architectural Report of Interior Restoration 1967–1968 Block 16 Building 3." Colonial Williamsburg Foundation Library Research Report Series, 0194, 1990 (originally prepared in 1968, revised in 1979).

"Statement of Willie S. Jett, May 6, 1865." Lincoln Assassination Suspects file, microcopy M-599, National Archives.

Wells, Camille. "Dendro-Dating the Domestic Architecture of Colonial Virginia: Exploring the Potential of Certainty." In *Proceedings of the Second*

International Congress on Construction History: Queens' College, Cambridge University 19th March–2nd April 2006, 3267–3278. Cambridge, UK: Construction History Society, 2006.

Wenger, Mark R. "Westover, William Byrd's Mansion Reconsidered." Master's thesis, University of Virginia, 1980.

Websites

Much of the information in *Tidewater Spirit* comes from a number of different websites. The owners of many of the buildings photographed for this book have websites—most with detailed history information. The web addresses for these buildings, as well as for all other internet sources, are identified in the endnotes.

Encyclopedia Virginia, www.encyclopediavirginia.org, is a treasure trove of concise informative articles written by history scholars. The Virginia Foundation for the Humanities began Encyclopedia Virginia in 2005. I have relied on it extensively. Specific Encyclopedia Virginia articles are identified in the endnotes.

Index

About the Author

Bryan Hatchett is a native of Hampton. He has photographed eastern Virginia for forty years. For nineteen years, he edited and published the annual "Chesapeake Bay Watermen Calendar." His "day job" has been as a lawyer in New York, first with CBS and later at Food Network. Retired from active practice, he continues to divide his time between New York and Virginia. Hatchett is a graduate of Washington & Lee University and a law graduate of the University of Richmond.

Visit us at
www.historypress.com
··